THE COLOSSAL

THE COLOSSAL

From Ancient Greece to Giacometti

PETER MASON

REAKTION BOOKS

Somehow we know by instinct that outsize buildings cast the shadow of their own destruction before them, and are designed from the first with an eye to their later existence as ruins.
W. G. Sebald, *Austerlitz*

For my good friend John Blake

Published by Reaktion Books Ltd
33 Great Sutton Street
London EC1V 0DX, UK
www.reaktionbooks.co.uk

First published 2013

Printed and bound in Great Britain by TJ International, Padstow, Cornwall

British Library Cataloguing in Publication Data
Mason, Peter, 1952–
The colossal : from ancient Greece to Giacometti.
1. Large-scale sculpture—History. 2. Symbolism in art.
I. Title
730.1′8-DC23

ISBN 978 1 78023 108 2

CONTENTS

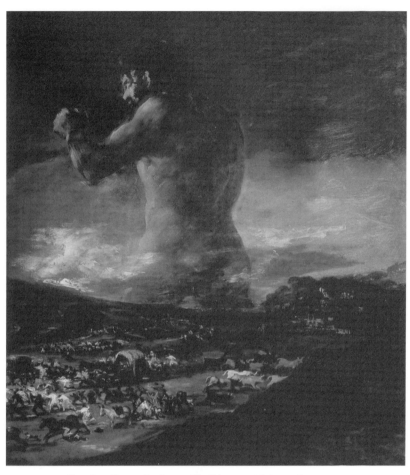

1 Francisco Goya y Lucientes, *The Colossus*, *c.* 1808–12, oil on canvas.

INTRODUCTION: INVENTIONS OF THE COLOSSAL

A striking absence from the exhibition 'Goya en tiempos de guerra' held in the Museo del Prado, Madrid, in 2008 was the museum's own painting variously known as *The Colossus*, *The Giant* or *Panic*. The question of attributions in the case of the oeuvre of Francisco de Goya y Lucientes is a vexed one, but the discovery of the initials 'AJ' and alleged imperfections in the rendering of the animals have led some to credit the work to Goya's assistant Assensio Julià.[1] Fewer doubts surround the aquatint of a seated giant that was admitted to the exhibition.[2] In the oil canvas, the huge figure strides above a scene of wartime carnage, the dark sky above him effectively mirroring the dark abyss in the lower right of the painting, while figures and animals scatter in panic; the gigantic figure in the engraving, on the other hand, finds himself in an atmosphere of profound calm. He is seated on top of – and dwarfs – a bleak landscape through which a river runs, and is turning his head backwards and away from the setting moon that announces the dawn in a pose based on the famous Belvedere Torso to which Goya turned time and again for inspiration.[3] In both cases various interpretations have been made of the two gigantic figures: as the Spanish people rising up against the Napoleonic tyranny, as an image of that Napoleonic power itself, as a mythological figure, as an abstract personification, and so on.[4] The title of the engraving is precisely what it shows: a *Seated Giant*.[5] As for the painting, however, the title *Colossus* was apparently not invented until 1928.[6] Its title in an inventory of Goya's property, drawn up in 1812 after the death of his wife in that year, is *The Giant*.

This might look like no more than a quibble, for we are accustomed to use the words 'gigantic' or 'colossal' as virtual synonyms. For instance,

in a draft plan for the design of Paris in which the French socialist Charles Duveyrier (1803–1866) 'wanted to give a human form to the first city inspired by our faith', he presented a completely anthropomorphic plan of the city like an anatomical chart in which he proposed 'to extend the left arm of the *colossus* along the bank of the Seine' and to 'extend the right arm of the *giant*, as a show of force, all the way to the Gare de Saint-Ouen'.[7] Another synonym that comes to mind is 'massive'. Among musicologists, for example, the term 'colossal baroque' is used to refer to the gigantic forces of massive choirs deployed in performing the polychoral compositions known in German as *Massenstil*; in the first half of the seventeenth century, in a city inspired by a very different faith from that of Duveyrier, the overwhelming effect of as many as twelve choirs, positioned in different parts of a church and each accompanied by its own organ, reflected the triumphalism of Catholic and Baroque Rome.[8]

The account of the colossal offered in this book, however, sets out to show that the assumption of such an equivalence between the colossal, the gigantic or the massive has not always been the case. In fact, as regards the colossal, *no guru, no method, no teacher*: apparently no one has yet attempted to theorize the colossal. The present response to that lack owes some of its inspiration to the philosopher J. L. Austin.[9] Just as he built his theory of performative utterances on how words, whose conventional meanings are sedimented in dictionaries and the language of jurisprudence, are used in everyday practice,[10] so we here initially take 'colossal' to designate whatever is referred to as colossal in conventional usage: the Colossus of Rhodes, the Roman Colosseum, and so on. And from those footholds we attempt to construct an account of the colossal based on common usage, but with the ambition of constructing, piece by piece, a 'theory' of the colossal that goes beyond the commonplace.

Neither a 'theory' nor a 'history' of the colossal as the words 'theory' and 'history' are usually understood, the arrangement of this text is broadly, but not strictly, chronological. Instead of attempting to narrate a linear history (which in the present case would be impossible anyway), it keys various instances of the colossal into their various specific temporal and cultural frameworks in a manner that is more archaeological than historical. Thus the obelisks that can be viewed in

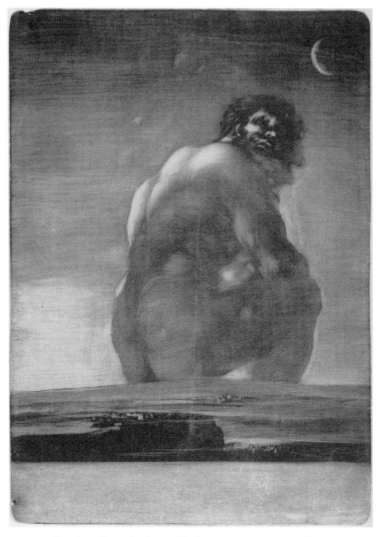

2 Francisco Goya y Lucientes, *The Giant*, c. 1818, aquatint and burin.

public places in Rome today are set within a series of archaeological strata extending backwards from the present to Papal Rome of the sixteenth and seventeenth centuries, further back still to imperial Rome, and even further back to ancient Egypt. The discussion of the stone statues (moai) situated on Easter Island links them to both the age of exploration and discovery of James Cook and others, and the present status of Easter Island as 'museum island'. In a later chapter, discussion

of the moai transported from the island to new settings elsewhere links them to the age of imperial expansion and rivalry as well as to present-day debates on forms of display. The colossal heads of the Olmecs similarly straddle two moments: their discovery towards the end of the nineteenth century when Freud, Darwin and others were changing the paradigms of European thought about the person, and their presentation in the era of Surrealism. The relation between technology and Surrealism that Walter Benjamin perceived structures the last chapter, which ends with the colossal *Cube* of Alberto Giacometti.

The choice of Giacometti, an artist more noted for his miniature works than for anything gigantic, is not as strange as it may seem. The word 'colossal', it is true, immediately conjures up those two ancient monuments, the Colossus of Rhodes and the Roman Colosseum. As they were both on a large scale, this seems to be a natural enough application of the term. But a passage from the *Agamemnon* by the fifth-century BC tragedian Aeschylus points in a different direction. The scene is the grieving Menelaos, whose wife Helen has deserted the palace in Argos in pursuit of her lover Paris. The chorus chants:

> From desire for one beyond the sea,
> A phantom will seem to rule the palace.

The phantom is the image of the absent Helen, for whom Menelaos still longs even though she has crossed the sea to Troy. In seeming to rule over the palace, the phantom thus *stands in for* her. The chorus continues:

> The charm of the well-shaped *kolossoi*
> Is hateful to the husband.

Whatever meaning the word *kolossoi* has here, it can hardly refer to anything gigantic. These are sculpted blocks that contrast with the absent bride not because of any notion of size, but because their dead material contrasts with the living body that is far away. They remind Menelaos of that very fact, instead of consoling him. The passage concludes:

In the absence of eyes,
All Aphrodite is gone.[11]

The phrase 'in the absence of eyes' is unclear, but whether we take it
to refer to the sightlessness of the statues themselves and their inability
to stimulate passion on the part of Menelaos, or to the disinterested gaze
of Menelaos himself, the result is the same: like the phantom that will
seem to rule the palace, the shapely statues are substitutes for the
missing bride, they *stand in for* her, they *replace* her, though in a far
from lifelike way.

This and other Greek evidence to be discussed in the following
chapter, as well as studies of the etymology of words like *kolossos*, all
point to the existence of an understanding of the colossal in which it
is not size that is of primary importance but, as we shall see, such
characteristics as immobility and sightlessness, singleness and verticality.
We can go further. Though the Greek model does not necessarily imply
figuration – indeed, the Greek *kolossos* is often referred to as aniconic
– its very role as a substitute for a living being confers a measure of
anthropomorphism on it. Thus though many of the examples
considered in this book are large or even very large, it is not size that
is, in the last analysis, the determinant factor.

Arguably, the artist who understood this better than most was
Alberto Giacometti, whose sculptures are patently anything but gigantic.
He seems to have tapped directly into the archaic world view of the
Greeks, and his sources of inspiration also include the ancient Etruscans
and Egyptians. Here is Jean-Pierre Vernant on the *kolossos* of archaic
Greece:

> The stone and the psychē of the dead contrast with the living
> being, the former by its fixity, the latter by its elusive mobility.
> Living beings move, standing on the surface of the ground,
> always in contact with it through the soles of their feet. The
> kolossos, thrust into the ground, rooted in the depths of the
> soil, remained fixed in immobility.[12]

And here is Giacometti on his statues of men and women: 'I had realized
that I can never do anything but a motionless woman and a man who

walks. I make the woman immobile and I always make the man walking.'[13]

The colossal statues of Rhodes and Rome; the colossal pyramids and obelisks of Egypt; the colossal heads sculpted in Mesoamerica by the Olmec; the famous moai of Easter Island: these can all be regarded as landmarks in the formation of the concept of the colossal, not only chronologically speaking but also in the way in which that concept of the colossal has been produced. In other words, besides just featuring in historical contexts, these examples have gone a long way to shaping and imposing themselves on the concept of what we understand today by the colossal, and to excluding the alternative, Greek conception. The present account is thus at the same time an alternative historiography.

There are two categories that will be left out of the discussion: the column and the *kouros* statue. Although in the last resort the column can and should be regarded as anthropomorphic, its primary function is as an architectural support, not as a free-standing and isolated object.[14] True, it may be very large. It may be found in the company of an obelisk, like the column erected in front of the Basilica of Santa Maria Maggiore in Rome as a pendant to the Egyptian obelisk at its rear. And there are cases of isolated columns, from Trajan's Column in Rome to Napoleon's column in the Place Vendôme or Nelson's Column in Trafalgar Square, or even Adolf Loos's design for the Chicago Tribune building in the form of a Doric column in polished black granite.[15] Yet none of these can be said to *stand in for* something else: Trajan's Column is a triumphal monument that serves as a medium on which to represent the subjugation of what is now Romania, and the columns in Paris and London are essentially nothing more than very tall pedestals.

As for the *kouros*, this was a stone or bronze statue of a male youth, usually life-size or smaller, that could fulfil a votive or a funerary function (its female counterpart was called a *korē*). In either case it was a substitute, standing in for the person it represented. In its role as a substitute (whether for the god Apollo or for the dead youth) and in its rigid attitude and fixed position, the *kouros* shared attributes with the *kolossos*. However, the latter was aniconic, while the *kouros*, though not a 'portrait', was an idealized representation of an identifiable person, as the inscriptions make clear.[16]

An Inaccessible Elsewhere

If we have established that the colossal does not need to be of vast proportions, nevertheless the Greek examples cited above could all be said to be larger than themselves, in that an object of modest size can nevertheless serve to connect the world of the living with the world of the dead and to articulate issues of mobility and immobility, vision and blindness. When confronted with the task of designing a war memorial for those who had fallen in the First World War, Edwin Lutyens astutely realized that a cenotaph to commemorate the absent dead should be as inclusive as possible, as well as capable of accommodating the various public activities that would be staged around it. The almost 11-m-tall version in Portland stone that was unveiled in Whitehall, London, on 11 November 1920 was 'larger than itself': the use of vertical and horizontal lines that were slightly convex, and therefore had an imaginary vanishing point, introduced a 'virtual' apex at a point 304 m above ground level, while the horizontals formed sections of a sphere with a centre 274 m below ground level. This way of uniting the seen with the unseen coincides completely with what we have learned about the Greek *kolossos*.[17]

The objects discussed in the following chapters are all cases of large worked stone artefacts – moai, obelisks, colossal heads – that are on display in a variety of settings, not just on exotic locations like Easter Island or the Mexican province of Tabasco but also in public squares, inside metropolitan museums, on traffic islands, in gardens. Each setting imposes on the viewer a certain distance from the object: relatively proximate but highly circumscribed in the museum, relatively distant but less strictly regulated on, say, Easter Island itself. These physical constraints impose certain conditions on the way in which we perceive those colossal objects. Each setting also belongs to a set of institutional practices – the cultural or aesthetic criteria of the museum, the civic or political criteria of the public monument – that to some extent condition our perception of those particular objects too. The two may be combined as, for instance, in Henry Moore's *Reclining Figure* as seen by visitors to the Festival of Britain on London's South Bank in 1951. The artist's precise positioning of the work in relation to its surroundings and to the point at which visitors entered the site enabled two

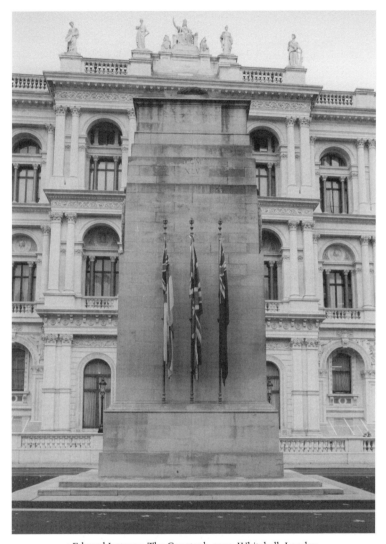

3 Edward Lutyens, The Cenotaph, 1920, Whitehall, London.

contradictory experiences: the presentation of a head that appeared to be looking upwards and screaming, reminiscent of the heads from Picasso's *Guernica*, while simultaneously gazing into the distance like the hieratic Maya Chac-Mool statues that so fascinated Moore.[18] The work had to be seen from a distance to achieve this effect.[19]

For the analyst, this involves a shift from trying to interpret what is expressed in the work to analysing the effect that is produced on the

observer by the specific combination of that particular work within that particular physical and institutional setting – in other words, a heightened sensitivity to the sense of place. In some respects this complements Walter Benjamin's thesis that 'History is the subject of a structure whose site is not homogeneous, empty time, but time filled by the presence of the now', for these objects are located in settings that are by no means homogeneous or empty but, precisely, filled by the presence of the now.[20] It is the meaning(s) conferred by the various settings in which they have found themselves in the past and may find themselves in the present – the various nows – that are at issue here, not the meaning(s) that these objects may have had within the 'original' cultures of ancient Egypt, pre-Columbian Mesoamerica or elsewhere. This in turn means that the analytical tools that may help to guide us through the material – such as the object larger than itself – will themselves be derived from that very material; they are picked up along the way rather than originating in some predefined theoretical framework.

Benjamin, however, went further: 'It is said that the dialectical method consists in doing justice each time to the concrete historical situation of its object. But that it is not enough. For it is just as much a matter of doing justice to the concrete historical situation of the *interest* taken in the object.'[21] Moai and colossal heads, for instance, were there long before Europeans discovered them but, as we shall see, interest in their discovery and how they are interpreted may vary from one historical conjuncture to another. That interest is brought into focus by the physical and institutional setting in which the object finds itself, be it near or far, on a traffic island, in an expo or a park, a sculpture garden or shrine.

Some of the objects considered here are exhibited in museum settings. After the rise in popularity of studies of the 'poetics and politics of' in the 1980s, it was inevitable that the 'poetics and politics of ethnography' should lead, sooner or later, to 'the poetics and politics of museum display'.[22] In a more self-indulgent vein, cultural analysts created a genre which we might call the 'museum travelogue' at roughly the same time. James Clifford, for example, contrasted aesthetic with historical displays, 'mainstream' with tribal displays and so on, in accounts of his visits to four museums on the northwest coast of North

America, while Mieke Bal did something similar for museums closer to the centres of u.s. political power.[23] However, the museum setting is not always the most appropriate perspective from which to view some of the objects considered here, since they appear to be equally at home – or not at home, as we shall see – as part of the civic architecture in public spaces where, arguably, the political might be expected to prevail over the poetic. Hence the importance of taking into account the 'concrete historical situation of the *interest* taken in the object' as well.

In the end the colossal will prove to be elusive to structuralist oppositions of the type either/or. The elusiveness of the colossal, it will be argued, lies in its ability to play on two contrasting planes. As Vernant wrote of the Greek *kolossos*: 'at the moment when it shows its presence it reveals itself as not being from here, as belonging to an inaccessible elsewhere'.[24]

1

LOCATING THE COLOSSAL

The word 'colossal' immediately calls to mind two ancient monuments: the Colossus of Rhodes and the Roman Colosseum. Since they were both built on a large scale, this seems to be a natural application of the term. But it is worth taking a closer look at these two monuments, for they turn out to be less enduring than they seem. As we shall see, the Colossus of Rhodes stood for less than a century, and the Colosseum may not have received this name until it was almost a millennium old; they thus offer a more shaky foundation on which to erect the term 'colossal' than may appear at first sight.

Colossus

One of the last items to be included among the Seven Wonders of the World was the statue of the sun god Helios known as the Colossus of Rhodes.[1] Coins of the island often included a representation of Helios on one side and a stylized flower to represent the name of the island – Greek *rhodos* means 'rose' – on the other. But the connection between Helios and Rhodes was spelled out on a much grander scale by the bronze figure that was begun after the Rhodians had successfully withstood and repulsed Macedonian forces under Demetrius Poliorcetes in 304 BC. In the sixth century the god Apollo had been evoked or represented at Naxos and Amyclae by statues 8.5 and 14 m tall respectively – suprahuman dimensions that corresponded to the stature of the gods assumed in the Homeric epics.[2] The Rhodian Colossus, however, stood no less than 32 m high. Not a single representation of the statue has come down to us from antiquity, which left artists scope to let their imaginations run. Writing soon after his visit to the Greek island of Rhodes in 1551, the French

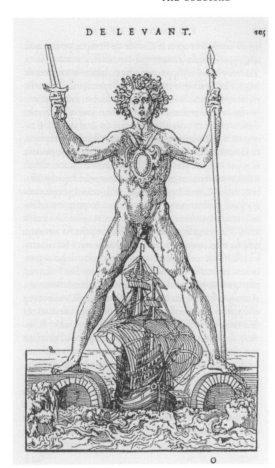

DE LEVANT. 105

4 'Colossus of Rhodes', from André Thevet, *Cosmographie de Levant* (1556).

O

cosmographer André Thevet presented an account and a woodcut of the statue.[3] Thevet's artist shows the gigantic figure with a mirror on its chest and holding a sword in its right hand and a spear in its left.[4] In placing it with a foot planted on each side of the entrance to the harbour, providing barely enough headroom for a ship to pass between its legs, the engraver was following a medieval conception that can be found in some fifteenth-century chroniclers of Rhodes.[5] Thevet's text, on the other hand, repeats almost word for word what Pliny the Elder had written about the colossus fifteen centuries earlier, apparently based on first-hand observation:

> But that which is by far the most worthy of our admiration, is
> the colossal statue of the Sun, which stood formerly at Rhodes,

and was the work of Chares the Lindian, a pupil of the above-named Lysippus; no less than seventy cubits in height. This statue fifty-six years after it was erected, was thrown down by an earthquake; but even as it lies, it excites our wonder and admiration. Few men can clasp the thumb in their arms, and its fingers are larger than most statues. Where the limbs are broken asunder, vast caverns are seen yawning in the interior. Within it, too, are to be seen large masses of rock, by the weight of which the artist steadied it while erecting it. It is said that it was twelve years before this statue was completed, and that three hundred talents were expended upon it; a sum raised from the engines of warfare which had been abandoned by King Demetrius, when tired of the long-protracted siege of Rhodes.[6]

Pliny, however, makes no mention of the figure straddling the two sides of the harbour entrance. It is now known that such a feat would have been technically impossible for an ancient bronze-caster.

Still, the figure had an obvious appeal to artists, and we find it repeated only a few years after Thevet in a unique series of prints of the Wonders of the World by the Dutch artist Maarten van Heemskerck.[7] In introducing the head of another colossus in the foreground, the artist appears to have had the continuation of the Plinian passage in mind:

> In the same city there are other colossal statues, one hundred in number; but though smaller than the one already mentioned, wherever erected, they would, any one of them, have ennobled the place. In addition to these, there are five colossal statues of the gods, which were made by Bryaxis.

There is a bustle of human activity here: figures measuring and scraping this colossal head, the figure on the left pointing out some feature of a gigantic fragment (of a hand?) to Chares the Lindian on the far left, the Rhodians worshipping the statue of Helios on both sides of the channel, as well as small figures who can be seen against the vast architectural background. The god not only holds a torch but is also equipped with a bow and arrows. These attributes of Apollo – for

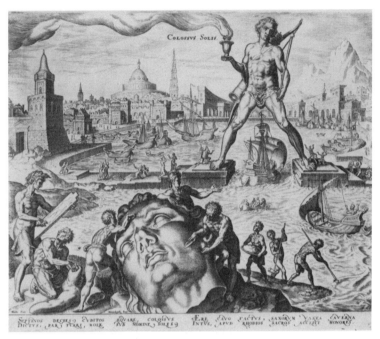

5 Philips Galle, after Maarten van Heemskerck, 'Colossus of Rhodes',
from *The Wonders of the World*, 1572.

example, in Cartari's image of the deity – underline the equivalence
between the sun god Helios and Apollo.[8]

Heemskerck had tackled the Colossus of Rhodes earlier in his
almost 4-m-long painting *Landscape with the Rape of Helen*, where the
huge figure holds a torch in his left hand (illus. 7).[9] Yet as the ruins in
that painting show, the wonders of antiquity, like Helen's beauty,
were destined to disappear, or to survive only as fragments. The
Colossus of Rhodes, which was completed in 282 BC, was destroyed
in an earthquake in 226 BC. According to some authorities it was
subsequently restored, perhaps under Vespasian or Hadrian. Various
accounts claim that, after the Arab conquest of the then-Christianized
island in 654, what was left of the statue was broken up, taken away
to Alexandria on a large number of camels and sold.[10] However, the
latter claims have been called into question and it seems more likely
that the statue was in a state of disrepair long before the Arab con-
quest.[11] Thevet's artist and Heemskerck were representing a vision
of the undamaged colossus which, whatever it may have looked like

6 'Apollo', from
Vicenzo Cartari,
*Imagini delli Dei de
gl'Antichi* (1647),
woodcut.

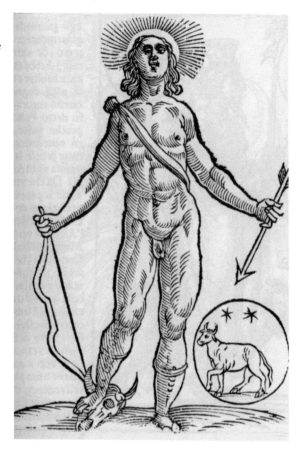

in reality, could only have been seen intact in its original state for a period of some 56 years.

The dream that comprises the whole of the *Hypnerotomachia Poliphili*, generally but not universally attributed to Francesco Colonna and published at the very end of the fifteenth century, includes an episode reminiscent of the figures in Heemskerck's engraving (or of Sylvia Plath in her poem 'The Colossus') scrambling over the colossal ruins that littered the island even before the famous colossus itself had fallen. As the protagonist, Poliphilo, advances over a field of ruins covered with large fragments and chips of marble, he decries 'a vast and extraordinary colossus, whose soleless feet opened into hollow and empty shins'. It emitted a low groaning sound caused by the wind entering through the open feet. He goes on:

This colossus lay on its back, cast from metal with miraculous skill; it was of a middle-aged man, who held his head somewhat raised on a pillow. He seemed to be ill, with indications of sighs and groaning about his open mouth, and his length was sixty paces. With the aid of his hair one could climb upon his chest, then reach his lamenting mouth by way of the dense, twisted hairs of the beard. This opening was completely empty; and so, urged on by curiosity, I proceeded without further consideration down the stairs that were in his throat, thence into his stomach, and so by intricate passageways, and in some terror, to all the other parts of his internal viscera. Then oh, what a marvellous idea! I could see all the parts from the inside, as if in a transparent human body. . . . All the closely-packed organs had little entrances giving easy access, and were illuminated by small tunnels distributed in suitable places around the body.[12]

Although the work contains 174 woodcuts, the author did not attempt to represent this episode visually. Rather, it is his prurient curiosity

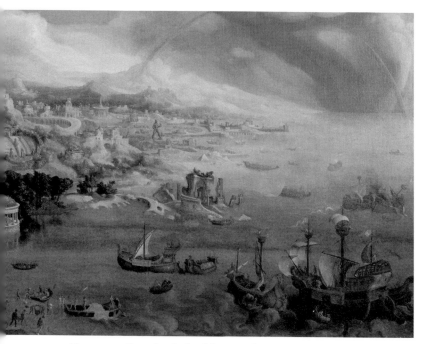

7 Maarten van Heemskerck, detail from *Landscape with the Rape of Helen*, 1535–6, oil on canvas.

and fascination with orifices that predominate, as if the theme of the fragmented colossus is put to the service of an erotic novel.

If it was an earthquake that brought about the dissolution of the Rhodian colossus, it was a different earthquake that led to the creation of another one. The mythographer Phlegon of Tralles, writing in the second century AD, quotes a certain Apollonius the Grammarian as reporting that in the time of Tiberius (*reg.* AD 14–37) an earthquake destroyed many notable cities in Asia Minor. Tiberius rebuilt them at his own expense, in gratitude for which the people constructed and dedicated to him a colossus beside the temple of Aphrodite in the Roman Forum, and also set up statues in a row next to it from each of the cities.[13] There were other colossal statues in Rome, such as the colossus of Augustus in the Forum of Augustus, representing the emperor as a mediator between the human and the divine. Extant fragments of the massive hands indicate that the statue itself must have stood about 11 m high.[14] Pliny mentions another two colossal statues in the centre of imperial Rome: the Apollo in the Capitol, which was

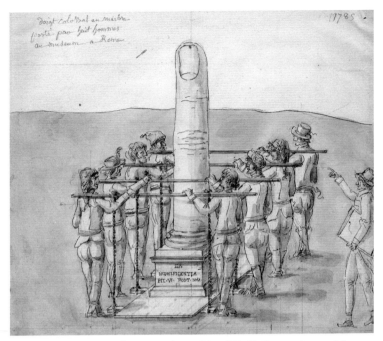

8 Antoine-Laurent-Thomas Vaudoyer, *Colossal Marble Finger*, 1785, pen, ink, pencil and wash.

brought by M. Lucullus from Apollonia, and the statue of Jupiter, in the Campus Martius, dedicated by the emperor Claudius 'but which appears small in comparison from its vicinity to the Theatre of Pompeius'.[15] If we were to believe the evidence of a watercolour inscribed 'Colossal marble finger carried by eight men to the museum in Rome' and dated 1785, we would have to add at least one more colossal statue to the list, but it is likely that the artist, Antoine-Laurent-Thomas Vaudoyer, was simply using the finger to poke fun at the mania for the antique that pervaded Roman culture at the time.[16]

The biggest of all these colossal statues in Rome, which was itself modelled on the Colossus of Rhodes (the artist even took the Rhodian cubit as his unit of measure) but exceeded it in size, was the bronze statue of Nero with the attributes of the Sun – or of the Sun with the facial characteristics of Nero – by Zenodorus, which may have risen to more than 38 m high without counting the base on which it stood.[17] Originally placed at the centre of the atrium of the Domus Aurea, as Nero's palace was called, the colossal statue was removed from that

site to make way for the construction of a grandiose temple to Venus and Rome by Hadrian.[18] It was transported by 24 elephants to a new location, situated between the Imperial Fora and a vast amphitheatre completed during the reigns of Vespasian and Titus: the Colosseum. Standing on its base, the colossal statue of Nero would have been almost as high as that towering edifice. From the fourth century until its destruction, it would have been visually framed for visitors from the south by the Arch of Constantine.[19]

Colosseum

After the death of Nero in AD 68, subsequent emperors engaged in new building projects to erase the Neronian ones from memory – although Freud was to open his *Civilization and its Discontents* by using the very example of the Colosseum to demonstrate the impossibility of such acts of destruction of the memory trace – by inscribing a new architectural order on top of the Neronian sites in order to restore the huge area that he had occupied to the city.[20] The task of building the largest amphitheatre in the world was completed during the reigns of Nero's successors Vespasian and Titus by draining the rectangular lake that had formed part of Nero's palace and using its basin as the foundation of the building. The result was a truly colossal, four-tiered elliptical building whose outermost ring was almost 50 m high and whose largest ellipse had a 'diameter' of 188 m.[21]

However, it was not until the eighth century at the earliest that the amphitheatre came to be called the Colosseum, after the proximity of the colossal statue of Nero, which had in the meantime been re-modelled with the features of the emperor Commodus as Hercules.[22] A prophecy contained in an anonymous eighth-century miscellany runs: 'As long as the Colyseum stands, Rome shall stand, when the Colyseum falls, Rome will fall too, when Rome falls the world shall fall.'[23] If this prophecy refers to the building and not to the statue, it is the earliest reference to the name Colyseum for the amphitheatre.[24] Otherwise it is documentation from around the year 1000 that first defines the monument as Amphitheatrum Coliseum, even though there were still those who thought it was a palace.[25] By the Middle Ages, con-fusion was such that in the fourteenth-century *De Mirabilibus civitatis*

Romae and in John Capgrave's *Ye Solace of Pilgrimes* from around 1450, the Colosseum could become a temple dedicated to the Sun, while the colossal statue of Constantine that once stood before the Lateran palace was identified with the colossus of Nero, and therefore with the statue of the Sun.[26]

The Colosseum did not feature among the Seven Wonders of the World for the simple reason that that list was compiled in the second century BC, long before it was built.[27] However, this did not stop Maarten van Heemskerck from including it as the eighth in his series of prints of the Wonders of the World, citing as his authority the first-century poet Martial.[28] Instead of rendering the statue of Nero outside the Colosseum, he has placed a statue of Jupiter, complete with lightning bolts, eagle and sceptre, inside the amphitheatre itself. Heemskerck had already familiarized himself with the world of antiquity at second hand while serving as a pupil in the workshop of Jan van Scorel, who returned to Haarlem from Italy in 1524.[29] Eight years later the pupil, now in his early thirties, was ready to make the journey himself and the sketches that

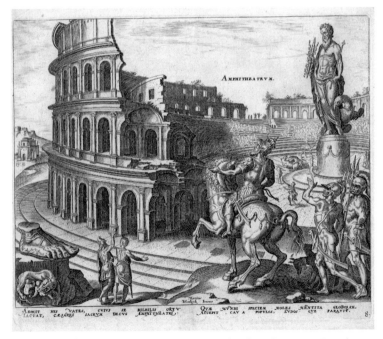

9 Philips Galle, after Maarten van Heemskerck, 'The Colosseum in Rome', from *The Wonders of the World*, 1572.

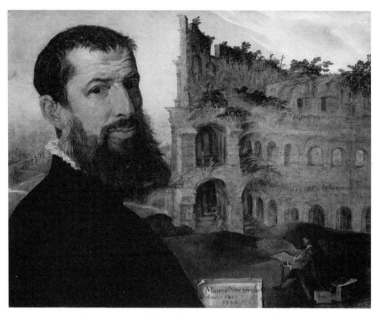

10 Maarten van Heemskerck, *Self-portrait*, 1553, oil on canvas.

he made during his five years in Rome – where, as Karel van Mander tells us, he did not waste his time drinking and suchlike with the other Dutch – display an urge to preserve records of the monuments, sculptures and ruins of the city for use in compositions that he would produce after returning to the northern Netherlands.[30] *Landscape with the Rape of Helen*, painted in 1535 or 1536 at the end of Heemskerck's stay in Italy, is an encyclopaedic compendium of all those impressions.[31] The painter's particular attachment to the amphitheatre, *the* symbol of Rome, can be seen in his double self-portrait from much later (1553), in which he represents himself as a proud figure at the age of 55, in front of a painting of the artist as a young man sketching the Colosseum. Although it was the only one of the Wonders of the World that he had seen with his own eyes, the artist rendered it in a particularly ruinous state to allow a better view of the interior, as well as to convey the message of *vanitas*, not only through the fall of ancient Rome but also through the inevitable decline from youth to old age.[32]

Some artists, such as Bartolomeo di Giovanni, depicted the Colos - seum in pristine condition without any signs of wear and tear, nor even of its setting inside an inhabited city, and this is also how it appears

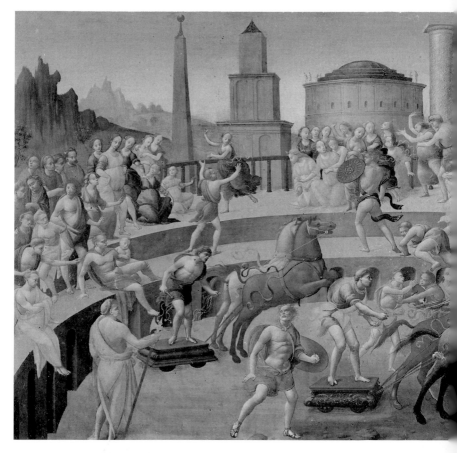

in the near-contemporary *Nuremberg Chronicle* of 1493.[33] Sectional or ruinous views of the Colosseum, on the other hand, as in Sebastian Münster's *Cosmographia* from half a century later, were popular.[34] Besides evoking the theme of the glory that once was Rome (after the sack of Rome in 1527), they afforded a better view of the interior and of the activities that went on there, as for instance in a painting from the History of Rome cycle from the Buen Retiro Palace in Madrid – one of the few examples of an interest in Roman antiquity on the part of the Spanish court (illus. 12).[35] In this respect they mirrored the contemporary production of illustrated works on the anatomy of the human body.[36] For instance, the names of the Rome-based Spanish print publisher Antonio de Salamanca and his French rival and later business partner Antoine Lafréry crop up not only in connection with

11 Bartolomeo di Giovanni, *Peace between Romans and Sabines*, c. 1488, tempera on panel.

the innovative sectional views of both the interior and the exterior of the Colosseum or of the Pantheon in their influential prints of Roman antique statues, monuments and ruins, but also as the publishers of Juan de Valverde's *Historia de la composición del cuerpo humano* in 1556, a work that might be said to present the body in ruins.[37] In a different vein, the little-known Flemish artist and architect Lambert Zutman (Latinized as Suavius, c. 1510–1567) combined a section of the Colosseum in ruins with inventions of his own making. There is no evidence that he was ever in Italy, and it may have been lack of first-hand contact that prompted him to combine designs that he could easily have derived from existing engravings with almost Surrealist architectural

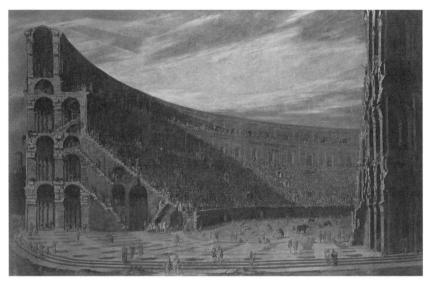

12 Domenico Gargiulo and Viviano Codazzi, *Prospect of a Roman Amphitheatre*, *c.* 1640, oil on canvas.

13 Engraving after Lambert Zutman, from *RUINARUM VARIARUM FABRICARUM DELINEATIONES . . .*, 1560.

14 Engraving after Gottfried Eichler, 'Gratitude', from Cesare Ripa,
Allegories and Conceits (1758–60).

constructions that seem to look ahead to the work of Giorgio de Chirico.
The monument could be put to allegorical use as well, as in an engraving by Gottfried Eichler (1715–1770) that uses the Colosseum as a setting for a number of symbols on the theme of gratitude: the stork showed gratitude to its parents by caring for them in their old age; the story of Androcles and the lion was famous; and the elephant on the far right was a symbol of remembrance of past favours.[38]

A favourite subject for painters from the sixteenth century onwards, views of the Colosseum could evoke a whole spectrum of emotions. In the nineteenth century, Samuel Palmer paired it with a

view of the Piazza del Popolo to contrast the modern city with ancient Rome, while the Romantic vision of the interior by moonlight depicted by artists such as Turner or the Italian painter Ippolito Caffi was as Goethe and other travellers on the Grand Tour preferred to see it, as we shall see at the end of this chapter.[39] Like Heemskerck, Turner had already studied and copied drawings of Italy before heading for Rome in 1819 to confront the immortal city at first hand. He spent three months of feverish activity and filled eight sketchbooks there.[40] Study of the sketchbooks, five of which contain views of the Colosseum seen from a variety of angles and both by daylight and by moonlight, reveals that so exhaustive was his visual exploration of the monument that when he returned to Rome in 1828 he hardly felt the need to record the Colosseum again at all.[41] Later in the century, Jean-Léon Gérôme's scenes of gladiatorial combats and Christian martyrdoms inside the arena exploit the full horror of such activities, while his contemporary Lawrence Alma-Tadema characteristically opted for a very different, more restrained take on the Colosseum, representing its anonymous architect musing over the constructional complexity of the vast edifice.[42]

Kolossos

As Émile Benveniste demonstrated in an article from 1932 on the meaning of the word *kolossos* and the Greek words for statue, the word is of pre-Hellenic origin and has no bearing on size.[43] For example, in a sacred law from Cyrene from the late fourth century BC, *kolossoi* feature in what may be a ghost-banning ritual: the person affected is to fashion male and female *kolossoi* out of wood or mud, allow these statuettes to partake in a ritual meal, and then take them to an un-cultivated wood and fix them in the ground.[44] A second source bearing on Cyrene, which was a Greek colony on the North African coast founded from Thera, involves an oath sworn by the colonists: *kolossoi* were fashioned of wax this time and thrown into the fire in a form of sympathetic magic to signify the liquefaction and disappearance of anyone who should fail to meet the reciprocal obligations.[45] In the latter case 'the efficacy of the ritual depends on the statuettes' capacity to represent the oath-takers, and not merely to symbolize but rather to

prefigure the perjurer's eventual fate.'[46] In both rituals, the *kolossos* mediates between the world of the living and the world of the dead.

Clearly size is not at issue here. Indeed, when the historian Herodotus wanted to indicate large dimensions, he had to add an epithet indicating size to the word *kolossos* to make that clear.[47] As a corollary, none of the larger-than-life statues known from ancient and later sources, with the exception of the Rhodian Colossus, was described as a *kolossos*. Further evidence pointing in this direction can be found in epigrams by the Hellenistic poet Posidippus that were first published in a scholarly edition of the papyrus containing them in 2001. Two of a series of these epigrams on statuary use the term *kolossos* to refer to any lifelike statue, regardless of its size. Indeed, lifelike implied not exceeding the dimensions of the human frame. The distinction drawn in these epigrams is between the rigid posture of archaic statues and the more supple forms of the sculptor Lysippos.[48] What is more, these epigrams may actually pinpoint the moment in the third century BC when the term underwent a semantic change and began to be used to refer to the size of statues, leading to a change of meaning of the term itself under the influence of the Rhodian Colossus.[49] We should therefore not try to be too rigid in determining the precise meaning of the term *kolossos*:

> The disparate examples of *kolossoi* scattered through the ancient sources suggest that the meaning of the term is most probably a flexible one, and depends on its particular context and setting; on some occasions it may carry a ritual charge, and serve to describe images deployed in funerary as well as ghost-banning rituals; on others the statue's morphology may dictate the use of the expression.[50]

What does nevertheless emerge from analysis of the epigraphic evidence, and from the literary evidence of the *Agamemnon* discussed in the introduction, bears out Benveniste's claim that the authentic meaning of the word refers to 'funerary statuettes, ritual substitutes, "doubles", that take the place of the departed and continue their earthly existence'.[51] Analysis of toponyms like the city of the Colossians to whom St Paul addressed an epistle likewise indicates that the primary reference is to something that is erected in a vertical position. A year after the publication

of Benveniste's seminal article, Charles Picard subscribed to its general conclusions and added important archaeological evidence that pointed in the same direction: the presence of two 'menhir statues', one larger than the other, in a tomb devoid of human remains excavated at Dendra near Midea by the Swedish archaeologist Axel W. Persson in 1927. In his view, these *kolossoi* fulfilled the role of the absent departed and were intended to continue their earthly existence.[52]

Developing Benveniste's findings in a paper given 30 years after their original publication, Jean-Pierre Vernant related the *kolossos* to the psychological category of the double.[53] Unlike some portable archaic Greek statues, the *kolossos* was a vertical stone that was fixed immobile in the ground. Buried in a cenotaph, it replaced the body of the dead. Nevertheless, this stone was not the image of the deceased; it was a double, just as the dead person was the double of his living counterpart. Vernant explains:

> A double is a completely different thing from an image. It is not a 'natural' object, nor is it a mental product: neither an imitation of a real object, nor an illusion of the mind, nor a creation of thought. The double is a reality external to the subject but which, in its very appearance, is opposed by virtue of its exceptional character to familiar objects, to the ordinary décor of life. It plays simultaneously on two contrasting planes: at the moment when it shows its presence it reveals itself as not being from here, as belonging to an inaccessible elsewhere.[54]

So just how are we to imagine the *kolossos*? It could be made of stone, wax or mud; it did not have a fixed range of dimensions; and although it might often be conceived as a rigid, columnar configuration comprising a statue with its legs pressed tightly together, if they were differentiated at all, there were exceptions to this rule as well.[55]

Still, in mediating between the world of the living and the world of the dead, the *kolossos* also mediates several other oppositions, and it may prove more useful to examine these rather than try to isolate certain traits. One such opposition is that between mobility and fixity. While other cultic objects could be moved about, carried in processions or bathed in the sea, once the *kolossos* was fixed in place it remained

there. Hence the ghost-banning ritual mentioned above concludes with the words 'once this ritual has been completed, you will take the *kolossoi* and portions [of food] to a virgin wood *to fix them there*.'[56] According to an (emended) ancient gloss, the *kolossoi* are 'those that do not walk'.[57] In this respect the immobility of the *kolossos* forms, by contrast, a pair with the mobility of the spirit (*psychē*). To cite Vernant again:

> The stone and the psychē of the dead contrast with the living being, the former by its fixity, the latter by its elusive mobility. Living beings move, standing on the surface of the ground, always in contact with it through the soles of their feet. The *kolossos*, thrust into the ground, rooted in the depths of the soil, remained fixed in immobility.[58]

When the *kolossos* is of stone, as are all the examples to be considered in this book, this contrasts an immobile, hard, dry and rigid material with the mobile, moist and supple live human body. Petrification occurs in several Greek myths as a transition from life to death, and the head of the Gorgon killed precisely by turning victims into stone.

Another opposition is that between sight and blindness, articulated in antiquity by the figure of the blind seer Teiresias. The archaeological record contains several examples of eyeless *kolossoi*.[59] Like the ability to walk, the ability to see is another defining aspect of human life. For the ancient Greeks, to live was synonymous with to see the light of the Sun, while the realm of Hades was the realm of blindness. The most relevant figure in Greek mythology in this respect is Oedipus, who famously blinded himself after having intercourse with his mother. In another version of the myth, however, he shut himself up in an inner room of the palace out of the sight of men.[60] Whether sightless or out of sight, he had cut himself off from the living world.[61]

Immobility, blindness and death come together in the messenger's speech at the end of Sophocles' *Oedipus at Colonus*, written shortly before the tragedian's death in 406 BC, which describes Oedipus' last moments in a sacred grove that was the entrance to the underworld:

> When he reached the sheer threshold
> Bound to the earth with brazen fetters

He stopped at one of the many-branching paths
Near the hollow bowl, where lie
The everfaithful tokens of Theseus and Peirithoos
Taking up position with the bowl at one corner
The Thorikian rock at another, the hollow wild pear tree
 at the third,
And the stone tomb at the last, he sat down.[62]

Theseus and Peirithoos had descended into Hades to help carry off Persephone and been immobilized there in a seated position – Peirithoos forever, Theseus until his liberation. A seated position was associated with some forms of punishment in ancient Greece, and this association was extended to death.[63] Therefore this allusion to the punishment of Peirithoos and Theseus implies that when the blind Oedipus sits down, he too will be immobilized in death.[64] The blindness and immobility of the *kolossos* converge in the death of Oedipus at Colonus – and the name of the place could hardly be more appropriate.

The Well-tempered Distance

Further useful elements for our inquiry can be gleaned from a passage in Immanuel Kant's *Critique of Judgement* (1790). For Kant, the mathematical estimation of magnitude was not bound by a maximum, but its aesthetic estimation was. In other words, while what he called 'apprehension' could go on ad infinitum, 'comprehension' soon attains its maximum and can go no further. To explain, he cited from a work by Claude-Étienne Savary (1750–1788), *Lettres sur l'Egypte*, who had argued in that work that one must keep from going very near the pyramids while at the same time keeping from going too far from them:

> For if we are too far away, the parts to be apprehended (the stones lying one over the other) are only obscurely represented, and the representation of them produces no effect upon the aesthetical judgement of the subject. But if we are very near, the eye requires some time to complete the apprehension of the tiers from the bottom up to the apex; and then the first tiers are always partly forgotten before the Imagination

has taken in the last, and so the comprehension of them is never complete.[65]

Kant locates the same bewilderment in the mind of the spectator who visits St Peter's Basilica in Rome for the first time. And it is the same impossibility of conceiving the whole by the Imagination that leads him to condemn 'the presentation of a concept which is *colossal* [*Kolossalisch*] i.e. almost too great for any presentation (bordering on the relatively monstrous [*Ungeheure*]) . . . because the purpose of the presentation of a concept is made harder by the intuition of the object being almost too great for our faculty of apprehension'.[66] There are too many points raised by Kant's not always convincing argument to go into here,[67] especially the strangely 'unphilosophical' repeated use of 'almost' [*beinahe*]. Suffice it to extract another element that will prove useful in the course of our inquiry: the relation between the colossal and *distance*, especially the 'well-tempered' distance. We shall return to this in a later chapter in connection with Walter Benjamin's concept of the aura.

A pair of colossi in Egypt – two seated statues of Amenhotep III – provoked a similar reaction on the part of the French artist Vivant Denon, who travelled with the Napoleonic expedition less than a decade after the publication of Kant's *Critique*:

> I then went to the two colossi, supposed to be those of Memnon, and took an accurate drawing of their actual state of preservation. These two pieces of art, which are without grace, expression, or action, have nothing which seduces the judgment; but their proportions are faultless, and this simplicity of attitude, and want of decided expression, has something of majesty and seriousness, which cannot fail to strike the beholder. If the limbs of these figures had been distorted in order to express some violent passion, the harmony of their outlines would have been lost, and they would be less conspicuous at the distance at which they begin to strike the eye, and produce their effect on the mind of the spectator, for they may be distinguished as far as four leagues off. To pronounce upon the character of these statues, it is necessary to have seen them at several intervals, and to have long reflected on them, and after this it often happens,

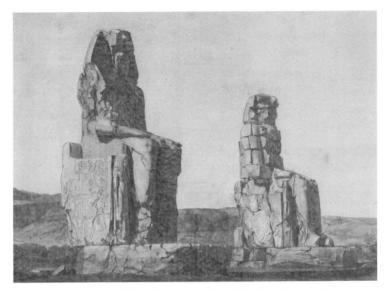

15 André Dutertre, *Thebes, Memnonium, View of the Two Colossi*, 1798–1801, pen and wash.

that what is at first considered as the work of the infancy of art, becomes assigned to its maturer age. If the group of the Laocoön, which speaks to the soul as well as to the eyes, were executed in a proportion of sixty feet, it would lose all its beauty, and would not present so striking a mass of workmanship as this; in short, if these statues were more agreeable, they would be less beautiful, as they would then cease to be (what they are now) eminently *monumental*, a character which should belong peculiarly to that outdoor sculpture, which is intended to harmonize with architecture, a style of sculpture which the Egyptians have carried to the highest pitch of perfection.[68]

Like Kant, Denon here combines distance in space with distance in time. But while Kant's eye 'requires some time to complete the apprehension of the tiers' of St Peter's, Denon's mind requires to have long reflected on the Egyptian colossi.

To return to Rome, Goethe appears to have had Kant's distinctions in mind when he came to write up the journal of his Italian journey some 25 years after the event, that is, well after the publication of Kant's third critique in 1790. When he set his eyes on the two colossi

on Monte Cavallo – the statuary group of Castor and Pollux standing 5.6 m high and their horses that were 'among the few colossal statues visible throughout the Middle Ages in Rome' – he wrote: 'To grasp them is beyond the power of the eye or the mind.'[69] The very title of Henry Fuseli's famous drawing *The Artist in Despair over the Magnitude of Ancient Fragments* (1778) conveys the same sense of powerlessness when confronted with the gigantic hand and foot from the colossal statue of Constantine.[70] Goethe's first glimpse of the Colosseum provoked a similar comment on the mind's inability to retain the image of what the eye sees:

> We came to the Colosseum at twilight. Once one has seen it, everything else seems small. It is so huge that the mind cannot retain its image; one remembers it as smaller than it is, so that every time one returns to it, one is astounded by its size.[71]

It was not long before he confessed to being so obsessed by the Pantheon, the Apollo Belvedere, 'one or two colossal heads [*kolossale Köpfe*]' and the Sistine Chapel that he could see almost nothing else.[72] The copy of the Hera Ludovisi that he acquired during this stay was probably motivated by Johann Winckelmann's description of this work as a most beautiful head *of colossal proportions*.[73]

Shortly before leaving the capital for Naples, Goethe returned to the Colosseum in February 1787:

> Nobody who has not taken one can imagine the beauty of a walk through Rome by full moon. All details are swallowed up by the huge masses of light and shadow, and only the biggest and most general outlines are visible. We have just enjoyed three clear and glorious nights. The Colosseum looked especially beautiful. It is closed at night. A hermit lives in a small chapel and some beggars have made themselves at home in the crumbling vaults. These had built a fire on the level ground and a gentle breeze had driven the smoke into the arena, so that the lower parts of the ruins were veiled and only the huge masses [*ungeheuern Mauren*] above loomed out of the darkness. We stood at the railing and watched, while over our heads the

moon stood high and serene. By degrees the smoke escaped through holes and crannies and in the moonlight it looked like fog. It was a marvellous sight. This is the kind of illumination by which to see the Pantheon, the Capitol, the square in front of St Peter's, and many other large squares and streets.

Like the human spirit, the sun and the moon have a quite different task to perform here than they have in other places, for here their glance is returned by gigantic, solid masses [*ungeheure Massen*].[74]

Goethe twice uses the epithet *ungeheuer* – the same word that Kant had used to refer to an object that 'by its size destroys the purpose which constitutes the concept of it' – to describe the massive walls, and in both cases 'colossal' would be a suitable rendering, here combining vastness of size with an awe-inspiring aspect.[75] But what I would like to stress here is the sense of place. Note the active role given to the 'gigantic, solid masses', which return the glance of sun and moon. We could paraphrase this by saying that it is the setting, as much as what that setting contains, that produces a particular effect on the viewer.

Goethe's farewell to Rome in April 1788 was also characterized by three consecutive nights of a full moon, but when he approached the grand ruins of the Colosseum, a shudder ran through his body and he quickly returned home, recording his experience of something that is both 'fascinating and awe-inspiring'.[76]

There is an uncanny resemblance between these passages from Goethe and Katherine Routledge's picture of an Easter Island sunset on the slopes of Rano Raraku, where the quarry from which the famous stone statues (moai) were sculpted is located. We find the same awe-inspiring dark masses, illuminated by the flickering of a fire, in a description that explicitly recalls the imagery of classical antiquity:

While the scene on Raraku always arouses a species of awe, it is particularly inspiring at sunset, when, as the light fades, the images gradually become outlined as stupendous black figures against the gorgeous colouring of the west. The most striking sight witnessed on the island was a fire on the hill-side; in order to see our work more clearly we set alight the long dry grass

. . . in a moment the whole was a blaze, the mountain, wreathed in masses of driving smoke, grew to portentous size, the quarries loomed down from above as dark giant masses, and in the whirl of flame below the great statues stood out calmly, with a quiet smile, like stoical souls in Hades.[77]

What the souls in Hades lacked, however, was the ponderous weight of the moai. But before moving the focus of our attention to the colossal statues of Easter Island, it is necessary to consider another striking feature of the Roman cityscape: the presence of more Egyptian obelisks than there are today in Egypt.

16 'Obelisk in Alexandria', from André Thevet,
Cosmographie de Levant (1556).

2
OBELISKS ON THE MOVE

Obelisks and Colossi

Obelisks belong in any study of the colossal. At the most superficial level, that of size, obelisks tended to be big, although miniature obelisks were sometimes carved to be placed in tombs and the Greek word *obeliskos* is itself a diminutive meaning 'little skewer'. Other words that are used to describe them in the textual sources are 'column' and 'pyramid', both of which carry connotations of verticality and grandeur. Moreover, they are monolithic; as the sixteenth-century traveller Pierre Belon remarked on the obelisks of Alexandria: 'What makes the obelisks so remarkable is that they are made from a single stone.'[1] The largest monolithic obelisk known, an unfinished one at Aswan in Egypt, would have been almost 42 m tall plus a pedestal if it had been erected – even taller than the statue of Nero that stood outside the Roman Colosseum. The tallest ancient obelisk in existence, the one that now stands in the Piazza di San Giovanni in Laterano (at the opposite end of Rome to the Vatican), is 31 m high, 47 including the pedestal. Although obelisks were usually raised in pairs in Egypt, the inscription on this one indicates that it was, exceptionally, intended to stand on its own. Probably the most radical break between the original settings of the Egyptian obelisks and their relocation in Europe lay precisely in their isolation from a pair, for in Rome and elsewhere they were placed in grand solitude – like a colossus.

One of the busiest locations in both ancient and modern (but not medieval) Rome is the site of the Colosseum and the colossal statue of Nero. There is no obelisk here; perhaps it was felt that there were already enough colossal attractions. Yet on the whole there was felt to be an affinity between colossi and obelisks, and it is not uncommon to

find one in the company of the other. After all, both were connected with cults of the sun: the colossus on Rhodes was a statue of the sun Helios, and the function of the Egyptian obelisk to pierce the sky like-wise links it with a solar cult. The protagonist of the *Hypnerotomachia Poliphili* sees the huge elephant surmounted by an obelisk just after he has emerged from the body of a colossus.[2] André Thevet (1516–1590) described an obelisk in Alexandria in his *Cosmographie de Levant*, noting that it was larger than the one near the basilica of St Peter in Rome.[3] When he returned to the topic in his *Cosmographie universelle*, in which his illustrator added a fallen obelisk beside the one remaining standing, he recorded that on the day the Turks entered Rhodes, where they were to dismantle the most famous colossus of all, one of the two obelisks in Alexandria fell to the ground and broke in two.[4] Thus by a kind of sympathetic magic, the fall of an obelisk presages the fall of a colossus.[5] In poetic usage the terms were interchangeable as well. For example, in a poem written by the Flemish Filippo Poelarius on the Vatican obelisk, the author states that although Rome at one time boasted many obelisks (*'olim iactabat Roma obeliscos'*), during the sack of 1527 these colossi were broken and destroyed (*'fracti interiere colossi'*).[6]

We find the same association between obelisks and the Colosseum in the background to *The Triumph of Fame* by the Dutch artist Maarten van Heemskerck.[7] In Heemskerck's series of prints of the Wonders of the World, no less than five obelisks, some with hieroglyphic inscrip-tions, accompany the pyramids of Egypt. Obelisks also recur in the works of several of Heemskerck's Dutch contemporaries who, like him, had been in Rome, such as Jan van Scorel.[8] In Spanish painting of the period they are particularly common in the works of Juan de Juanes, though there is no evidence that he ever visited Rome, or even Italy.[9]

This chapter is not a survey of all the obelisks of Rome, and even less a survey of the innumerable obelisks that have come to populate civic centres, parks and cemeteries all over the world in the course of the past two centuries or more, such as the meridian obelisks set up in the Old Deer Park, Kew, for George III's observatory; the obelisk that marks the spot of Captain Cook's landing at Kurnell, Botany Bay, in 1770; or the 63-m obelisk (67.5 m including the base) that has towered above the Plaza de la República in Buenos Aires since 1936 to commemorate

PRÆPETIBVS PENNIS CAPVT INTER NVBILA CONDIT MARMARICA INMANI QVAM CORPORE BELLVA DVCIT
FAMA LOQVAX, ACRIQVE TVBA LATE OMNIA COMPLET. HAC VIVVNT VATES, ATQVE INCLITA CORPORA BELLO.

17 Philips Galle, after Maarten van Heemskerck, 'The Triumph of Fame', from
The Triumphs of Petrarch, c. 1565.

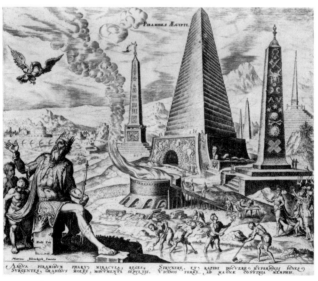

18 Philips Galle, after Maarten van Heemskerck, 'The Egyptian
Pyramids', from *The Wonders of the World*, 1572.

the 400th anniversary of the founding of the city. Instead, its purpose is to examine the different contexts in which some obelisks could and can be found in Rome with an eye for the sense of place. It concludes with an obelisk that, though located thousands of miles away from Italy, still betrays the influence of its Roman models.

Urban Villas and Public Squares

The first of the ancient obelisks in Rome to be erected in the early modern era was described by one visitor to Rome at the beginning of the twenty-first century as 'seen only with difficulty through a rickety fence, tall weeds, and rusty scaffolding'.[10] The original upper part of this obelisk was at an unknown date taken from Egypt to the large sanctuary of Isis near the Pantheon in Rome. At some time in the Middle Ages it was restored, placed on top of a new shaft and erected in a corner of the Campidoglio at what was to become the centre of the political life of the city with Michelangelo's redesign of the Piazza del Campidoglio in 1538.[11] The obelisk did not fit in with Michelangelo's plans, however, and fell into disrepair until it was given to the Roman nobleman and art collector Ciriaco Mattei and transferred in 1582 to the extensive grounds of his villa on top of the Caelian Hill, which boasted an aviary and a series of fountains as well as an impressive collection of antiquities. Its position at the centre of a large stadium-shaped open area may have been intended to recall the connection between the Mattei family and the Circus Flaminius, which at the time was believed to have been located near the group of *palazzi* belonging to the family close to the foot of the Capitoline Hill.[12] When the Marquis de Sade saw these gardens during his Italian journey of 1775–6, he was appalled by their neglected condition, but noted that the small obelisk was still erect in spite of being broken at two points.[13] By the end of 2009, however, as part of the ongoing recuperation of the Villa Mattei, the obelisk had been restored to its former glory and given an elegant setting far from the madding crowd that populates the centre of the city.

We can contrast this setting with that of another ancient obelisk, but one that now stands in one of the busiest squares of Rome. After the defeat of Cleopatra and Mark Anthony at Actium in 31 BC and the proclamation of Octavian Augustus as pharaoh of Egypt in the

19 First obelisk
to be re-erected
in Renaissance
Rome in 1582,
Caelian Hill, 2007,
before restoration.

20 Obelisk, Caelian Hill, Rome, after restoration.

following year, it became harder to reconcile the traditional Roman hostility to oriental cults with the need to emphasize the continuity of the rule of Augustus as successor to the pharaohs. Egyptian cults were banned from the sacred boundary of Rome (the *pomerium*). However, this only reinforced their presence in the Campus Martius, the low-lying area enclosed by the sharp bend in the river Tiber and regularly subjected to flooding, which made it an appropriate setting for things Egyptian, including a sanctuary of the goddess Isis, down to the end of the fourth century.[14] This was the site of, among other Egyptian antiquities, a second obelisk of the same antiquity as the Caelian obelisk. Said to have been discovered in 1374, it was initially transferred to the secluded Piazza Macuto, immediately adjacent to the better-known Piazza S. Ignazio, where its modest dimensions fitted in with its sur-roundings. For the last 200 years, however, it has stood a few hundred metres away from Piazza Macuto in the Piazza della Rotonda, opposite the entrance to the Pantheon, on top of a sixteenth-century fountain. In some ways, the related but different fates of the two obelisks are indicative of the lives and travels of these particular monuments as well as of the very different kinds of impact each of them produces on the viewing public by virtue of its setting. While the Caelian obelisk blends perfectly with the relative obscurity of its green surroundings, the obelisk in the Piazza della Rotonda seems too small for its monumental setting, which is no doubt why Piranesi felt the need to blow it up to enormous proportions to prevent it from being dwarfed by the impressive Pantheon. Various visitors to Rome have been struck by disparities of this kind:

> Such intimations that Rome might challenge or destabilise the observer through its discords or contradictions had caused Goethe to acknowledge it as *das gestaltverwirrende Rom* (form-confusing Rome) in a formulation suggesting both the frag-mented appearance of the city and many of its monuments and the difficulty of relating it to any systematic intellectual model of interpretation. The lack of unity so strikingly captured by some of Piranesi's *Vedute* with their contrasts of ancient and modern and their vast empty spaces seemed to resist any straightforward reading.[15]

The obelisk to which André Thevet referred as the 'obelisk of the Vatican' is on a much grander scale, and stands on one of the most famous locations in the world. Standing 25.5 m high and weighing 500 tonnes, it now occupies the centre of the Piazza San Pietro in front of St Peter's Basilica, and its removal, transport and subsequent re-erection in 1586 marks the start of the first wave of papal obelisk-raising. This obelisk has had a chequered history and been re-dedicated to various individuals on a number of occasions.[16] It may have been originally intended as a monument to Mark Anthony, who was buried in the Egyptian capital of Alexandria,[17] while the sphere on top was believed to contain the ashes of Caesar. In 30 BC it was dedicated to Augustus by C. Cornelius Gallus, the first prefect of Roman Egypt. The inscription by Gallus was in turn replaced in AD 14 by a dedication to Augustus and Tiberius. When Caligula, who was related to Mark Anthony, brought the obelisk to Rome from Alexandria in AD 37, he may have intended to honour his relative when he placed it in the Circus Vaticanus beside the basilica of St Peter, a site where Christian martyrs were later slaughtered under Nero. At some time in the Middle Ages, perhaps in the twelfth century, a new inscription was added on a bronze tablet.

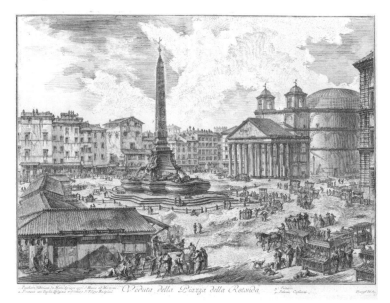

21 Obelisk facing the Pantheon, Giovanni Battisti Piranesi, 'View of the Piazza della Rotonda', from *Vedute di Roma, c.* 1745–78, copperplate engraving.

In 1586 Pope Sixtus v had it moved from its position south of the basilica to its present, more prominent location in the middle of the piazza in an astonishing feat of engineering. On that occasion it was stripped of its associations with Caesar: the sphere at its apex was opened, exorcized and found not to contain any ashes at all. The sphere was replaced with a bronze cross, and four new inscriptions were added to the base of the obelisk, one with the words 'ECCE CRUX DOMINI FUGITE PARTES ADVERSAE VINCIT LEO DE TRIBU IUDA' ('Behold the Cross of the Lord. Flee, enemies. The lion of the tribe of Judah is victorious').[18] From its secular origins as an instrument for measuring time, the obelisk had become an instrument of the Counter-Reformation. On a smaller scale, a reliquary of the Sacred Thorn that encased the holy relic in a rock-crystal obelisk (the mineral was chosen for its associations with purity and incorruptibility) reflects the same renewed interest in obelisks as vehicles of a religious message in the Counter-Reformation thought of the time.[19]

Although some fanatical clergy did make attempts to eradicate all traces of pagan antiquity from Christian places of worship,[20] there is nothing strange about finding such a pagan object as an obelisk at the centre of such a powerful Christian place of worship as the Piazza San

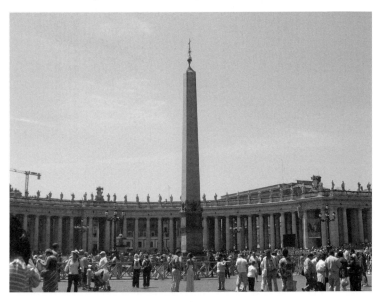

22 Obelisk, Piazza di San Pietro, Rome.

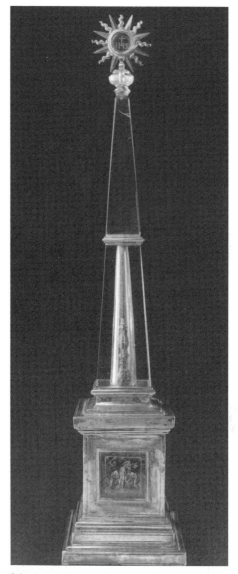

23 Reliquary of the Sacred Thorn, 1575–80, gilt silver, rock crystal, oil on copper.

Pietro. In his century-old pioneering study of the origins of the Renaissance *Kunst- und Wunderkammer*, Julius von Schlosser drew attention to the continuity between the museum function of the temples of Greek antiquity and the role of the medieval and Renaissance church as a museum.[21] San Marco in Venice and the Campo Santo in Pisa are

among the prominent examples of Christian buildings whose architecture contained antique spoils that had been incorporated into them. Indeed, many antique sculptures owe their preservation to having been recycled within a Christian setting during the pre-Renaissance period.[22] During the physical process of incorporation, they were sometimes inserted upside down (to deprive them of their potency, in accordance with the logic of what anthropologists have called the 'ritual of reversal'), chained to the wall or buried in the foundations in an attempt to rid them of any non-Christian taint still attaching to them. The obelisk in the Piazza San Pietro will likewise have carried the message of the triumph of Christianity over pagan spoils, as well as overtones connected with the tradition that St Peter had been crucified nearby. Like the Colosseum and the colossal statue of Nero, it too had witnessed the martyrdoms of many Christians. More specific details of its guise, minus the globe and plus the cross and inscriptions, referred more particularly to its relation to the papacy. The cross was not placed directly on top of the obelisk but on top of a star surmounting three hills, taken from the heraldic device of Pope Sixtus v, while the supporting of the obelisk on the backs of four star-crowned lions was another reference to his coat of arms. The message must have been clear enough at the time: 'the light of Christ was filtered through the man who incarnated his living image before being diffused all around' and 'the weight of the church of Christ and of the whole known world . . . rested on the strong back of Felice Peretti [Sixtus v].'[23] Other religious connotations of the Egyptian obelisk could be exploited too. At a time when Protestant iconoclasts were destroying what they regarded as idols in the churches of northern Europe, the message of long-term continuity between the monotheistic religion of the Egyptian pharaohs and the religion of the Catholic Church contrasted centuries-old tradition with the schisms created by the upstart Lutherans.

These Egyptian obelisks in Rome are examples of what Eric Iversen called 'obelisks in exile'.[24] Rome had its movable obelisks, such as the one that was carried through the city on a float commemorating Pope Julius ii as 'liberator of Italy and expeller of the schismatics' during the carnival of 1513.[25] However, it seems to have been of the nature of obelisks, not just such temporary ones but also the colossal obelisks made of stone, to travel, and they did so not just within their native Egypt but

further – sometimes much further – afield. After all, Thevet's obelisk in Alexandria had already been moved from its original site: it was one of a pair originally erected in Heliopolis that bore inscriptions by both Thutmose III and Ramses II before receiving an inscription in Greek and Latin after the incorporation of Egypt into the Roman Empire. The two obelisks were moved to Alexandria by the Emperor Augustus. In the nineteenth century one of them was moved to the Thames Embankment in London, where it became known as Cleopatra's Needle; the other was transferred to Central Park, New York.[26] The archaeologist M. J. Versluys aptly sums up the various stages of reuse:

> in the Ptolemaic period Pharaonic monuments were re-used in the city [of Alexandria]. These monuments were therefore probably on display as trophies of Ptolemaic (Greek) power over Pharaonic (native) Egypt. Entangled [sic] from their original context, these objects were first re-used in an Alexandrian context before being shipped to Rome (second re-use), where their re-erection by one of the popes was thus in fact already a third re-use.[27]

The Vatican obelisk also shows how a succession of names could become associated with a single monument, sometimes in competition with one another. For not only were names inscribed on the obelisk; by positioning it so that the inscription by Tiberius was no longer visible to most of the spectators of the games held in the circus, Caligula hoped to eclipse the memory of his hated predecessor.[28] In this he was merely repeating the policy of the pharaohs themselves. For instance, Thutmose III had stone walls built around the obelisks that his predecessor Hatshepsut had erected in Karnak to hide their inscriptions from view.[29]

In spite of such discontinuities, the fact that many of the obelisks of Egypt were placed within the raised barrier between the turning points of a Roman circus (*spina*) nevertheless maintained some continuity with the solar associations of the Egyptian obelisks, for the anti-clockwise movement of the charioteers seven times around the *spina* was perceived by the Romans to resemble the movement of the planets.[30]

The Vatican obelisk was the only one that had stood throughout the Middle Ages. It is estimated that there were nearly 50 obelisks in

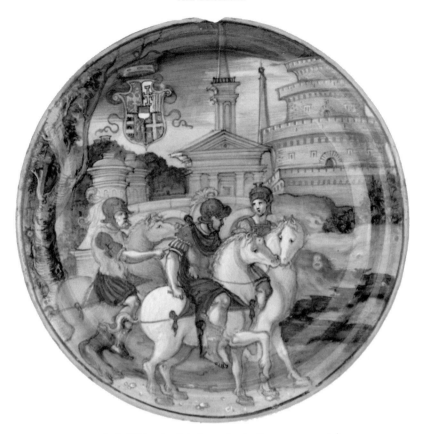

24 Nicola da Urbino (attrib.), *Caesar Leaving Rome, c.* 1533, majolica.

Rome in the fourth century,[31] but by the twelfth this was the only one still erect. A majolica from Urbino from around 1533 depicting the departure of Caesar from Rome shows the solitary obelisk next to a stylized version of the Castello Sant'Angelo;[32] the associations of this particular obelisk with Caesar would have appealed to Pope Julius II, who modelled his papacy (1503–13) on the historical and symbolic figure of his namesake Julius Caesar. Like a column or a *kolossos*, the symbolic function of the obelisk depended on its verticality to link the earth with the sky above or the world of the dead beneath. But for the popes too, only an erect obelisk, topped by the figure of a saint, could stand for the victory of Christianity over paganism.

In consciously deploying ancient obelisks to carry a religious message, the popes were following in the footsteps of Augustus, who had

reshaped the appearance of Rome with statues and monuments, including obelisks, to drive home the political message of the Pax Augusta.[33] Just as he had deployed them strategically to create an urban geography that was a celebration of his own rule, the popes created intersecting visual axes that linked sites of historical importance in the rise of Christian Rome, such as the bridge over the Tiber that was connected with the crucial victory of Constantine in AD 312, thereby combining *Roma instaurata* and *Roma sancta*. Obelisks could serve as visual markers to make those lines of vision clear for all to see.[34]

After the successful relocation of the Vatican obelisk by Domenico Fontana in 1586, Pope Sixtus V and his architect embarked on an ambitious programme for the excavation, transport and erection of three more obelisks in the city: behind the Basilica di Santa Maria Maggiore, in the Piazza di San Giovanni in Laterano and in the Piazza del Popolo.[35] It should be noted that for almost all foreign visitors to Rome, the scenic entrance to the city was formed by the Piazza del Popolo; if the pilgrim continued in a straight line, that route would cross both Santa Maria Maggiore and San Giovanni. In other words, the Sixtan obelisks set out an easy-to-follow route that led past the major sanctuaries of the city and left an indelible impression on the minds of any visitor to Rome. Not surprisingly, obelisks figure prominently in the frescoes that Sixtus commissioned from Matthijs and Paul Bril for the Palazzo Apostolico and Santa Scala, both in the Lateran area, and for his Villa Montalto-Peretti.[36]

The wave of obelisk erecting begun by Sixtus V was resumed in the seventeenth century to convey a similar religious message. An example is provided by a 16.5-m obelisk that Emperor Domitian had carved from Egyptian stone with his own name in hieroglyphs.[37] It is not known where he intended to erect it. At any rate, after a spell outside the city in the Circus of Maxentius on the Appian Way, it was brought back within the city walls and – after restoration of the hieroglyphic inscriptions by the polymath Athanasius Kircher – placed on top of Gian Lorenzo Bernini's famous Fontana dei Quattro Fiumi in the bustling Piazza Navona in 1650 (illus. 28). This piazza was an appropriate choice of location, since Domitian himself had inaugurated this vast circus structure five years after becoming emperor in AD 81. As for Bernini's sculpture, it provided a setting suitable for an Egyptian obelisk, albeit from Roman Egypt: besides the presence of a personification of the

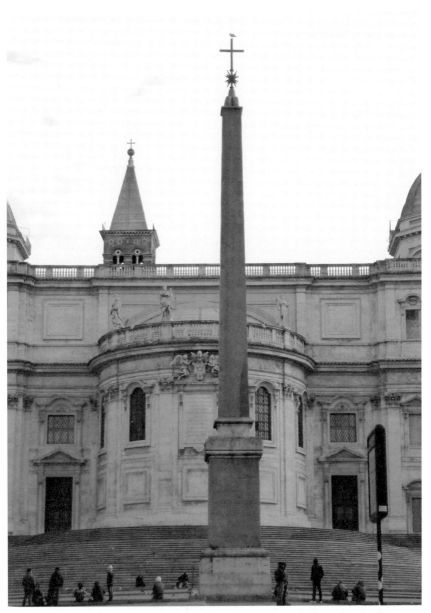

25 Obelisk, Basilica di Santa Maria Maggiore, Rome.

26 Obelisk, San Giovanni
in Laterano, Rome.

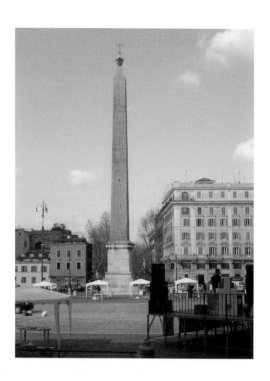

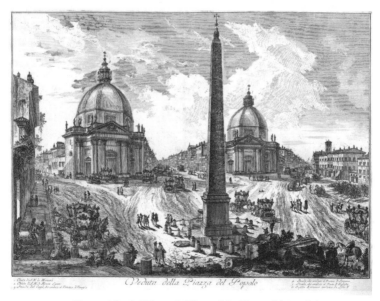

27 Giovanni Battisti Piranesi, 'View of the Piazza del Popolo',
from *Vedute di Roma, c.* 1745–78, copperplate engraving.

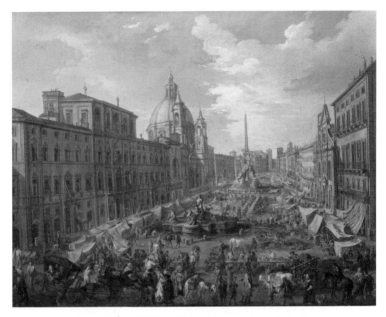

28 Andrea Locatelli, *View of Piazza Navona*, 1733, oil on copper.

Nile, its blindfold signifying the ignorance about the location of the river's source, the horse and the lion had a special significance in Egyptian mythology. According to Kircher, the constellation of the lion marked the start of the rainy season and thus symbolized life in Egypt. The horse, on the other hand, stood for the 'river horse' or hippopotamus, in Egyptian mythology a symbol of the drought of the Nile and therefore death (a connotation reinforced by the biblical serpent with its jaws wide open placed above the horse).[38]

An anonymous canvas, mentioned in the 1681 inventory of the heirs of Bernini and perhaps commissioned by Bernini himself, shows Pope Innocent x inspecting the finished work. The painting not only twists the perspective in order to show three of the four river statues, but also magnifies the obelisk in size to bring it up to expectations.[39] Another example of this blowing up of obelisks to colossal proportions is provided by the often reproduced print of Athanasius Kircher showing two visitors around his collection of curiosities in the Collegio Romano. The interior is dominated by towering obelisks, although we know that the wooden models of obelisks that Kircher had made, and which are still extant, were of various heights of no more than 140 cm.[40]

29 'Museum of Athanasius Kircher', from G. de Sepi, *Romani collegii Societatis Jesu musaeum celeberrimum* (1678).

Bernini was also involved with the display of an obelisk from the sanctuary of Isis in the Campus Martius that still stands in the same area where it was excavated in front of the church of Santa Maria sopra Minerva facing one side of the Pantheon. Although Pope Leo x had kept a baby elephant as a pet until it died in 1516, and another elephant was reported to have visited Rome in 1630, the source for this composite figure, designed by Bernini and sculpted by Ercole Ferrata for Pope Alexander vii in 1667, was a literary one.[41] From handwritten marginal glosses to a copy of the *Hypnerotomachia Poliphili* that belonged to

 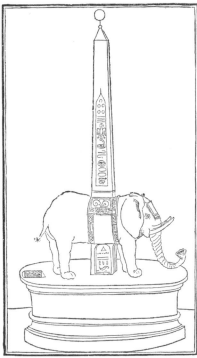

30 Ercole Ferrata, after a design by Gian Lorenzo Bernini, elephant surmounted
by obelisk, 1667, Santa Maria sopra Minerva, Rome.

31 Elephant surmounted by obelisk, woodcut from Francesco Colonna,
Hypnerotomachia Poliphili (1499).

Alexander, it is known that the pope was particularly struck by the
woodcut of an elephant surmounted by an obelisk in Francesco
Colonna's rambling fiction and persuaded Bernini to give tangible form
to his wishes.[42] Although the ostensible message of the statue was that
wisdom needed to rest on a firm support, Bernini – assisted once again
by Kircher – deliberately positioned the elephant with its broad posterior
facing the entrance to the Dominican convent. There was little that
the Dominicans could do about it.[43]

 The range of such symbolic uses to which obelisks could be put
was considerably wider than the perspective of the papal iconographic
programme, and might even explicitly try to outstrip that programme.
The first obelisk encountered by Poliphili in the *Hypnerotomachia Poliphili*
rested on top of an 'immense and awe-inspiring pyramid', which left him

'in no doubt that there was none other resembling or comparable to it, not even that of the Vatican, nor the Alexandrian, nor the Babylonian'.[44] But his finest eulogy of an obelisk is reserved for a *Wunderkammer*-like object inscribed with hieroglyphic characters:

> I began unhesitatingly to feel a greater pleasure than in any other marvellous work that my eyes had enjoyed. I thought the obelisk so mysterious, so ineffable in its upright symmetry, so solid and eternal in its firmness and persistence, forever in equilibrium, unbreakable and incorruptible.[45]

We find an equally lofty sentiment expressed half a century later, when the engraver Giulio Bonasone produced a woodcut for the book of symbols by Achille Bocchi in which an obelisk topped by a sphere occupies the centre, flanked on one side by a circular building and on the other by a female figure with a broken column (probably a personification of strength). There is no hieroglyphic inscription, but the most curious detail is presented by the eyes, ears, noses, lips and hands – the

32 Obelisk on top of immense pyramid, from Francesco Colonna, *Hypnerotomachia Poliphili* (1499).

61

33 Giulio Bonasone, 'Happy is He Who Established the Good that Is One', from Achille Bocchi, *Symbolicarum quaestionum, de universo genere, quas serio ludebat, libri quinque* (1555).

five senses – on the steps that form the base of the obelisk. The message is that the subjugation of the senses leads to virtue.[46]

Obelisks are given an astonishing number of different symbolic meanings in the engravings designed for a new edition of Cesare da Ripa's famous *Iconologia* by Gottfried Eichler the Younger. His father, the German artist Gottfried Eichler (1676–1759), had studied with Carlo Maratta in Rome for five years, long enough for him to become familiar with the topography of the ancient city. Obelisks make a frequent appearance in the architectural decor of the scenes designed by his son Gottfried (1715–1770). The first illustrated edition of Ripa's work, published in Rome in 1603, had contained one pyramid and not a single obelisk, but the new Eichler edition, printed at the end of the 1750s by the Augsburg publisher Johann Georg Hertel, contains several. The scene of the personification of Depravity is identified as ancient Rome by the architectural decor, including an obelisk overlooking a square,

to form a setting for the depraved Tullia driving her chariot over the body of her murdered father. Corinthian columns, a classical statue of Minerva and two obelisks form the foreground of the personification of Architecture, while the scene in the background is the city of Babylon. When inscribed with hieroglyphs, the obelisk pointed to ancient Egypt as a source of wisdom and enlightenment, as in the personifications of Sight and of Grammar, or of magic, as in the personification of Prediction of Happy Events with a prophetess.[47] A broken obelisk in the foreground and the toppling of another obelisk in the background of Reform are reminders of the destruction of pagan altars by Josiah, as well as the more recent iconoclastic troubles of the sixteenth century.[48] The ruined obelisk in the background of the garden that illustrates Smell confers an Arcadian touch on the setting, while the broken obelisk standing beside a flight of steps in the foreground of

34 Engraving after Gottfried Eichler, 'Depravity', from Cesare Ripa, *Allegories and Conceits* (1758–60).

Philosophy underlines the need for the inquiring mind to rise from the depths to the heights.[49]

There were lone voices like that of Lione Pascoli, author of the biographies of many artists, sculptors and architects, who reacted to the picturesque confusion of Baroque Rome, condemning what he called 'the excessively expensive caprice of erecting an obelisk, pyramid, monument or building purely for display purposes and involving the imposition of levies or taxes'.[50] But the Grand Tour and an enthusiasm for things Italian fired the imagination of travellers from every country in Europe, and obelisks were a part of that image too.[51] Thus when Goethe was portrayed by Johann Tischbein, the painting had to include the subject sitting on a fallen obelisk.[52] A diary entry written a week later on 6 January 1787 describes the writer's delight at setting up in the hall outside his room 'a new cast, a colossal head of Juno, the original of which is in the Villa Ludovisi'.[53] Clearly obelisks and colossi still went together in some minds.

The Second Wave

Pope Clement XI managed to associate his name with an obelisk when in 1711 he took advantage of the need to repair the fountain in the Piazza della Rotonda in order to transport an obelisk there from neighbouring Piazza di San Macuto and to erect it in front of the Pantheon. But the second wave of obelisk excavation and erection really took off during the last quarter of the eighteenth century, which paradoxically coincided with the exodus of many ancient columns from the capital to destinations such as Syon House, London.[54] Pope Pius VI was responsible for the erection of three obelisks in a programme clearly intended to evoke, if not to compete with, the obelisk-raising activities of his illustrious sixteenth-century predecessor Sixtus V.[55] The placing of one of them outside what is now the palace of the President of the Italian Republic in the Piazza del Quirinale in 1786 is indicative of this: not only does it claim a position in between the statues known as the Dioscuri put there by Sixtus, making it necessary to modify their position to accommodate the newcomer, but it came from the Mausoleum of Augustus, just like the obelisk erected behind the Basilica di Santa Maria Maggiore by Sixtus.[56]

35 Obelisk, Piazza del
Quirinale, Rome.

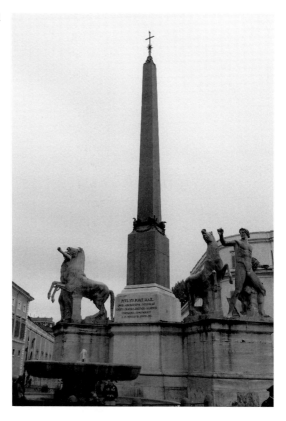

Something of the excitement these activities could arouse can be seen from an entry in the diary of the Welsh painter Thomas Jones. Writing in the summer of 1778, he recorded that he had seen the model of the apparatus that would be constructed to raise the column discovered in March and to erect it in the Piazza di Montecitorio.[57] Not everyone was equally excited. In fact, this obelisk had already been discovered several times since the beginning of the sixteenth century, but had failed to generate enough interest for its excavation and re-erection. The Marquis de Sade, who had seen it only two years before Jones, recorded that it was in seven pieces at that time.[58] When it was finally installed in its present location, the Piazza di Montecitorio, in 1792, it was a model of archaeological accuracy in that the original base of the obelisk was used and missing sections of the hieroglyphic inscriptions were not restored. It was not until 1998, however, that the installation of a meridian in the square restored the original function

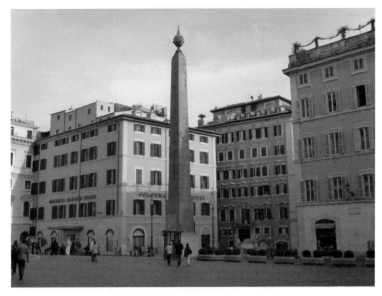

36 Obelisk, Piazza di Montecitorio, Rome.

of what had once been a solar obelisk – the one that had occupied a central place in the Augustan *horologium* in the Campus Martius.[59]

Pius's third obelisk was a small Roman copy of an Egyptian one, probably erected by the emperor Aurelian, and known as the Sallustian obelisk for its placement in the gardens between the Quirinale and Pincio hills that had belonged to the historian Sallust before passing into the hands of successive emperors.[60] It was visible during the Middle Ages, but only in fragments. It was re-erected in the year of the French Revolution overlooking what must be the most thronged of all Roman squares, the Piazza di Spagna, in perfect alignment with the above-mentioned obelisk-studded route leading from the Piazza del Popolo to San Giovanni in Laterano. Goethe writes:

> A proposal has been made to erect an obelisk in front of the Church of Trinità dei Monti, which was unpopular with the people because the piazza was too small, and to raise it to the proper height, the little obelisk would have to be set on a very high pedestal. This had given someone the idea of wearing a cap shaped like a huge white pedestal with a tiny red obelisk on top. The pedestal bore an inscription written

37 Obelisk, Trinità dei Monti, Rome.

38 Obelisk, Pincian Hill, Rome.

in large letters, but probably only a few people could guess what it meant.[61]

Given the obvious phallic symbolism of the obelisk and the play on words like *guglia* (needle) in erotic verse,[62] it is not too hard to guess what the gist of the inscription seen during the Roman carnival must have been. Still, the solution adopted of putting the rather diminutive obelisk on top of a tall pedestal went ahead and blends well with the multiple perspectives offered by the eighteenth-century Spanish Steps.[63] An anonymous wall painting from the Vatican Library, one of three celebrating Pius vi's obelisk programme, shows the pope observing this obelisk in front of the facade of Trinità dei Monti.[64]

The example of Domitian in commissioning an obelisk from Roman Egypt was followed by the emperor Hadrian. He had a small one (9.25 m) made to commemorate his lover Antinous. After standing in the new Egyptian town of Antinopolis founded by Hadrian, it was brought to Rome and apparently went through a series of erections and topplings, including a re-excavation in 1630 by Cardinal Francesco Barberini, before eventually finding its way to a secluded spot on the Pincian Hill in 1822.[65] It is worth noting that whoever devised the hieroglyphic inscription in the second century AD was writing in a language and style that had been dead for centuries.[66]

Not far from the Pincian Hill, a small obelisk that had been found near Santa Maria sopra Minerva was taken to the garden of the Villa Medici. However, since the Medici was a Florentine family, it was transferred to Florence in 1790 and given a place at the centre of the so-called amphitheatre in the Boboli Gardens, where it still exercises a purely decorative function. Another obelisk that followed the same route from ancient Egypt via Rome to an Italian location outside the capital is the obelisk of Urbino. Fragments, possibly from two or more different obelisks,[67] deriving from the same location as the one in the Boboli Gardens – the Isaeum of the Campus Martius – were combined to form the obelisk that has stood in Piazza Rinascimento opposite the Palazzo Ducale in Urbino since 1737.

By the nineteenth century the supply of ancient obelisks was decidedly thin, so when Prince Alessandro Torlonia decided to erect two obelisks in the grounds of the new Villa Torlonia in Rome (which

39 Modern obelisk erected in 1842, Villa Torlonia, Rome.

40 Franceso Podesti, 'Africa', from *Three Continents*, *c*. 1835 (detail).

became the private residence of Mussolini in 1929), he had to have them cut from fresh stone. The inscriptions that were carved into them bear witness to the advances that had been made in the deciphering of hieroglyphic script by the 1840s.[68] Along with an architectural folly and fake classical ruins, their purely ornamental function is obvious, and is echoed in the interior decoration of the Hall of Bacchus in the Neoclassical Casino Nobile by one of the favourite painters of the Torlonia family, Francesco Podesti. There were nevertheless some ancient obelisks still available. A rather neglected Heliopolitan obelisk found in the Isaeum of the Campus Martius – the source, as we have seen, of a number of the obelisks of Rome – was incorporated in a monument to the Italian soldiers who fell at Dògali in Eritrea in 1887 and erected in front of the Termini railway station; the monument was moved a short distance to its present location in the gardens of the Viale Einaudi in the 1920s.[69]

41 Obelisk, Viale Einaudi, Rome.

WE HAVE SEEN that by no means all the obelisks came from ancient Egypt. Though the nineteenth century – by which time the Egyptian Revival was in full swing,[70] especially in architecture and the decorative arts – witnessed the transfer of an ancient obelisk from Luxor to the Place de la Concorde in Paris as well as that of Cleopatra's Needles to London and New York, it was always possible to fall back on local production to come up with a monument resembling an obelisk, albeit not of Egyptian ancestry. This was also the century in which obelisks proliferated as part of the decoration of cemeteries, sometimes vying with one another for precedence.[71] Yet, curiously, it is far from the centres of metropolitan power in London, Paris or the United States that we also find obelisks from the eighteenth century and later whose inspiration goes straight back to the obelisks of Rome.

From 1724 onwards, Zacatecas, the third city in importance of New Spain (Mexico), could boast an obelisk, erected to commemorate the coronation of Luís I of Spain. The inspiration for this monument came from Kircher's works and 'his' obelisk in the Piazza Navona.[72] It was later followed by the obelisk, equally of Kircherian inspiration, to Carlos III in the Plaza Mayor de Puebla in 1763,[73] more or less contemporary with plans to set up a counterpart to Kircher's Museo del Collegio Romano in Madrid. However, the expulsion of the Jesuit order in 1767 put an end to this project and to Kircher's direct influence. From now on, South American obelisks would have a different source of inspiration.

Further to the south, Argentina had a commemorative obelisk in the Plaza de Mayo (formerly Plaza de la Victoria) in the centre of Buenos Aires almost right from the start of national independence. The modest adobe obelisk surmounted by a decorative globe, constructed to celebrate the revolution of 25 May 1810, was erected in the following year and later restored by the artist Prilidiano Pueyrredón in 1856, when the addition of a statue of Liberty on top brought its full height up to almost 19 m.

In neighbouring Chile, however, although decrees were passed in the 1810s to erect obelisks to commemorate its independence,[74] none of these monuments materialized. The first free-standing commemorative monument in the Chilean capital is connected with the series of interventions to prevent the river Mapocho, which flows along an east–west axis through the city, from periodically bursting its banks.[75]

The containing walls (*tajamares*), whose history went back to the first decade of the seventeenth century, were destroyed by the flood of 1748, and the subsequent engineering works to keep the river within its banks were celebrated with the erection of an obelisk. This was the period when the south bank of the river was turned into a shady promenade, which took its name, Paseo de la Pirámide, from the presence of the obelisk on its course (as we have seen, obelisks were often referred to as 'pyramids'). This shift of the centre of public life from the square known as Plaza de las Armas to the riverside in turn necessitated a further extension of the containing walls. On this occasion the architect who was brought in as technical director to work under the supervision of Manuel de Salas was the Italian Gioacchino Toesca.

Born in 1745, Toesca studied in Italy under Francesco Sabatini before following his mentor to the Spanish court in Madrid. After his arrival in Santiago in 1780, he was asked not only to redesign the cathedral and to design the mint and the town hall, but also to work on the containing walls. His design for the latter envisaged the creation of a promenade on top of the defensive wall itself (thereby eclipsing the Paseo de la Pirámide) and a commemorative obelisk. Given the Seine-like appearance of the Mapocho today, the fact that the commission was placed only a couple of years after the outbreak of the French Revolution, and that Manuel de Salas introduced the Academia de San Luís, modelled on the French Institut National, in the same decade, it has been suggested that the presence of the obelisk is due to Parisian influences and that it symbolized the republican liberty of the French Revolution.[76] However, the first obelisk in the French capital was not erected until 1836, when the choice of placing an obelisk that celebrated kingship, albeit Egyptian kingship, on the politically charged spot of the Place de la Concorde where the guillotine had stood was dictated by the fact that the obelisk did not and must not have clear associations with any faction. Far from standing for republican liberty, it was a 'non-political allegory about national unity and the law'.[77] As Chateaubriand optimistically put it: 'The hour will come when the obelisk of the desert will find once again, on Murderers' Square, the silence and solitude of Luxor.'[78]

So the search for a model has to proceed in a different direction: towards the city with the largest number of obelisks in the world, Rome.

Sabatini had trained in architecture in Rome; Toesca was born in Rome, where he could have seen at least six obelisks in different locations.[79] If he appropriated the Roman use of the obelisk to mark a triumph (of Rome over Egypt), it was entirely suitable to commemorate what was viewed at the time as a subjugation of the river Mapocho and an end to its permanent threat to the city. Moreover, the use of an obelisk to celebrate an engineering victory was not without precedent, for the Egyptian obelisks themselves were 'at the same time both perfect symbols, in their strict geometry, of the life-giving force of the sun, and the highest expression of human technology'.[80] It was precisely these twin aspects that Pope Sixtus v had wished to emphasize and combine through the engineering feat of re-erecting the Vatican obelisk as a symbol of the triumph of Christianity over the pagan world. So ultimately the antecedents of Toesca's obelisk lie not in revolutionary France but in the public squares of Rome, where the triumphs of the Roman emperors and Christian popes were celebrated. Although it may not look colossal to us today, it draws on a colossal heritage.

Like the obelisks of Rome, Toesca's obelisk also fell victim to the tooth of time. A painting from the 1860s by the Genoese artist Giovatto Molinelli shows that the containing walls and their obelisk had fallen into disrepair by then. The turning of the river into a canal in 1888 and its continuation in 1927 marked the demise of the obelisk. In 1950 the municipality of Providencia had the obelisk reconstructed on its original location in the Parque Balmaceda (today the Parque Providencia) to mark the northwestern limit of the district.[81] In contrast to the highly public locations of most of its Roman models, standing as it does today accompanied by a few fragments of the original containment walls and shaded by the trees of the park, it must be one of the most inconspicuous obelisks in the world.

THIS DISCUSSION OF some of the obelisks of Rome and their influence further afield indicates that their impact could be of a variety of kinds depending on their location. They could find themselves in very different places, ranging from the representational demands of a very public Baroque square to the secluded Arcadian groves of the Pincian Hill, or from the bustle of Piazza Spagna to the calm of the Caelian Hill. Those obelisks in a less public setting like the Villa Torlonia will have had a

42 Reconstruction of Gioacchino Toesca, *Obelisco de los antiguos Tajamares*, 1950, brick. Parque Providencia, Santiago de Chile.

more ornamental value: if one can speak of a cult here, it would be the cult of *otium*, or leisure. An obelisk could find itself variously in harmony or in strange juxtaposition with its setting. Sometimes it was almost as though an Egyptian 'bed' had been made for them to rest on, as in the Piazza Navona; others, like the diminutive obelisk opposite the entrance to the Pantheon, were in conflict with the vastness of the public space that surrounded them.

There are striking continuities over an extremely long period of time – or as Pierre Belon put it, 'All the obelisks that can be seen today in Rome had been cut in Egypt before Romulus set foot in Rome.'[82] The primary message conveyed by these erections – the victory of Christianity over paganism, and more particularly the triumph of the Counter-Reformation – actually picked up and transposed the original solar motif of the obelisk, for just as the sun's rays proceeding from a single source penetrated to the four cardinal points, the light of divine illumination reached the four corners of the world. In this way, like The Cenotaph on Whitehall, the colossal obelisks were larger than themselves and united the seen with the unseen as did the Greek *kolossoi*. Their resulting capacity to provoke admiration and wonder can be seen very clearly from the impression they made on Belon: 'When we speak of an obelisk, we are speaking of one of the most admirable things in this world, and which set us wondering why they have been cut in such a strange way.'[83]

3

THE COLOSSAL STATUES
OF EASTER ISLAND

First Images of the Moai

In a passage of his *Italian Journey* from October 1787 – the year in which he acquired his colossal head of Juno – Goethe mentions that Johann Gottfried von Herder has asked him to supply Georg Forster with a list of questions and suggestions for the latter's projected second trip around the world.[1] This expedition, under Captain Grigory Ivanovich Mulovsky, was commissioned by Catherine II of Russia to explore the North Pacific and the western coast of America, but as a result of the outbreak of war between Turkey and Russia, the expedition was postponed.[2] All the same, Forster's enthusiasm to take part and the very fact that Goethe was approached with such a purpose in mind are indicative of the interest in things Pacific at the time, when voyages of discovery were still being envisaged by many of the European nations.

Forster had good credentials for such a position. James Cook's first voyage aboard the *Endeavour* had failed to resolve the question of whether or not there was a large continent in the Southern Ocean, and when he set out aboard the *Resolution* from Plymouth in 1772 on his second voyage, he was accompanied not only by the naturalist Johann Reinhold Forster but also the latter's son Georg, who was to draw specimens of natural history collected by his father. After his return, Forster Jr was appointed Professor of Natural History at the University of Vilnius. Both Forsters were members of the prestigious Royal Society, the very body that had promoted Cook's first voyage to the Southern Ocean in 1768, and both of them recorded their separate impressions of the statues of Easter Island.

The *Resolution* sighted Easter Island on 11 March 1774, and when Cook went ashore the next day he saw a massive hewn stone wall

with two huge statues lying shattered beneath it. On the following day, Cook and his companions walked inland from the village of Hanga Roa and saw a stone pavement where a great stone idol about 6 m high and 1.5 m wide stood gazing out to sea with a round red stone on its head.[3] Forster Jr was not impressed by the quality of the carving of these large statues:

> The eyes, nose, and mouth were scarcely marked on a lumpish ill-shaped head; and the ears, which were excessively long . . . were better executed than any other part, though a European artist would have been ashamed of them.[4]

Forster Sr was carried back to ancient Egypt in his journal entry for 15 March:

> The images represent Men to their waist the Ears are large & they are about 15 foot high & above 5 foot wide; they are ill-shaped & have a large bonnet on their head like some of the old Egyptian divinities.[5]

It may have been the dimensions of the figures as well as their 'ill-shaped' bonnets that recalled the monumental figures of Egyptian statuary; in the published account of his voyage, Forster Sr returned to the theme of the size of the statues, some of them 8 m high, and took them to be 'the only remains of the former grandeur and population of this isle'.[6] The largest such moai known today on the island, nick-named El Gigante, is an unfinished statue no less than 20 m long: in short, colossal. Indeed, the Swiss anthropologist Alfred Métraux referred to the proliferation of gigantic moai on the island – a 2006 survey refers to a total of 887 known monolithic moai – as indicative of 'a mania for the colossal'.[7] If Georg Forster's sketch, the earliest known drawing of a moai,[8] presents features that look a good deal more European than those that we can recognize on the moai today, that has the effect of lessening the impressive monumentality of these colossal figures.

Easter Island owes its European discovery and name to the year 1722, when the well-to-do Dutch notary and navigator Jacob Roggeveen carried out an unfulfilled plan of his father Arend by becoming

43 Georg Forster, the
earliest drawing of a moai,
1774, pen and ink on paper.

commander-in-chief of three vessels dispatched by the Dutch West
India Company to discover the as yet unknown Southland.[9] One of those
three, the *African Galley*, sighted the island on Easter Sunday (5 April).
Five days later the Dutch organized a shore party of 134 armed men to
investigate the island. In spite of the fact that they shot around a dozen
natives dead and wounded more, they were still able to barter linen for
food and to obtain a cursory picture of the island and its inhabitants.
Roggeveen commented on the moai:

> What the form of worship of these people comprises we were
> not able to gather any full knowledge of, owing to the shortness
> of our stay among them; we noticed only that they kindle fire
> in front of certain remarkably tall stone figures they set up;
> and thereafter squatting on their heels with heads bowed down,
> they bring the palms of their hands together and alternately
> raise and lower them. At first, these stone figures caused us
> to be filled with wonder.[10]

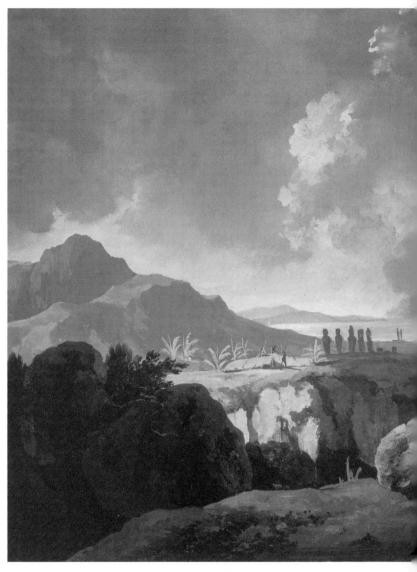

44 William Hodges, *A View of the Monuments of Easter Island*, 1776, oil on panel.

Forster's sketch of a moai was not published, Roggeveen failed to leave any visual impression of what they looked like, and his brief account was in fact not published until 1838, perhaps due to the concentration of curiosity about this region on Tahiti.[11] So these discoveries of the exotic remained unrevealed.

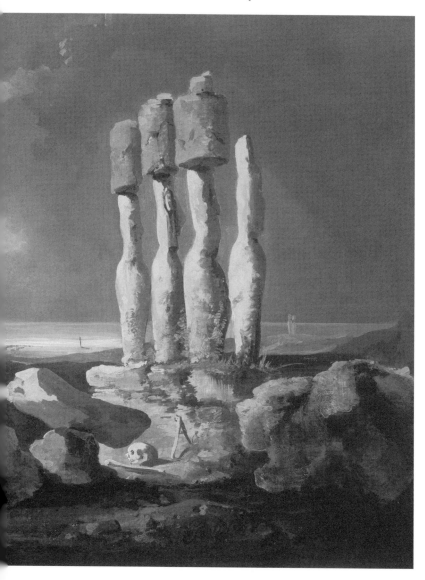

It was not until 1776 that the first visual representation of the island and its moai could be seen by the British public (as we shall see in chapter Five, their first opportunity to obtain a glimpse of an actual stone moai came more than a century later, in London in 1887). This was a large painting in oils on panel by the artist who accompanied the *Resolution* voyage, William Hodges, entitled *A View of the Monuments of Easter*

Island. The mysterious moai were bound to appeal to Hodges, whose debut at the Society of Artists in 1768 had been *A View of a Druid's Altar in Pembrokeshire*.[12] Hodges went on two walking tours of the island and made drawings there, but it is most unlikely that he would have painted a panel measuring 77.5 by 121.9 cm on the island itself. Moreover, the existence of a painting on panel of almost the same dimensions – *View of the Province of Oparee, Island of Otaheite, with part of the Island of Eimeo* (76.2 by 123.2 cm) – depicting Tahiti suggests that Hodges conceived of the two paintings as pendants. It seems most likely that he did them in England, where he was employed for a salary of £250 a year by the admiralty to complete the paintings and drawings he had brought back with him, several of which were exhibited at the Royal Academy in 1776 and 1777.[13]

Hodges's painting shows a group of four moai standing in a row on a platform (ahu) and looking out to sea. Three of them have the pukao, a red stone cylinder placed of top of the head, which is only found in association with statues on the largest and most important platforms. Cook and his men had also found a number of red stone pukao lying on the ground when they climbed the crater of Puna Pau, behind Hanga Roa. If we follow the gaze of these moai we can see a further two moai in the distance, close to the sea. On the left-hand side of the painting there is another group of moai in a row, five this time, and beyond them, close to the sea, another pair. The group of four moai in the foreground look heavily weathered – in fact, they are almost featureless. It has been argued that the lack of detail is because Hodges was more interested in atmospheric effects – the storm clouds hanging over the sea and the strong contrasts in light.[14] But however much the artist's interest in mood and atmosphere may have influenced its composition, his painting does show how groups of moai could produce a desolate effect. The scene is remarkably devoid of human activity; indeed, the only traces of human presence are the three small figures engaged in some activity on the left, and a human skull lying at the foot of the ahu on the right.

During the first day on which Cook and his men explored Easter Island, Georg Forster noticed human bones around the base of one of the great statues.[15] His father too noted: 'I observed many human bones scattered on the surface of the stone parapet wherein the stone pillars

were erected.'[16] The drama in Hodges's painting is conveyed not by the small skull in it but by the groups of tall moai and the brooding atmosphere. But when William Woollett came to make an engraving of *The Monuments of Easter Island* for publication in Cook's *Voyages*, he enlarged the skull into a large skeleton that dominates the foreground, and reduced the moai to two, apparently facing away from the sea this time, one with its pukao in place, while another pukao lies on the ground in front of the other moai. One solitary human figure completes the scene. The engraving is a much more literary composition than Hodges's painting and draws on the tropes of memento mori or 'how are the mighty fallen', in line with J. R. Forster's reference, cited earlier, to 'the former grandeur and population of this isle'. Akin to Piranesi's exploitation of the juxtaposition of ruins and human remains in his *Ancient Altar*, drama has given way to pathos.[17]

Not all moai were found in groups. When Walter Benjamin characterized two of Baudelaire's poems from *Les Fleurs du mal* with the words 'as strange and solitary as the great stone gods of Easter Island',[18] he had in mind not the groups of moai found on platforms but the solitary moai, such as is found in another of the early European representations of Easter Island, this time connected with the visit to the island by La Pérouse in 1786. Like the Dutch before him, La Pérouse was to spend one day on the island. Most of the drawings by the artists who accompanied La Pérouse perished following the wreck of the French vessels at Vanikoro. Duché de Vancy was the landscape and figure draughtsman, and the engraving 'Insulaires et monuments de l'Île de Pâques' by Godefroy in the *Atlas du Voyage de la Pérouse* (1797) is presumably based on a drawing by him.[19] The focus of attention is the large moai on the right, its monumentality emphasized by the ahu on which it stands. If the European measuring the moai may be supposed to have been about 1.6 m tall, then the moai is around 4.5 m tall. There is a smaller moai depicted behind it, but there is no suggestion that they are standing in a row. Like the moai sketched by Forster, each moai has a circular stone or pukao on its head. In the foreground on the left a fallen pukao is lying on the ground. It is noteworthy that the physiognomies of both the islanders and the moai are European rather than Polynesian. It is also noteworthy that the ahu on which the moai is standing has steps, while the platforms on Easter Island have a vertical wall

45 William Woollett, *Monuments in Easter Island*, etching after William Hodges, 1777.

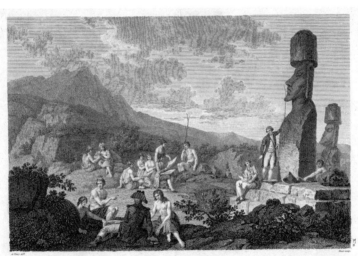

46 Engraving after drawing by Gaspard Duché de Vancy, *Inhabitants and Monuments of Easter Island*, 1798.

on one side and a ramp on the other. The platforms on Tahiti, on the other hand, known as *marae*, did have steps; that at Mahaiatea, for example, was over 100 m long and had eleven steps. As Katherine Routledge recorded in the account of her visit to Tahiti, 'It is obvious

that these structures in no way resembled the ahu of Easter Island.'[20] La Pérouse's artist, however, appears to have confused the two, just as he confused native and European physiognomies.

Tales Full of Sound and Fury

Since those eighteenth-century voyages of discovery, Easter Island has been repeatedly visited by persons in a variety of capacities and from several different nations. It was by chance that Katherine Routledge from Britain spent seventeenth months on the island during the First World War.[21] As she records: 'When, therefore, we decided to see the Pacific before we died, and asked the anthropological authorities at the British Museum what work there remained to be done, the answer was, "Easter Island".'[22] A French–Belgian expedition took Alfred Métraux and others to spend five months on the island in the mid-1930s. Most famously of all, the Norwegian Thor Heyerdahl organized the *Kon-Tiki* expedition in the 1950s in an attempt to prove his thesis that the Easter Islanders had an Amerindian, not a Polynesian, culture, which he expounded in *American Indians in the Pacific* (1952). Like Routledge's *The Mystery of Easter Island*, many of the books published about Easter Island contain words like 'mystery' or 'enigma' in their title.[23] For such authors, the biggest mystery or enigma of the island was the presence of almost 900 stone statues with an average height of about 4 m. This raises obvious questions: how were they made, how were they transported from quarry to final resting place, what did they signify?

The fascination of the technological aspects of the question will be left to a later chapter. For present purposes, it is the interpretation of the moai that is at issue. As we have seen, there was no innocent eye: the very first Europeans to observe the moai of Easter Island already had certain preconceptions or associations that coloured their vision, such as the assumption that the moai had some religious significance or the association with ancient Egypt. Interpretations might be advanced in (more or less) scholarly treatises. However, there is a form of implicit interpretation that is not always recognized as such: the way in which the moai are arranged on the island today – what Steven Roger Fischer has called 'Museum Island'.[24] For every (archaeological) (re)arrangement

presupposes a certain view of Easter Island society and a certain exegesis of Easter Island beliefs and practices.

Ahu Tongariki, the biggest group of stone statues on the island, now has no less than fifteen moai of varying shapes and sizes, standing in a row facing inland. It has been stated that 'we may regard each increasingly larger and heavier statue raised on image *ahu* as an objectification in stone of each attempted claim to an increasingly elevated level of chiefly status,'[25] but such an assertion that the tendency to erect ever bigger and heavier moai followed a linear progression remains to be proved; it is an implicit assumption, and one that entails an implicit interpretation. The fifteen moai were put in place on their platform by a Japanese corporation in the 1990s.

Near Ahu Tongariki stands a solitary moai (illus. 49). This was erected by Heyerdahl's Norwegian expedition in the 1950s. Plundering of the platforms over the years, and the effects of the massive tsunami of 21 May 1960 which swept fifteen moai more than 150 m inland from the platform, leaving them broken and covered by thousands of tonnes of ahu wall and fill, make it hard to determine exactly what the original moai and platform looked like. Besides, as J. Flenley and P. Bahn sagely point out:

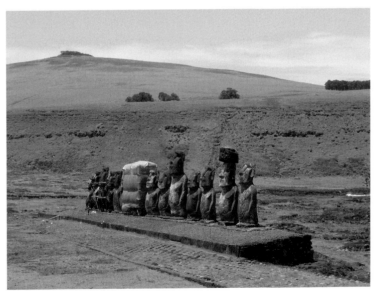

47 Ahu Tongariki, the largest moai platform on Easter Island.

The few dozen platforms excavated so far cannot yield a clear picture of the evolution of the image ahu form, and moreover, recent reconstructions of platforms may combine architectural features from more than one construction episode, and hence influence both archaeologists and the public.[26]

Not all ahu were on the coast; Ahu Akive, with its seven moai, is inland and faces the sea. At Anakena, several generations of platform seem to have been built one on top of another, and we find the same juxtaposition of a group of seven moai on a platform with a solitary moai nearby, once again one that was erected by the Danish expedition of 1955. The original features of these moai were permanently lost when a local carver gave them a face-lift in 1978.[27] In some cases, such as that of the – in many respects atypical – moai *Pou hakanononga* that was removed from Easter Island to Brussels in 1935, it is even uncertain whether it stood in isolation or in a group.[28]

Whether solitary or in a group, these moai were eyeless. None of the European explorers who saw moai still standing on their ahu mentions the presence of eyes. Felipe González y Haedo stated in 1770 that 'the only feature in the configuration of the face is a rough excavation for the eyes.'[29] The Belgian ethnologist Henri Lavachery had recorded in his notes made during the Franco-Belgian expedition of 1934 that he suspected some of the coral he was finding at various image platforms had been used to fill the eye sockets of the moai,[30] but it was not until 1978 that fragments of an eye made of white coral and red scoria were discovered under a fallen statue at Anakena. Since then, reproduction eyes have been fitted into the sockets of several moai (illus. 48). However, not all of the moai had eyes. No statue in Rano Raraku, or in transport to an image ahu, has eye sockets.[31] Apparently only those which stood on platforms had them. In fact, the presence or absence of eyes is only one of a number of features that introduce differentiation into the corpus of 887 moai that have been found on the island to date. Although the four moai in William Hodges's *Monuments of Easter Island* are very similar to one another in size and morphology – thereby rendering the group even more forbidding – there were considerable differences in size, materials and morphology. Most of the statues were made of porous volcanic tuff, but some are made of red scoria, basalt or trachyte. The height of the

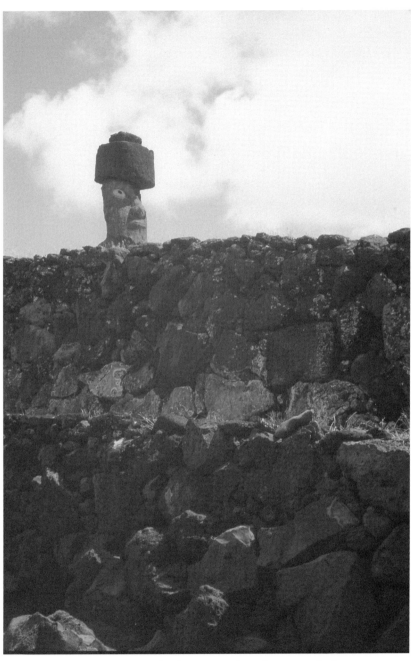

48 Solitary moai with pukao, Ko Te Riku, Tahai, Easter Island.

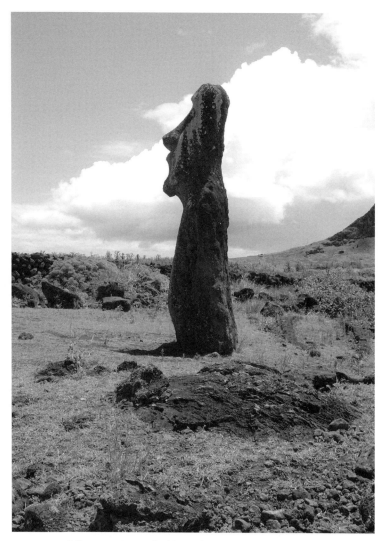

49 Solitary moai near Ahu Tongariki, Rano Raraku, Easter Island.

statues on an ahu varies from 2 to almost 10 m, and there could be considerable variation within a single row of moai. The presence of a beard or vulva on some statues indicates that they could be male or female respectively; most of them bear no obvious mark of gender at all, although they have generally been taken to be male. Sometimes the gender is itself open to doubt: while a Belgian catalogue labels one of its moai *'Colosse masculin'*, Van Tilburg refers to the same moai as having

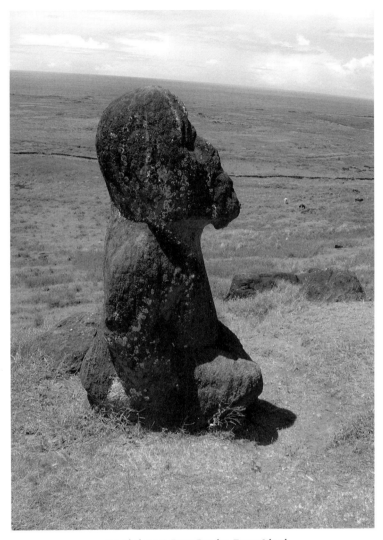

50 Bearded moai, Rano Raraku, Easter Island.

'a bas-relief protrusion which further emphasizes the female sex' and refers to a ritual practice of clitoral elongation – once again extrapolating social practices on the basis of a dubious identification.[32]

While empty eye sockets reinforce the brooding appearance of the figures and render them more anonymous and remote from the world of humans, the addition of oval eyes of cut and polished coral makes the figures less so. When the reproduction eyes were fitted, however, it

was found that the angle of the sockets made the statues look not ahead but upwards to the sky. Although erected on massive platforms binding them to the earth, their gaze was fastened on the heavens.

Some moai, usually those associated with the largest ahu, have a red pukao on top of their head, which has been variously explained as representing a hat, a top-knot or a red feather headdress. Whatever it may have represented, red was a colour associated with ritual and chiefly power throughout Polynesia. The sailors who accompanied Cook soon realized that the possession of red feathers would allow them to take their pick of native women on the islands, and the scarlet cloaks of the marines probably led some of the Tahitians to regard the arrival of the European ship as marking the return of the great war god 'Oro, since red was his colour and a sign of his presence.[33]

As for the function of the moai themselves, Johann Forster drew attention to the fact that the moai were associated with burial places when he referred to: 'The vestiges of former plantations on the hills, together with many huge stone-pillars, erected near the burying-places, to the memory of their deceased chiefs and heroes.'[34] He returned to the subject in connection with religion:

> In Easter-island they bury their dead near the ranges of gigantic stone figures, which serve in lieu of the wooden Taheitean Teèhees, (because wood is extremely scarce on their island) for I was told that these figures represented their deceased chiefs or hareekees; I observed many human bones scattered on the surface of the stone parapet wherein the stone pillars were erected.[35]

Don Felipe González y Haedo, who after the British occupation of the Falkland Islands in 1765 was sent from Peru in 1770 to seize Easter Island for the Spanish Crown before the British could lay claim to it too, and who produced the first map of Easter Island – on which the three moai indicated on the coast are all wearing the pukao – also connected the moai with the dead:

> We have ascertained that what we took for shrubs of a pyramidal form are in reality statues or images of the idols which the

natives worship; they are of stone, and of such a height and corpulence that they look like great thick columns, and as I afterwards ascertained in examining them and taking their dimensions the entire body is of a single block, and the crown or head-dress of another: there is a small concavity on the upper surface of the latter in which they place the bones of their dead, from which it may be inferred that they serve at once for idols and funeral pyres.[36]

It is worth noting that, in the case of a solitary, erect moai that stands for a dead person, there is a fundamental anthropomorphism linking it to that dead person, but at the same time it is not a representation of that person: the monumentality of the volume, carved out of a single block of stone, *kolossos*-like in that none of its members is detached from that volume, rules out any one-to-one identification of the moai with a single individual.[37] It is this simultaneous interplay of identity and difference, of the non-individual, non-representational replacement of an individual by a massive block of stone, that makes the moai so *unheimlich*. And this quality of being *unheimlich* is reinforced by the moai's isolation: devoid of context, devoid of company,[38] it defies interpretation just as the colossal, beyond the measure of the human body, defies measure.

Although it has often been assumed that the platforms on Easter Island were built as burial mounds, the damage done to the platforms over the years by plunderers and the elements makes it difficult to reconstruct past practices with any accuracy. Only a few of the platforms actually seem to have functioned as burial mounds. Cremation, a practice unknown in the rest of eastern and central Polynesia, was commoner than burial in early periods on the island, and when burial did come to replace cremation in pits behind the platforms – perhaps around 1700 – the bodies were often left exposed for a period of time before being placed in family caves. The French traveller Pierre Loti, who visited the island in 1872, said that the whole island was like an immense ossuary and that merely to lift a bit of earth would reveal skulls and jaws. Most of these bones probably dated from the period after contact with Europeans.

But whatever the connection may have been between the platforms and burial, by the time of Captain Cook's expedition in 1774 they had

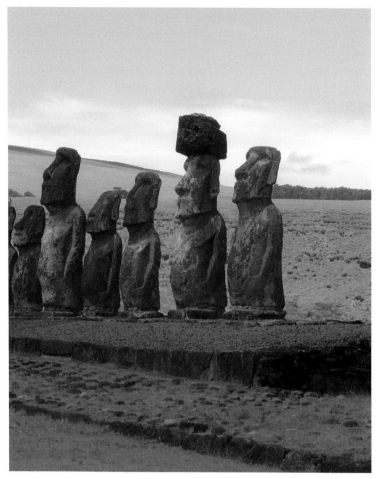

51 Moai with pukao, Ahu Tongariki, Easter Island.

become cemeteries of a different kind: they were littered with the bodies of fallen moai, though a number were still standing. Roggeveen did not mention them in 1722, nor did González – the first European to visit the island after Roggeveen – in 1770, but by 1774 they had become a conspicuous sight. Johann Forster wrote:

> It should therefore seem, that, since that time [Roggeveen's arrival in 1722], some disaster had befallen this spot, and ruined the woods, and thrown down many of the huge stone pillars, for we found several on the ground.[39]

Though the moai in William Hodges's *Monuments of Easter Island* are erect, what looks like a large toppled stone leaning on top of another, just to the left of the skull in the right foreground, looks suspiciously like a toppled moai. In fact, given Hodges's eagerness to produce a dramatic and forbidding image of the monuments, we cannot take his painting as evidence that few of the statues had been toppled by that time, as he may have used his imagination to re-erect some of them. Russian visitors to the island in the nineteenth century bear witness to a steady increase in the number of fallen moai. The last eyewitness testimony of a standing moai is from 1838: during his voyage of circumnavigation aboard the *Vénus*, the French admiral Abel Albert Dupetit-Thouars saw a platform with four erect red statues on the west coast.[40] By 1868, when Linton Palmer, an English surgeon, visited the island, apparently not a single moai remained upright. This was confirmed by Katherine Routledge during the First World War, when she wrote: 'The only piece of a statue which still remains on its bed-plate is the fragment . . . at Tongariki . . . No one living remembers a statue standing on an ahu.'[41]

It is possible that at least some of the statues were toppled by natural causes. As noted above, the massive tsunami of 1960 swept fifteen moai more than 150 m inland, and Easter Island itself is in a very active earthquake zone. Oral tradition and many archaeologists have related the phenomenon to tribal wars. On the archaeological record, Van Tilburg notes: 'it is abundantly clear that this process was not an iconoclastic sweep over the entire island. Every image *ahu* site has its own discretely timed history of building, re-building and deconstruction.'[42]

As for the oral tradition, its reliability is called into question by the fact that it was collected a century after the events it purports to describe.[43] The name Rapa Nui (Big Rapa) is itself a nineteenth-century invention, devised when Polynesians who had been taken as de facto slaves to Peru were repatriated and needed to indicate whether they came from Easter Island or from Rapa, 3,850 km to the west.[44] The invention of tradition was already well under way on the island in the late nineteenth century, when the first collection of folktales began and the first tablet inscribed in Rongorongo was described; incidentally, of the remaining 25 Rongorongo artefacts that survive today, not one

is on Easter Island.[45] After the depredations of Peruvian slave traders in the 1860s, the population of Easter Island had dropped to no more than 110; of the roughly 1,500 Easter Islanders who had been kidnapped and taken to Peru, only about a dozen returned home. One of these was infected with smallpox, and the subsequent epidemic decimated the island's remaining population.[46] The resulting gap in continuity between the pre-nineteenth- and post-nineteenth-century cultures therefore means that all of the folktales should be treated with a large degree of circumspection: 'Sadly, the oral testimony – because of the island's severe depopulation and cultural contamination in the latter nineteenth century – is too unreliable to serve even as a basis for historical conjecture.'[47]

Routledge, who recorded knowledge about the island and its traditions during the First World War, remarked: 'Deliberate invention was rare, but, when memory was a little vague, there was a constant tendency to glide from what was remembered to what was imagined.'[48] Twenty years later, the informant Juan Tepano, who had provided Routledge with information, repeated to the anthropologist Alfred Métraux what he had learned from her.[49] And Van Tilburg's occasional paper on the moai also acknowledges a debt to Christián Arévalo Pakarati, great-grandson of Juan Tepano.[50] Such a monopoly of knowledge in one

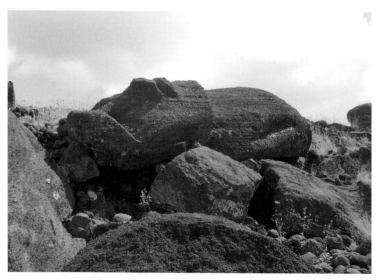

52 Toppled moai, Vinapu, Easter Island.

family is in inverse proportion to its reliability. Heyerdahl noted the islanders' ability to copy nineteenth-century carvings known from ethnological publications, and he was himself taken in by imitations of Peruvian material that the islanders were anxious to sell him. German visitors to the island in 1882 were surprised that the locals not only accurately knew currency exchange rates but also displayed their carvings on European-style shelves with attached price tags.[51] And when Alexander Salmon Jr and John Brander Jr arrived on the island in 1884 with title deeds to almost all of the land for livestock farming, Salmon not only 'had his labourers scour the island's caves in search of original artefacts to be sold to passing vessels', he also 'encouraged them more than before to make imitation pieces with imitation inscriptions copying the old *rongorongo* (but of far inferior quality)'.[52] This is also the era when the new 'traditional' corpus of settlement and other legends was created.[53] This was truly the invention of tradition with a vengeance.

Some of the moai have elongated ears, while others do not. This fired the lively imagination of Thor Heyerdahl, who took the 'long-ears' to have had their ear lobes elongated and perforated for disc ornaments, recalling South American practices, and therefore to be descended from the first Amerindian settlers on the island, while the 'short-ears' were taken to be the more recent Polynesian arrivals. It was but one step from here to see the 'long-ears' and 'short-ears' as rival clans. Oral tradition claimed that a major battle took place between these two warring clans at Poike Ditch, a series of trenches that almost isolates the Poike peninsula at the eastern tip of the island.

However, excavations in the ditch failed to find any archaeological confirmation for such a battle. The claim of the islanders that the ditch was called the 'Cooking Place of the Long-Ears' and was constructed to roast the short-ears is part of the same imaginative construction, drawing on the spectre of cannibalism that has been imputed to many 'others' at various times and in countless places.[54] Van Tilburg writes that 'cremations and burials took place near or on image *ahu*, and human sacrifices may have as well', but cites no evidence to support the latter claim.[55] Indeed, as has been pointed out by others, the occurrence of cannibalism on Easter Island is entirely narrative, and not archaeological.[56] The British officers of HMS *Topaze* were told how six years

53 Toppled moai, detail from William Hodges, *A View of the Monuments of Easter Island*, 1776, oil on panel.

before, three Peruvians had been killed, cooked and eaten by islanders, but there is no way of confirming the veracity of this boast.[57] The ditch may in fact have been used as a place for a series of ovens to prepare food for the workers in the nearby quarry of Rano Raraku; or it may have been used for growing crops.[58] As for the names 'long-ears' (Hanau Eepe) and 'short-ears' (Hanau Momoko) themselves, Sebastian Englert, an expert on the language of the island who lived there for many years as a pastor, denied that they had any connection with ears; he took the terms to mean 'broad or stocky people' and 'slender people' respectively.

This urge to create a narrative to account for the fallen statues is perhaps inherent in the fact that they are fallen: that is, they have been moved from their original place. Once an intentionality is conferred on this fact, a motivation has to be sought, and the hypothesis of internecine warfare – nourished by the stereotype of non-Europeans living in a state of pre-civility – offers a convenient solution. The only documented case of the deliberate mutilation of a moai is set in 1872, when the French admiral F. T. de Lapelin decided to saw off the

head from the body to facilitate the transportation of a moai from the island to Paris.[59]

Georg Forster calls the huge stone statues 'the only remains of the former grandeur and population of this isle', although this seems hard to reconcile with his observation that 'the gigantic statues of Easter Island . . . cannot be of very remote antiquity, as the stone is of an extremely perishable nature.'[60] The notion of a progressive degeneration is a very common trope in travel accounts of the eighteenth and nineteenth centuries. We find it, for example, in the attitude of nineteenth-century British travellers in Rome:

> Many of the most powerful Romantic engagements with Rome tended to eliminate or to marginalise contemporary Romans and to find solitude and space for imaginative engagement with the spirit of the city and its history. It was no accident, too, that Rome was a 'City of the Dead' (a phrase which Shelley overtly borrowed from Germaine de Staël) since Romantic writers were often more comfortable with cities when their animation was, at the least, suspended.[61]

Writing on the ruins of Yucatán, John Stephens set out to counter the argument that 'a people possessing the power, art, and skill to erect such cities, never could have fallen so low as the miserable Indians who now linger about their ruins.' Though he does not accept this as an argument that the cities could not have been built by Amerindians, he does accept the existence of a huge disparity between the Indians of the past and what he regards as the degraded Indians of his day.[62]

But besides their role in such debates on the antiquities of the Old and New Worlds, the image of the fallen moai had a Romantic quality reminiscent of the theme of *'et in Arcadia ego'* (Smith explicitly evokes Richard Wilson's painting *Et in Arcadia Ego* in connection with Woollet's engraving of the *Monuments of Easter Island*).[63] It is in this Romantic spirit that Katherine Routledge evoked the atmosphere of the camp of the British expedition overlooking the Ahu Tongariki:

> Immediately above the camp towered the majestic cliff of Raraku, near at hand were its mysterious quarries and still

54 Frederick Catherwood, *Broken Idol at Copán*, c. 1841, ink on paper.

erect statues; on the coast below us, quiet and still, lay the overturned images of the great platform of Tongariki, one fragment of which alone remains on its base, as a silent witness to the glory which has departed.[64]

Once again, it would not be difficult to find parallels in the illustrations of Yucatán that the English explorer Frederick Catherwood made during his travels with the archaeologist Stephens, such as *Broken Idol at Copán*, a fallen stele in the tropical forest, observed only by a passing deer. (Like the moai of Easter Island, Stele C has now been restored and stands in Copán's central square.)[65] Such an emotionally charged rendering of an ancient monument recalls the work of Piranesi, to which Catherwood had been exposed during his period as a student at the Royal Academy in London.

If the fallen moai can be taken as a sign of their demise, the images of them in the quarry mark their coming into being. Almost half of the statues that have been inventoried to date on Easter Island are at the quarry of Rano Raraku, which overlooks the Tongariki ahu. They stand on the outer and inner slopes of the volcanic crater and illustrate

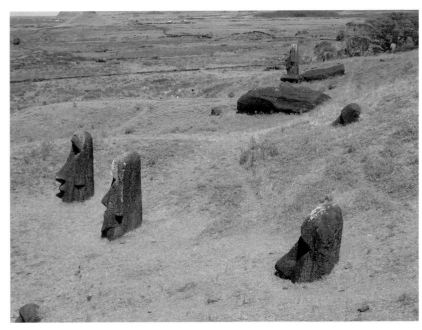

55 Moai on the hillside of the quarry, Rano Raraku, Easter Island.

56 The quarry, Rano Raraku, Easter Island.

various stages of the carving process. Cook and his men saw both solitary standing statues and statues standing in ranks at Rano Raraku. The quarry itself is filled with unfinished statues and the empty niches from which others have been hacked out. This is where the largest moai of them all, nicknamed El Gigante, is to be found. This unfinished statue is 20 m long.

The task of raising and moving a statue like El Gigante has led some scholars to suppose that it was in fact never intended to be a standing statue, but that it was an enormous petroglyph like the recumbent funerary statues in European cathedrals; Katherine Routledge was reminded of 'the side-chapel of some old cathedral, save that nature's blue sky forms the only roof'.[66] At any rate, the effect produced by the horizontal moai in the quarry today is more reminiscent of Egyptian mummies than of upright statues. Their anonymity and their horizontality contrast with the differentiation in the features of the standing moai and the verticality of the latter. We can also see a contrast between the economical way in which the rock has been used – to derive the

57 Henry Warren, 'Colossal Head at Izamal', lithograph after Frederick Catherwood, from *Views of Ancient Monuments in Central America, Chiapas and Yucatán* (1844).

largest number of statues from the available material – and the sacrality of the statues themselves – in other words, a complicity between the mineral material and the numinous values embodied in it.[67] The way in which the horizontal moai in the quarry are still imprisoned in stone, as it were, once again has a parallel in Catherwood's illustrations: the dramatic *Colossal Head at Izamal* shows a face carved in stone, embedded in the surface of the wall of the monument.[68] Stephens recorded: 'In sternness and harshness of expression, it reminded us of the idols at Copan, and its *colossal* proportions, with the corresponding dimensions of the mound, gave an unusual impression of grandeur.'[69]

The moai of Easter Island are indeed colossal by all accounts, simply in terms of their proportions. Yet the moai as a vertical stone that was fixed immobile in the ground and replaced the body of the dead, not as an image of the deceased but as a double, also partakes of what we have seen to be the nature of the archaic Greek kolossos. Vernant's words on the *kolossos* as something that 'plays simultaneously on two contrasting planes: at the moment when it shows its presence it reveals itself as not being from here, as belonging to an inaccessible elsewhere' could be applied equally well to an Easter Island moai.[70]

The failure to convince of many of the interpretations reviewed above is a sign that the invention of narratives will not take us very far in trying to grasp the nature of the moai. The tales full of sound and fury signify nothing. This is because they fail to do justice to a presence that reveals itself as not being from here. Standing erect like sentinels, tranquilly guarding the inhabitants of the island, the moai remain aloof from the clash of dissenting voices, from the ordinary decor of life. They just *are*.

4

COLOSSAL HEADS

Things manage their own rhetoric by themselves
and their eloquence is their intrinsic heritage.
Carlos Pellicer

Impression and Expression

We have already seen how easy it was for the European imagin-
ation to switch from the moai of Easter Island to the cathedrals
of England or to the statues of ancient Egypt. And we have also seen
how a pair of colossi in Egypt – two seated statues of Amenhotep III
– could produce a monumental effect on the French artist Vivant Denon.
Few visitors at that time will have been aware that the two figures
standing in stark isolation actually belonged to a group of six, which in
turn formed part of the vast temple complex of Amenhotep III.[1] Images
of them also found their way into the works of Fredrick Catherwood
and John Stephens. Catherwood reached the two statues in 1832 and
proceeded to get to grips with them by erecting a scaffolding around
them and measuring every single element in order to produce the first
scientifically accurate drawings of their decorations. Stephens included
an engraving of one of them in his *Incidents of Travel in Central America,
Chiapas and Yucatan* to demonstrate what he called the 'total want of
similarity' between Egyptian and Maya art.[2] Elsewhere in the same
work, Stephens drew a strong contrast between Egypt, where 'the colos-
sal skeletons of gigantic temples stand in the unwatered sands in all the
nakedness of desolation', on the one hand, and Copan, where 'an immense
forest shrouded the ruins, hiding them from sight, heightening the
impression and moral effect, and giving an intensity and almost wildness
to the interest' on the other.[3]

One of the reasons why these statues attracted visitors was not
just their size, but the fact that, as a result of damage sustained during
an earthquake in antiquity, one of them produced a whistling sound
in the morning. Though repairs carried out in the third century AD

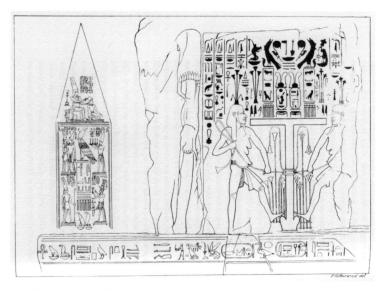

58 Tip of obelisk of Karnak (left) and detail from the Colossi of Memnon (right),
engraving after drawing by Frederick Catherwood, from John L. Stephens,
Incidents of Travel in Central America, Chiapas and Yucatan (1841).

deprived it of its voice again, it remained a tourist attraction. In Greek
mythology, after the warrior Memnon had fallen in battle, his mother
Eos prevailed upon Zeus to bring her son back to life briefly once a day.
As the Sun's early rays reached him, Memnon would set up a plaintive
wail and then fall silent again. The strange wail produced by the cracked
colossus earned it the nickname Colossus of Memnon. Memnon's lament
was set to music by Franz Schubert in 1817 with words by his friend
Johann Mayrhofer. The latter's unfulfilled longing for the gift of artistic
inspiration – he died after throwing himself out of an upper-storey
window – mirrored the longing of the dead hero:

> to unite myself with you, Goddess of Morn,
> and from this futile commotion far removed,
> from spheres of noble freedom and pure love,
> shine down, a pale and silent star.

The only colossal element in the music, however, is what one critic
has referred to as the 'colossal' effort of the singer's having to rise a
full octave and a half at measure 35.[4]

But to return to travellers in the Americas, the influence on nineteenth-century thought of visits to the New World has not always received sufficient emphasis. The case of Aby Warburg is well known: his stay among the Pueblo and Navajo of the United States in 1896 was to have important consequences for his later intellectual trajectory.[5] Less well known is the fact that Warburg was merely following in the footsteps of the anthropologist Edward B. Tylor, who travelled in Mexico between March and June 1856 and published an account of his journey, *Anahuac*, in 1861, ten years before the appearance of his classic *Primitive Culture*. The effect of Charles Darwin's travels in South America on his subsequent theories is well known, too.[6] Less well known is the fact that he also drew on a network of correspondents in the preparation of his *The Expression of the Emotions in Man and Animals* (1872). To that end he circulated a questionnaire among informants from various countries, including Revd Thomas Bridges, who had worked among the Yámana of the southern coast of Isla Grande in Tierra del Fuego since 1869, for details of how the native peoples of different regions expressed emotions.

Expression might be said to have been in the air. Karl Marx was explaining how the economic conditions under which a society exists find expression in its superstructure. Sigmund Freud in Vienna and Jean-Martin Charcot in La Salpêtrière in Paris were interpreting the motions of emotional life through their expression in symptoms. Paul Régnard from La Salpêtrière was using a Marey pneumographic device to chart the respiratory behaviour of patients as an expression of an attack of hysteria.[7] Seismologists used similar devices, and produced similar wave patterns, in an attempt to understand the inner motions of the Earth as expressed in the eruptions that burst out, like symptoms, on its surface. Freud, in turn, was to influence Warburg's understanding of expressive forms (*Pathosformeln*) that demonstrated a striking continuity from the classical world to the Renaissance.[8]

In 1862, one year after the publication of Tylor's *Anahuac*, a new Central American culture was discovered when a farmer came across the first of what are now known as colossal heads in Hueyepan (today Tres Zapotes) in Veracruz, Mexico. Nothing like it had been seen before. To which culture did it belong? And, in the idiom of the day, what did it *express*?[9] Incidentally, it should be noted that this discovery was in

fact a rediscovery, for there is evidence that earlier, both the Maya and the Aztecs had valued and modified original artefacts of this culture as heirlooms.[10]

As so often, discovery and interpretation went hand in hand. Impressed by the fleshy lips, the explorer José Melgar published a description of the head entitled 'Study of the Antiquity and Origin of the *Colossal* Head of *Ethiopian* Type Found in Hueyepan in the Canton of Los Tuxtlos'.[11] Almost twenty years later, the Mexican historian and dramatist Alfredo Chavero reproduced the Colossal Head from Hueyepan as evidence of the presence of what he referred to as the '*Negro*' race in Mexico, in his *México a través de los siglos*.[12] The italicized words tell us two things: that this head belongs to the history of the colossal; and that perceptions were coloured by preconceptions or associations with other continents. Just as the vision of the moai of Easter Island had taken Johann Reinhold Forster back to ancient Egypt, that of the colossal head of Hueyepan brought Ethiopia or Black Africa in general to the minds of Melgar and Chavero.

By the end of the twentieth century, seventeen such heads had been found and various theories had been advanced to explain their origin and function. The first problem was to assign them to a specific culture. Nowadays they are known as Olmec heads; the term 'Olmec' was first applied to them in 1927 by Hermann Beyer. But who were these Olmec? Were they Maya, proto-Maya, or something else? There was clearly a risk of getting caught up in a vicious circle here, for to explain Olmec culture on the basis of the evidence of the heads was about as reliable as interpreting the heads on the basis of suppositions about Olmec culture. The term 'Olmec' is found in various written sources from the sixteenth century,[13] when it was applied to groups who settled on the coast of the Gulf of Mexico and lived there during the Postclassic era (AD 900–1524). However, the Olmecs to whom the colossal heads are attributed are an entirely different category. Based in the centres of La Venta (Tabasco), Tres Zapotes (Veracruz) and San Lorenzo (Veracruz), they colonized the southwestern part of the Gulf between about 1500 and 400 BC – that is, during the Preclassic period. The chronological succession of cultures in the area is neatly summed up by the history of an Olmec jade pectoral in the British Museum, which was later inscribed with name glyphs and reused by a Maya lord as a precious heirloom.[14]

Chronologically, therefore, the Olmec culture of the Colossal Heads does not coincide with the groups of Olmecs mentioned in the historical documents. Neither does it coincide with the culture of the present-day occupants of those centres. Archaeologists have been obliged to resort to the methods of prehistoric archaeology because of the absence of both written historical sources and a contemporary oral tradition.[15] And it is the attempts to fill in this historical and ethnographic gap – efforts to create or invent an Olmec identity – that interest us here.[16]

Colossal the heads certainly are. Monument 1 from San Lorenzo is 2.85 m tall. Far from being uniform, however, there is a striking degree of variation when it comes to the representation of the eyes, nose, mouth, cap, and ear ornaments. As one scholar puts it: 'The careful and subtle sculpting of the eyes, mouth, and other features creates the impression that one is viewing the faces of specific, living individuals.'[17] This is a characteristic that the Olmec share with the Maya and the Moche, but which is otherwise rare in the ancient cultures of the New World. This emphasis on personality suggests that the intention was to represent the vesting of supreme power in the person of one individual, a trait that has led, by contrast, to the hypothesis that the absence of such distinctive features in the Olmec centre of Tres Zapotes in the last four centuries BC points to a downplaying of the differences between the local elites.[18] In spite of these individual variations, similarities between the features of some of the colossal heads suggest relations of kinship between the persons represented. Moreover, almost all of the colossal heads have one feature in common: the use of a geometric compositional principle to guarantee a harmony of proportions.[19]

It was not until the 1920s that systematic excavations began in La Venta and other Olmec sites. The publication of *Tribes and Temples*, the report of an expedtion from the University of Tulane, disseminated knowledge of the Olmec culture. This report and illustrated articles that appeared in magazines such as the *National Geographic* attracted the attention of a wider public, including artists. Sculptors like Frank Dobson and Henry Moore drew on the findings at La Venta in precisely these years.[20] The Maya Theatre in Los Angeles, an amalgam of different pre-Columbian American styles,[21] was completed in 1927, and the Mexican pavilion at the 1929 Exposition in Seville, designed by the Yucatán-born architect Manuel Amabilis, combined the use of modern

construction techniques with elements derived from both Toltec and Olmec culture.[22] The coincidence of the publication of the discovery of Olmec culture with the rise of Modernism in the 1920s, especially in its Surrealist variant, was to have a major impact on how the products of that culture were interpreted.

Diffusion of images of the Olmecs sped up with the publication in *National Geographic Magazine* of photographs from a series of excavations in the region by Matthew W. Stirling between 1938 and 1946. Stirling unearthed the colossal head that had been discovered in Hueyepan 80 years earlier, as well as continuing excavations at La Venta and unearthing a further four colossal heads in San Lorenzo Tenochtitlan. However, the arrival of the Olmecs on the archaeological scene complicated the situation that had predominated until then. An idealized, romantic vision of the Maya was propagated by the English archaeologist Eric Thompson and others in the first half of the century and met with a warm welcome in certain quarters in the 1960s. According to this view:

> The Maya were believed to be extraordinarily spiritual, know-ledgeable priests unconcerned with prosaic and material matters in life – without wars, without bloody sacrifice; a people of philosophers and astronomers, 'pure' scientists, with their eyes glued to the sky, confined to sidereal space.[23]

Such a judgement contains an implicit comparison with the Aztecs, who were believed to be bloodthirsty, cruel and transgressive – which goes a long way to explaining their attraction for the French philosopher of the abject, Georges Bataille, whose essay on the virtues of self-mutilation, anthropophagy and human sacrifice was published in 1928.[24] At the level of aesthetics, Roger Fry, author of *Vision and Design*, the influential work from 1920 that was to produce a major impact on the artists of that decade, considered that 'the Aztecs had everything to learn from the Maya, and they never rose to the level of their precursors.'[25] Writing much later, Eric Wolf continued to see a link between artistic styles and social values:

> The Mexican style is geometric, monumental. The Maya style, on the other hand, loves riotous movements, luxuriant form,

flamboyance. Both styles are equally Classic. Yet their difference denotes in all probability a wide divergence in basic values and feeling-tones.[26]

To a certain extent, the Maya/Aztec dichotomy reflects the more general one between the noble and the ignoble savage that is to be found in virtually all European descriptions of Amerindian society from the sixteenth century onwards.[27]

Today, discussions of Olmec style are not confined to the colossal heads. A substantial number of other artefacts have been found: the so-called altars (referred to more accurately nowadays as thrones), a tomb of monolithic columns, stelai, axes, mosaics and sculptures of various types, such as the wooden figures found in El Manatí. In the following discussion, however, I shall limit my remarks to the more monumental works, namely the colossal heads and the thrones.

Violent Warriors or Spiritual Philosophers?

Mere iconographical description of the heads does not tell us much about Olmec social organization or culture, but the various indications of damage that can be seen in the surface of the stone have led some scholars to hypothesize a deliberate act of mutilation. According to M. D. Coe and R. Diehl, this evidence of mutilation is connected with religion, warfare, the death of a prominent figure (*cacique*) and the protection of the members of society from the supernatural power taken to reside in the colossal heads.[28] They combined this interpretation with the theory that the colossal heads were ritually buried in the ground for the same reason.

However, basing her conclusions on a detailed technical analysis of the surface of eighteen colossal Olmec heads, the Dutch archaeologist Suzi Gerards has called into question this image of the Olmecs as violent and destructive.[29] She regards the theory that the circular incisions ('circular damages') in the surface of the monumental heads ('Cabezas Colosales') are the result of intentional destructive acts as unsustainable and argues that they are the product of natural processes of erosion.[30] She sums up her findings as follows:

Within the present vision, there are many theories regarding the intentionally buried statues, violent acts of war, ritual destruction out of fear, like the deliberate circular damages (c.d.). Despite the large number of burial theories it is certain that not more than one Cabeza Colosal was deliberately buried in a pit. It has also become clear that the Olmecs were less frightful and less destructive than is generally assumed. The circular damages, found on many of the Cabezas Colosales, were subject to technical analysis about the way these circular carvings were made by man. According to researchers they had a direct connection to the demise of the depicted ruler. It was demonstrated however that these c.d. were all caused by natural processes. Also there was no evidence whatsoever, found pointing towards violent acts of war. Many of the damages seen on the Olmec monuments, which were the trigger for these elaborate war theories, proved to be mainly due to natural causes and not caused by deliberate acts.[31]

In interpreting the colossal heads as representations of human rulers, some have related them to a hypothetical form of political organization, though competing views exist as to the precise form this may have taken. After all, the main problem in trying to determine whether Olmec culture was a 'mother culture' on the one hand, or just one of several 'sister cultures' that contributed to the formation of Mesoamerican civilization on the other, arises in the process of extrapolating from archaeological artefacts to socio-political institutions.[32] Others have seen in the colossal heads reflections of ritual practices or representations of supernatural ancestors or mythological figures. In that case the heads might be relevant to a theory of Olmec religious practices, but not of Olmec social organization.

Another hypothesis that entails a view of Olmec culture as one of violence is the proposal that the presence of heads without bodies attests to the practice of decapitation. Once again, the argument is one of analogy, and depends on the choice of culture with which the analogy is drawn. After all, bodies lacking limbs and heads form the vast majority in collections of Graeco-Roman sculptures, but it would be unthinkable to invent a theory of deliberate mutilation in such a case. It is the image

of decapitated heads that can be found in the art of the Nazca of Peru and other pre-Columbian societies that appears to have contributed to the formation of this image of the Olmecs. As a variant of this, it has been suggested that if their headgear corresponds to that worn the heads would then represent those of the decapitated losers. However, the Olmec colossal heads never belonged to a body with a neck, shoulders or other limbs in the first place. It is difficult to speak of decapitation when they had no body to be separated from.[33]

Another persistent stereotype belonging to the same configuration of condemned practices is that of human sacrifice. It is not surprising, therefore, that the discovery of the 'Lord of Las Limas', a seated figure holding a child in his arms, has been combined with the similar postures shown in the thrones from La Venta to support the hypothesis of the existence of child sacrifice among the Olmecs. Once again, however, the interpretation is based on subjective factors. Gerards advances an equally subjective interpretation that leads to the opposite conclusion: she claims that the variety in age of the children and the respectful way in which they are represented are indicative of a relation with life rather than death.[34]

The so-called Altar Four from La Venta contains figures carved in low relief on the sides who are connected by the three-dimensional figure in front by means of what appears to be a cord. Some scholars have interpreted this as a sign of the subordination of the figures on the sides to the three-dimensional figure, that is, of their status as bound slaves.[35] In another case, a heavily damaged monument of unknown provenance has been variously interpreted as representing either 'copulation between an anthropomorphized jaguar and a human woman' or 'a victor dominating a captive'.[36] Once again, Andean styles, particularly that of the Moche, in which the figure of the bound captive does frequently recur, appear to have influenced the perception and interpretation of Olmec objects. Gerards puts forward the original thesis that the cord is an umbilical cord and analyses the iconography of the throne in terms of kinship and filiation.[37]

If we pass from the iconography of the colossal heads to their material, basalt, we have to travel 100 km from the plains of La Venta to the mountains of Tuxtlas to find this material. The ceremonial mound 30 m high on the La Venta site does not have the regular pyramidal form that is found on Maya sites, and given that its concave sides give it the

form of a white blancmange, it is plausible that it was modelled to imitate a volcano. Did the Olmecs of La Venta migrate from the mountains to the riverine lowlands and remember their mountain origins in the shape of their ceremonial mounds?[38]

However that may be, the difficulties involved in transporting these blocks of stone over a distance of 100 km or more has been one of the fundamental considerations behind the formulation of a picture of Olmec society as a highly organized hierarchy with a large supply of labour power and a level of coercive power that imply the existence of a polity. The parallel with the moai of Easter Island comes to mind, where the presence of moai from the same quarry scattered all over the island implies the capacity to transport them over distances of several kilometres and, once there, to erect them. Hypotheses about the nature of Easter Island social structure and economic organization have been constructed depending on the theory of which particular technique of transportation and erection was used.[39]

To return to the colossal heads, it is by no means certain that they were transported from one place to another at all. Volcanic rocks from the Tuxtlas Mountains have been found dispersed over a large area. It is thus possible that the creators of the colossal heads took advantage of local stones, in other words, fragments of basalt from the Tuxtlas Mountains that had been moved by natural processes in the remote past. They would have chosen them for their suitability to represent a head. This is the thesis put forward by Román Piña Chan, who argues that the large blocks of natural stone aroused the admiration and wonder of the Olmecs as something endowed with magico-religious power.[40] Such an image of the Olmecs as admirers of nature is very different in aesthetic and emotional terms from the picture of a hierarchical and highly organized state. It also has implications for a quality of Olmec art that has been emphasized in the past: its monumentality and its faithfulness to the material.

So far the present analysis has covered various images of Olmec culture and society that have been projected on the basis of different, often contradictory, interpretations of the colossal heads. However, an image of Olmec culture is also conveyed through the *presentation* of the colossal heads and other Olmec artefacts in different twentieth-century settings. Each form of presentation has an effect on the

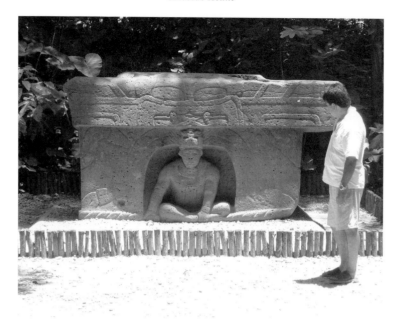

59 'Altar Four' from La Venta, Parque-Museo La Venta, Villahermosa, Tabasco, Mexico.

monumentality and faithfulness to the material of the colossal heads, and thereby to how they are perceived and interpreted. At the same time, an explicit or implicit interpretation is already present in the conception of a particular form of presentation. So at this point we move from representation to presentation.

The Return of the Aura

Between the period of Tylor, Darwin, Warburg and the others – the theoreticians of expression – and the laying out of the site where most of the Olmec colossal heads are on show today, a major intellectual shift intervened: Surrealism. In the 'Surrealist Map of the World' published in 1929, the new centres of 'symbolic power' are Easter Island and Mexico, while the United States of America does not exist. A plethora of pre-Columbian artefacts entered the private collections of Surrealists such as Breton, Aragon and Éluard and appeared side by side with objects of modern art in exhibitions and in the pages of periodicals such as the short-lived *Documents*.[41] For Walter Benjamin,

Surrealism was 'the death of the nineteenth century in comedy'.[42] And the form in which this new world presented itself was not through interpretation but through *presentation*, through allowing objects to speak for themselves. As Benjamin described his own project:

> Method of this project: literary montage. I needn't *say* anything. Merely show. I shall purloin no valuables, appropriate no ingenious formulations. But the rags, the refuse – these I will inventory but allow, in the only way possible, to come into their own: by making of use of them.[43]

As mentioned in the Introduction, the analysis here shifts from consideration of the various interpretations of what the work is taken to express to an examination of the effect that is produced on the observer by the specific combination of that particular work within a particular physical and institutional setting: the sense of place.[44]

Today none of the four colossal heads discovered in La Venta is still there.[45] One is in the Museo Regional de Antropología Carlos Pellicer Cámara, Villahermosa, Tabasco, while the three others are in the Parque-Museo La Venta in Villahermosa in the Mexican province of Tabasco. The former is a museum building dating from the 1970s in the modern industrial sprawl of Villahermosa; the latter is a park on the outskirts of the city created by the Tabascan Modernist poet Carlos Pellicer (1897–1977) in 1958, where a setting amid lush vegetation and water forms the natural showcase in which not only the three colossal heads from La Venta but also 28 other items and twelve fragments from the same site are displayed. Visitors to the park can choose to observe the tropical animals in its zoo or take the archaeological route.

Piña Chan indicated that the creators of the colossal heads wanted them to be visible from afar. As a result, they were arranged in La Venta itself in a way that enabled appreciation of their form rather than of detail. In the Parque-Museo La Venta, on the other hand, they are within reach. In fact, it is impossible to view them from afar because of the vegetation that surrounds them and because of the boundary of the park. In La Venta, the colossal heads were arranged like sentinels of the ceremonial centre.[46] Moreover, investigations of both this site and

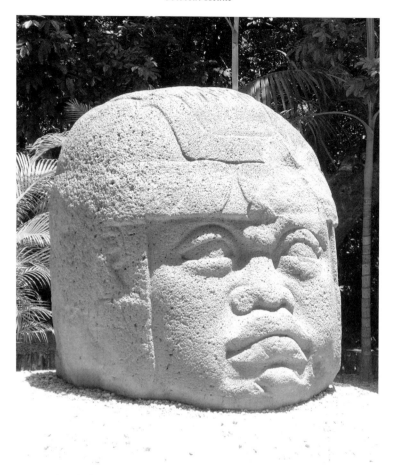

60 Colossal Olmec head from La Venta, Parque-Museo La Venta, Villahermosa, Mexico.

of the site of San Lorenzo have shown that the Olmec were quite capable of placing monuments in tableaux to convey a narrative of ritual action, creating a stage on which the primordial act of creation was ritually reenacted.[47] In the Parque-Museo, for obvious reasons, such an arrangement is impossible.

But this loss of their aura is compensated by the acquisition of a new aura, albeit a Modernist one. Some of the objects on show have been given a 'Brancusi' touch, such as the sculpture of a dolphin or the 'monkey gazing at the sky', whose dramatic title is owing to its vertical position, even though the object in question was probably

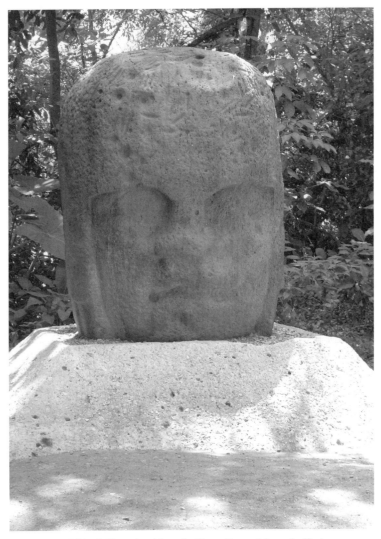

61 Colossal Olmec head from La Venta, Parque-Museo La Venta.

originally horizontal. The aesthetic effect has been produced in and by the Parque-Museo. Evocations of Giacometti will be discussed in more detail in the final chapter, but it can be mentioned here that a work of his, *Three Figures in a Field*, which was completed in 1930 and subsequently destroyed, bears an affinity with the tomb in the park.[48] As for 'the silhouette', it is a piece of unworked stone that was found at La Venta, but in its evocative, highly aesthetic setting it invites

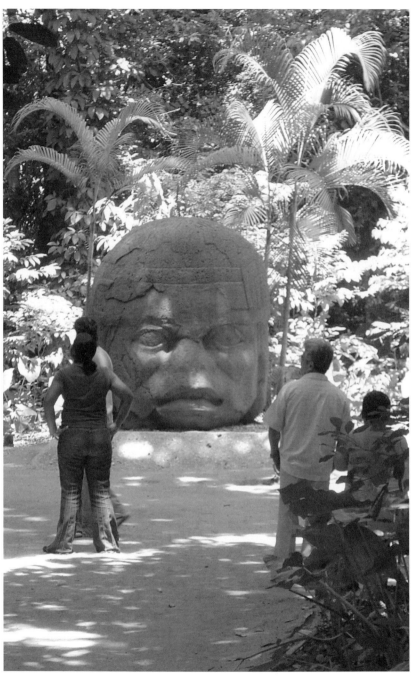

62 Colossal Olmec head from La Venta, Parque-Museo La Venta.

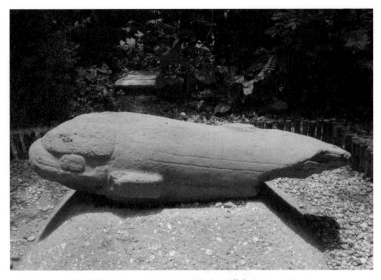

63 Dolphin, Parque-Museo La Venta, Villahermosa, Mexico.

64 Monkey gazing at the sky, Parque-Museo La Venta.

65 Silhouette, Parque-Museo La Venta.

comparison with, say, the photograph of *Balzac* in Rodin's studio or of Medardo Rossi's *Child in the Sun*.

The version of Monumento 2 from La Venta in the Parque-Museo is a replica. The original is on show – in fact is the centrepiece – in the archaeological museum in the new centre of the city. Other monumental Olmec pieces are on display in the same museum in the room to the left; as the sign indicates, the room on the right is where the toilets are situated. This might seem an unpromising location. And yet, occupying as it does a space all of its own in the foyer of the museum, deprived of the immediate company of other Olmec objects, raised on a pedestal and isolated from its surroundings by a red-orange background, in this mundane building, far from the evocative aesthetics and poetics of the Parque-Museo, the head has nevertheless maintained some of its primordial aura. Its frontality is exploited to the full in such a setting: indeed, it is this very frontality that gives us the impression that, in looking at the face in front of us, our gaze will be returned by its object. A response common in human relationships is here transposed to the relationship between the inanimate object and the human viewer. As Walter Benjamin put it in an essay 'On Some Motifs in Baudelaire', 'To perceive the aura of an object we look at means to invest it with the ability to look at us in return.'[49]

From the moment one enters the museum, the colossal head dominates both the space and the visitors. It both protects and is protected by the museum surroundings. It cannot be approached or touched; it is out of reach. Its form rather than its details is what is appreciated. It is isolated from the company of the other Olmec objects, but they are on a smaller scale and could never be suitable companions anyway. But this aura is not its original aura either. In its original location at La Venta, this colossal head was situated between two others (Monuments 3 and 4) of the same type and size.

Benjamin defended a concept of the aura that comprises the 'unique manifestation of a distance'. He added: 'The essentially distant is the unapproachable: unapproachability is in fact a primary quality of the ceremonial image.'[50] But the distant, the unapproachable, can still be near. In his famous essay 'The Work of Art in the Age of Mechanical Reproduction', published in 1936, Benjamin remarked: 'we define the aura . . . as the unique phenomenon of a distance, *however close it may*

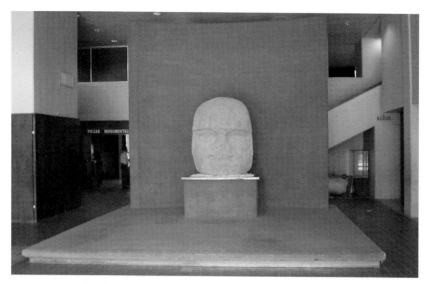

66 Colossal head from La Venta, Museo Regional de Antropología Carlos Pellicer, Villahermosa, Mexico.

be.'[51] In a note to that essay he explains these rather cryptic remarks in more detail:

> The definition of the aura as a 'unique phenomenon of a distance however close it may be' represents nothing but the formulation of the cult value of the work of art in categories of space and time perception. Distance is the opposite of closeness. The essentially distant object is the unapproachable one. Unapproachability is indeed a major quality of the cult image. True to its nature, it remains 'distant, however close it may be'. The closeness which one may gain from its subject matter does not impair the distance which it retains in its appearance.[52]

It is in that distance, however close it may be, that the colossal defies measure.

In investigative practice, we often resort to a language of grasping or comprehending, which are actions connected with the sense of touch, and therefore with proximity or the abolition of distance. However, it might be the case that, the closer we approach the colossal heads, the greater the distance that separates them from us becomes. For if we

could get closer to what is distant, its distance would be lost.[53] As a corollary, by increasing the distance between the colossal Olmec heads and ourselves, or rather, by allowing them to put us at a distance, it might be that we would be better able to appreciate their enigmatic identity and not run the risk of 'extinguishing the magic of distance'.[54]

5

COLLECTING MOAI

After travelling to Mexico in 1938, André Breton declared it the most Surreal country in the world. The first 'primitive' object that he acquired, however – an Easter Island figure, which he bought at the age of twelve, to the horror of his parents – reflected a fascination not with the Americas but with Oceania.[1] As Christian Zervos, editor of *Cahiers d'Art*, remarked in 1927, 'What took place twenty years ago with African sculpture is happening at the moment with Melanesian and pre-Columbian art.'[2] In the 'Surrealist Map of the World' published two years later in *Variétés* (the same year in which a special issue of *Cahiers d'Art* was devoted to Oceanic art), the tiny Easter Island had been blown up almost to the same size as the whole of South America.

One of the artists who took a keen interest in the art of Easter Island was Paul Gauguin. A wooden cylinder he carved in 1891–2 shows the figure of Christ crucified surrounded by images derived from the Rapanui Rongorongo script.[3] They recur in the background of the portrait of his fourteen-year-old lover, painted in 1893, entitled *Merahi metua no Tehamana* ('Tehamana Has Many Parents').[4] Gauguin could have come into contact with Easter Island art, as he did with that of the Marquesas, in both Paris and Tahiti.

This explosion of interest in the art of Easter Island was partly fuelled by publications on that art in European periodicals. The notebooks of Alberto Giacometti, for example, contain copies of two wooden statuettes from Easter Island reproduced in the article 'L'Île de Pâques' by Mgr Tepano Jaussen in the special issue of *Cahiers* on Oceanic art.[5] But a stronger influence was the very presence of objects from the island in the capitals of Europe, and later further afield, from the second half of the nineteenth century onwards. Prominent among

these objects, of course, were the famous moai. And their appeal to the Surrealists could not have been stronger.

London, Paris, Brussels

At the end of chapter Three we left the moai lying face down on the shores of Easter Island. The urge to move and re-erect them proved irresistible to the major colonial powers. The earliest moai to reach Europe were two that were first presented to the British public in the British Museum in 1870.[6] Roggeveen had mentioned that the islanders 'kindle fire in front of certain remarkably tall stones they set up', though he left no impression of what they looked like, and Cornelis Bouman, one of Roggeveen's captains, had written 'on land we saw several high statues in the heathen fashion'.[7] But now Londoners could get at close quarters – uncomfortably close, according to a caricature published in the *Illustrated London News* in 1887 showing the Easter Monday crowds flocking and picnicking around the statue – with the real objects in three dimensions.[8] Sculptural presentations had taken the place of visual representations.[9] So in considering this presence of three-dimensional objects on a variety of sites, we shall have to consider both the effects that their presence produces on those sites themselves, and vice versa the impact of their setting on how the objects themselves are viewed – all of this beyond the purview of whatever values may have pertained on Easter Island itself.

HMS *Topaze*, under the command of Commodore Richard Ashmore Powell, set its course for Easter Island from the Pacific port of Callao in October 1868 to conduct a survey of the island, to verify its position and to search for any other islands in the vicinity. Although these instructions make no mention of collecting 'souvenirs', after native guides had led a party from the vessel to the Mataveri area of the island to see what one of them described as 'an ugly lump of stone', the stone statue was promptly named *Moai Hava* and transported to Hanga Roa, the only harbour on the island, for shipment. While some take the name, in combination with the upturned face and hands, to refer to crying at death, the interpretation of *Hava* as 'dirty' is a more down-to-earth rendering. The basalt statue is 1.56 m high and displays signs of lack of finishing.

Moai Hava is overshadowed, however, by the bigger and more impressive moai called *Hoa Hakananai'a*, which was discovered only two days later, buried up to its middle in the earth inside a low building on the Orongo ceremonial site at the southwestern tip of the island, where the dense basalt rocks are festooned with no less than 1,274 petroglyphs.[10] Once again, there are various interpretations of the name. If the descriptive and derisive 'dirty statue' is the right translation of *Moai Hava*, a rendering of *Hoa Hakananai'a* as 'stolen (or hidden) friend' would share the same register. This basalt moai 2.42 m high and well preserved is clearly superior to *Moai Hava*. After the destruction of the building, the statue was disinterred and dragged overland by sailors from Orongo to the sea. Red and white pigment on the statue was washed off during the transport of the moai to the ship.

It is unclear where this particular moai stood before its transfer to the building in Orongo, although its pointed base shows that it was never intended to stand on a platform. In any case, semi-burial in isolation in Orongo will most probably have marked a change of function. In other words, the attribution of different meanings to the moai depending on their location and position is a process that was already under way on the island itself. However, the metaphor of 'layers of meaning and function' employed by Van Tilburg is inappropriate; rather, one could speak of the stripping away and eradication of the previous meaning with each new context in which the object finds itself.[11]

It is evident that the collecting of these moai has to be seen within the wider context of the expansionist phase of British colonialism. The larger of the two was initially offered as a gift to Queen Victoria, who in turn expressed the wish that it should be presented to the British Museum.[12] After the arrival of both statues in the British Museum, the two moai were placed as a pair in various indoor and outdoor locations. Katherine Routledge, writing in 1919, remarked of *Hoa Hakananai'a* that it was 'wholly and dismally out of place under a smoky portico, but on the slopes of a mountain, gazing in impenetrable calm over sea and land, the simplicity of outline is soon found to be marvellously impressive'.[13] Nevertheless, it made a sufficiently strong impression on the sculptor Henri Gaudier-Brzeska, who arrived in London from France in 1910; the elongated cheeks, deep-set eyes and overhanging brows of his sculpted *Hieratic Head* of fellow Vorticist Ezra Pound have

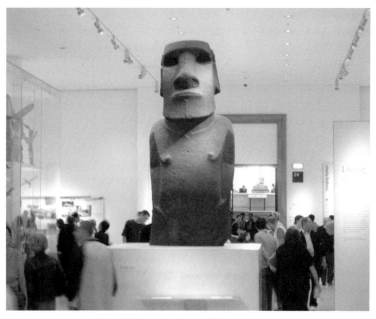

67 Moai Hoa Hakananai'a, basalt, Wellcome Trust Gallery,
British Museum, London, 2004.

been taken to imply a familiarity with the moai that stood in the portico
of the British Museum.[14]

Hoa Hakananai'a was displayed in the front hall of the Museum
of Mankind until its return to the British Museum in 2000. It was briefly
on display in the Great Court, though this was a far from ideal location
in view of the presence of a visitors' café nearby, which violated the
taboo on the proximity of food to the sacred statues. By 2004 it could
be seen indoors in the Museum's Wellcome Trust Gallery.

It is worth examining the effect of each of these contexts on the per-
ception of the moai in question. For instance, the division of the museum
collections in 1970, contrary to the original aim of Sir Hans Sloane to
keep all the collections together under one roof, removed the moai
from a quasi-heraldic function on the colonnade of the British Museum
and highlighted their insertion within a display of objects labelled as
'ethnographic'. In the current thematic display in the Wellcome Trust
Gallery, the ethnographic specificity of an object from Polynesia is lost
amid the plethora of objects from different parts of the (non-European)
world. In 2004 there was even an appreciable 'Harry Potter' content to

the display. Though it was not found on a platform (ahu), *Hoa Hakananai'a* was probably connected with a sacred site on Easter Island; this sacral dimension is bound to be lost when it stands in one of the busiest parts of the museum amid a host of objects with which it has no geographical or ethnographic connection. What remains, however, is its massive character: towering above the mass of visitors, it commands the space.

Moai Hava, the second of the pair of moai transported by HMS *Topaze*, initially fared less well than its more impressive counterpart and was placed in storage in the newly opened Museum of Mankind in 1970.[15] However, in 2011 it was displayed in the august surroundings of the Royal Academy of Arts, London, as part of the exhibition 'Modern British Sculpture', where it rubbed shoulders with a sculpture of a baboon from second-millennium BC Egypt and faced works from the first decades of the twentieth century that were considered to betray the influence of ancient hieratic sculpture.[16]

TWO OF THE three moai heads now in the Musée du Quai Branly in Paris come from larger-than-life moai.[17] The oldest to be collected, a head

68 Moai Hoa Hakananai'a, basalt, Wellcome Trust Gallery, British Museum, London, 2004.

1.85 m tall, was removed from the island only four years after the removal of *Hoa Hakananai'a* and *Moai Hava* by the British; like that British expedition, the French one too belongs to the wider context of expansionist foreign policy. Dramatic changes, however, had taken place on the island in the time that had elapsed between the two expeditions: as a result of the exodus of 275 islanders to Mangareva in French Polynesia in June 1871, the remaining native population able to witness the activities of the French numbered only around 230.[18] Contemporary sources, including sketches made on the spot by the writer Pierre Loti, indicate that the French set out from the harbour of Hanga Roa to a nearby site with an ahu platform. Like most moai at the time – and still today – this one had been toppled and was lying face-down on the ground. After efforts to move the 4-m statue proved too much, it was decided to decapitate it and to take the severed head back to the French capital. Probably because of its rather weathered condition and the damage caused during its removal from the island, it has fared rather worse than its counterparts in the British Museum: a visitor to the Jardin des Plantes in 1906–7 described the head as 'surrounded by a lot of scrap iron and rubbish'.[19] While the colossal head was on display in the Muséum Nationale d'Histoire Naturelle it was apparently seen by the artist Odilon Redon. It must have made an impression on him, for the first lithograph in the series *Homage to Goya* (1885), entitled 'Face of Mystery (In my dream I saw in the Sky a FACE OF MYSTERY)', appears to have been influenced by it.[20] The moai was subsequently donated to the Musée de l'Homme and later moved, with the contents of that museum, to the present-day Musée du Quai Branly when it opened in 2006. When the present writer saw it in 2009, it was located outside the museum in the grounds next to the restaurant – once again in violation of the traditional taboo – in the company of several heads from South America, a region, as noted earlier, more than 3,500 km away from Easter Island. Since then it has been moved to a more salubrious and commanding position inside the main building, in splendid isolation.

The other large head in the collection of the same museum, with a height of 1.5 m, was found in the vicinity of Anakena, close to the Rano Raraku quarry from whose tuff both large heads were carved. It was collected by the Franco-Belgian mission that was dispatched in 1934 under the leadership of the archaeologist Louis-Charles Watelin

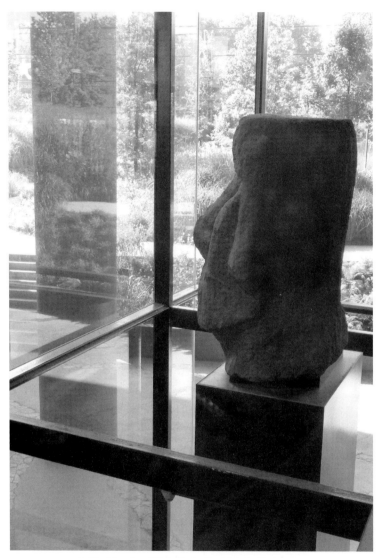

69 Moai head, tuff, Musée du Quai Branly, Paris, 2009.

to investigate the mysteries of Rongorongo script for the predecessor of the Musée de l'Homme at the Trocadéro, the Musée d'Ethnologie. After the death of Watelin on the outbound journey, the Swiss anthropologist Alfred Métraux was appointed new leader of the expedition. When the expedition proved unable to find any Rongorongo tablets anywhere, the attentions of the Belgian ethnologist of the expedition,

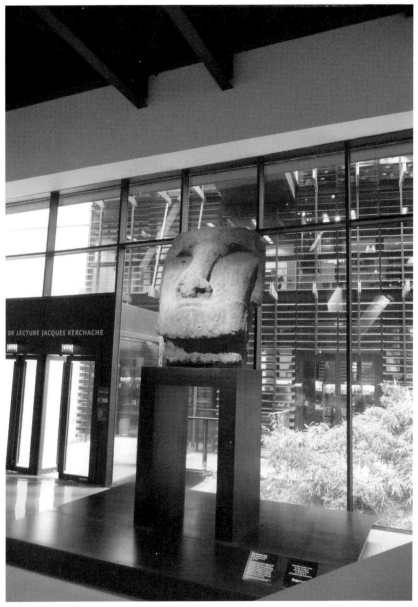

70 Moai head, tuff, Musée du Quai Branly, Paris, 2012.

Henri Lavachery, turned to rock art, and he completed the first survey of mainly petroglyph sites and types, while Métraux collected data for a projected ethnography.[21] Métraux had been a fellow student with Georges Bataille, with whom he maintained a lifelong friendship until the former's suicide in 1963. Both men were closely associated with the Surrealist movement that had turned its attentions from Africa to Oceania and was showing a particular interest in Easter Island at the time. Profiles of Easter Island moai heads feature in the work of another Surrealist, Max Ernst, whose collage novel *Une semaine de bonté* was published in the very year in which the Franco-Belgian expedition set its course for Easter Island. Clearly, Easter Island and its moai were in the air.

This background may explain why the large head is displayed in a very distinguished location today: the Pavillon des Sessions of the Louvre, where it is one of more than 100 works of non-European art that have been on display there since 2000 so that, as Jacques Chirac put it in his speech at the opening of the pavilion, the 'first arts' – as 'primitive art' was called at the time – could be 'confronted with the numerous forms of artistic expression present in the Louvre'. This is a far cry from the scrap iron, rubbish or restaurant whose company the other large head in Paris has had to keep over the years. And the message to the public in this august setting is that the rock art of Easter Island deserves artistic recognition for its outstanding aesthetic quality.

Another moai brought back by the Franco-Belgian expedition on board the *Mercator* is now in the Musées Royaux d'Art et d'Histoire situated in the Parc du Cinquantenaire in Brussels. The various sources differ as to where this large specimen – it is 2.7 m tall – carved in basalt was found: it is variously assigned to different platforms, and it is by no means certain that it stood on an ahu at all.[22] Its date is equally uncertain, for the dating of moai is carried out on stylistic grounds, but the unusual style of this particular one (for example, it is asymmetrical and has no neck) renders such dating particularly problematic. Moreover, the statue's name, *Pou Hakanononga*, is obscure. Most commentators take it to refer to tuna fishing and connect the statue with a tuna fishing site. The moai was removed from its position by being wrapped in a net and then dragged on top of a wooden sledge to the beach. Whether due to the techniques used in collection or to other causes, in its present state the

statue presents signs of serious damage. Indeed, a photograph taken in 2006 shows it clamped between metal supports as if under restraint, and very much the worse for wear.

Spectacular, on the other hand, is the presentation of another moai in the same museum. Dramatically lit and standing in splendid isolation at the foot of a staircase, it produces a stunning impact on the unsuspecting visitor who has just turned the corner. The massive head does not feature in the museum catalogues, however, because it is a copy of a moai from the slopes of Rano Raraku, one of a pair made in 1988 for the ambitious exhibition that was presented in the museum in Brussels and in the Senckenbergmuseum in Frankfurt.[23] So in this case the strongest aesthetic effect is produced by a twentieth-century copy, while the 'historical' moai in the same museum's collection can convey

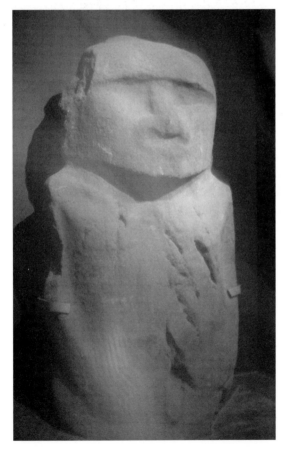

71 Moai Pou hakanononga, basalt, Musées Royaux d'Art et d'Histoire, Brussels, 2006.

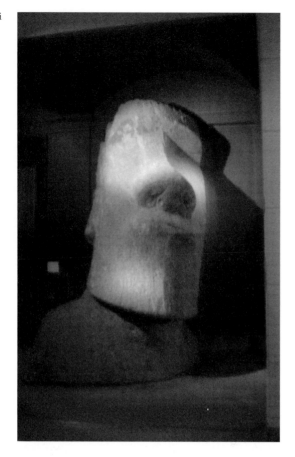

72 Replica of a moai from the Ranu Raraku quarry on Easter Island, Musées Royaux d'Art et d'Histoire, Brussels, 2006.

only little of the 'sense of quiet dignity, of suggestion and of mystery' to which Routledge referred.[24]

We Move South: Chile and Italy

The earliest evidence for the presence of a moai from Easter Island in the Chilean capital comes from the Russian scientist, traveller and humanist Nikolai Miklouho-Maclay, who was in Santiago in 1871 studying and collecting Easter Island objects as well as holding conversations with specialists prior to a planned expedition to the island. He mentioned the presence of a 'big idol made of black lava' in an unspecified Santiago museum.[25] It is known that objects from Easter Island were brought to the mainland by a Chilean expedition on board the *O'Higgins* commanded

by Ignacio L. Gana in the previous year – that is, only two years after the British expedition to Easter Island.[26] It may be that this 'big idol' can be identified with a moai now in the Museo Nacional de Historia Natural in the green Quinta Normal district of Santiago, as Van Tilburg thinks probable, though very little information is available about the provenance of this statue either on the island or afterwards.[27] In fact, the moai in the collection of that museum, which is mainly visited by groups of school pupils attracted by the huge skeleton of a whale, are in a poor state of conservation and are unimaginatively displayed as mere adjuncts to educational wall panels on the history of Easter Island. The museum also has a replica of a historical moai, made in 1975.[28]

Besides the presence of both original moai and twentieth-century replicas of historical moai, the cases of Chile and Italy introduce us to yet another category: the proliferation of moai newly created in the twentieth century by carvers from the island. Consideration of these moai within the present context must sound preposterous to any archaeologist. However, since the focus is on the impressions produced by moai far from home, the distinction between (replicas of) 'archaeological' moai and modern creations will be disregarded. It is not the authenticity of the object that guarantees its impact. If the first 'native' object that overseas visitors to Santiago de Chile see upon leaving their downtown hotel is a moai, this will colour – exoticize – their perceptions of the South American ambience in which they find themselves, irrespective of the question of its historical or geographical provenance.

So let us begin with that moai in the centre of Santiago carved in white travertine marble (a type of mineral that is not to be found on Easter Island) and wearing a red pukao on its head.[29] It faces visitors who emerge from the foyer of a 5-star hotel close to the church of San Francisco – a part of what Nobel Peace Prize winner Henry Kissinger (in)famously characterized as America's 'back yard'. Named *The Brotherhood Moai*, the white moai in Santiago is intended to form a symbolic bridge between East and West. As a plaque boasting the UNESCO logo proudly states, it was sculpted by Bene Tuki Paté, a woodcarver who grew up on Easter Island in the 1950s and who has been invited to carve moai on various locations far removed from the island.[30] A wooden one that stands on the Dutch island of Texel – it would be hard to imagine a setting more unlike the volcanic and hilly island of Easter

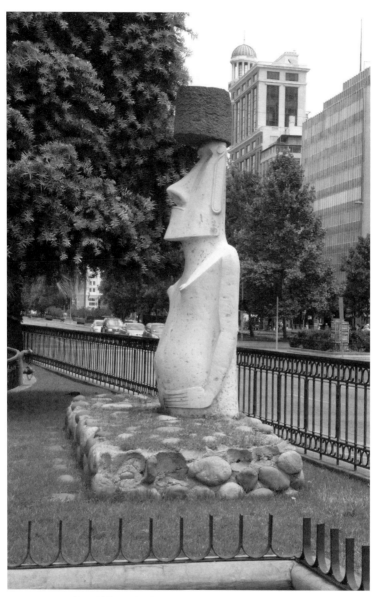

73 Bene Tuki Paté, *The Brotherhood Moai*, travertine marble,
Santiago de Chile, 2009.

Island than this dune landscape – was carved to commemorate the Dutchman Roggeveen's 1722 landing.[31]

Two other moai occupy positions very close to locations that have acquired a strong symbolic charge in recent Chilean history. Close to the civic heart of the capital, on a traffic island opposite the La Moneda where the democratically elected President Salvador Allende was killed during the U.S.-orchestrated military coup of General Augusto Pinochet on 11 September 1973, is an original moai from Easter Island with the slogan 'Distance does not keep the Chileans apart / Easter [Island] is in the heart of the fatherland / Municipality of Santiago 1978'.[32] The mound on which it stands may have been intended to be reminiscent of the raised platforms of the island, and the large stones scattered around it also recall the rubble surrounding the toppled moai that the Europeans found on the island.

Another moai connected with a location with strong historical links to the installation of the military regime is situated in the Ñuñoa district of the capital. This modern statue of a moai was inaugurated next to the statue of the Discobolus in front of the main entrance of the

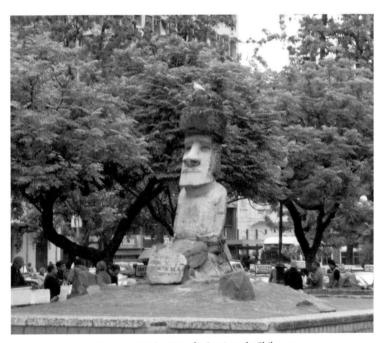

74 Moai opposite La Moneda, Santiago de Chile, 2009.

national stadium in May 2008. It thus stood in the forecourt of the stadium where thousands of political opponents of the junta were tortured and killed. However, the declaration of the stadium as a Historic Monument in 2003 precluded the presence of newcomers to its grounds and the moai had to be moved to a traffic island on the other side of the road at the end of 2009.[33] It would be hard to imagine a site further removed from the dignity of a raised position on a platform, while the conferment of the status of a Historic Monument on the Estadio Nacional has given that building and its grounds what might be called a 'secular sacrality'.

Some of the displays of moai in Santiago have been very brief. A moai taken from the island in 1927 and given to the newly elected Chilean president Ibáñez del Campo was sold in 1970 and travelled to the Netherlands before being shipped on to Argentina. It passed into the hands of an antiquarian, ended up in the Buenos Aires customs office and was eventually recovered by his daughter, the sculptress Rosa Velasco. In April 2004 it was returned to Chile, displayed for one day opposite La Moneda and then taken on board a vessel in the port of Valparaíso for the return journey to Easter Island, which it had not seen for 80 years.[34]

But to see a well-preserved original moai displayed with dignity in the grounds of a Chilean museum, one has to travel 120 km from Santiago to the coastal resort of Viña del Mar, where a moai brought to the Chilean mainland in 1950 now stands outside the Corporación Museo Fonck. It was first located near where the present Hotel Miramar and the eccentric folly known as Castillo Wolf overlook the Pacific, before being moved to its present museum situation in 1988. There are a number of features of its display that are worthy of note. First, although the plaque at its base outside the fence and hedge that protect it today reads 'MOAI DE AHU ONE MAKAIHI RAPA-NUI', the absence of carved eye sockets indicates that this moai did not come from an ahu, since it is assumed today that only the moai erected on ahu were given such eye sockets.[35] Second, a large piece of stone disposed nearby in the same grounds bears the inscription 'Piedra tacita concon periodo arcaico 8000 años a.C.' By association, the dating of this large stone with man-made perforations from the Concón area not far north of Viña del Mar to the archaic period of 8000 BC (to paraphrase the Spanish inscription)

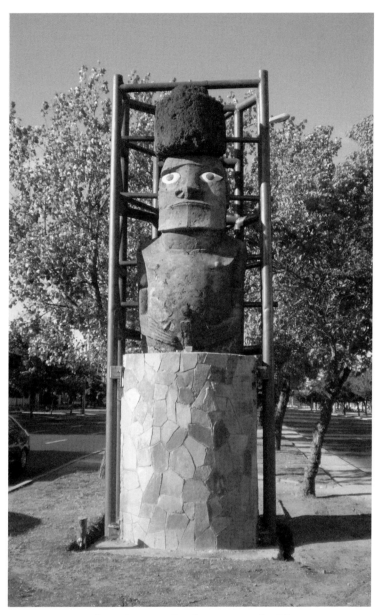

75 Moai facing the National Stadium, Santiago de Chile, 2009.

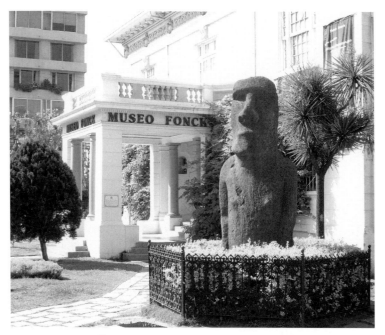

76 Moai, tuff, Corporación Museo Fonck, Viña del Mar, Chile, 2009.

implies that the large manmade moai standing in the same precinct is equally archaic.[36] 'Archaic' the style of the moai certainly is; but the earliest known statue of Rano Raraku tuff dates from the twelfth century AD.[37] Perhaps the association was eased by the juxtaposition of the remote in time (8000 BC) with the remote in place (a statue from the remotest island in the world). We can find a similar elision of a huge time gap in the context of an exhibition inaugurated in the Museo Chileno de Arte Precolombino in Santiago in 1997, entitled 'Chile before Chile'.[38] It referred to 'the prehistory of Chile . . . including tropical Polynesia' or even 'the prehistory of Polynesian Chile', as though the cultural links between Easter Island and mainland South America went back more than 12,000 years. In fact, however, it was not until 1888 that British rivalry with France in the Pacific led the Republic of Chile, where British commercial interests were particularly strong, to annex Easter Island.[39]

NOT A MOAI, but islanders themselves, were brought from Easter Island to Italy in 1990 to carve a moai from a block of locally supplied *peperino*,

77 Stone with man-made perforations, Corporación Museo Fonck,
Viña del Mar, Chile, 2009.

a stone that has been in use in the region as a material for sculpture since
the fourth century BC. This time it was not the ubiquitous Bene Tuki
Paté but eleven members of the Atan family from the island who had
been invited by RAI Television to the village of Vitorchiano on former
Etruscan territory, near the famous sixteenth-century garden of
monsters in Bomarzo, to make the sculpture in order to draw attention
to the deterioration of the original moai on the island as the result
of erosion.[40]

In February 2007, however, the moai itself – almost 10 m high and
weighing almost 30 tonnes – was removed from its place in the village
square (piazza Umberto I) of Vitorchiano to be displayed for eight
months in an exhibition entitled 'Arte precolombiana', organized by
the Museo del Territorio Sa Corona Arrùbia on the island of Sardinia.[41]
The title is rather misleading, as the initiative, supported by Chilean
organizations, was confined to the art of the north, central and southern
regions of Chile. Moreover, neither the photographs of Mapuche (the
dominant native minority in Chile) and Selk'nam (a now-extinct ethnic
group that lived in Tierra del Fuego at the southernmost tip of the

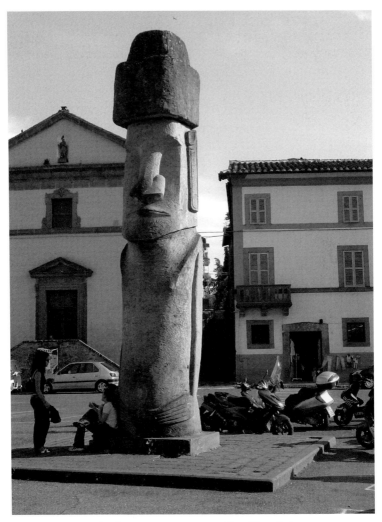

78 Atan family, moai, peperino stone, Vitorchiano, Italy, 2006.

continent) from the beginning of the twentieth century, nor the moai sculpted in Italy at the end of the same century, can properly be regarded as pre-Columbian.

Incidentally, this was not the first modern moai to visit Sardinia. Moai had put in a brief appearance there in 1968, when 'artificial' moai featured in the grounds of the villa of the wealthy eccentric Sissy Goforth, constructed for the set of Joseph Losey's film *Boom!* (1968) starring Elizabeth Taylor and Richard Burton.

A Sense of Place

This list of moai outside Easter Island is by no means exhaustive. Besides the moai now in Otago Museum, Dunedin, New Zealand, which was purchased in 1929 from the Scottish Brander family who had been active on the island at the end of the nineteenth century, Van Tilburg also mentions examples in the Smithsonian Institution in Washington, DC, that were collected on the island in 1886 by the USS *Mohican*, which had instructions 'to bring away one of the colossal stone images to be found on the island', and an almost 3-m moai of uncertain provenance in the Museo Arqueológico de la Serena in the Chilean coastal resort of La Serena.[42] In the light of the repatriation of some moai, the indeterminate date and provenance of others, and the expansion of moai carved in the course of the last two decades, any list is bound to be provisional. The cases examined here are confined to those instances that the author has been able to examine *in situ*.

Nevertheless, on the basis of this sample it is possible to draw some conclusions. There are a number of tensions inherent in the ways in which these moai are displayed. The first is a tension between aesthetic and archaeological considerations. In a 1963 interview the Uruguayan architect Ernesto Leborgne explained his conception of a pre-Columbian museum in Montevideo as follows: 'To our way of thinking, a museum like this had three fundamental missions: to exhibit, to conserve and to study. The exhibition offered two possibilities: the archaeological or the aesthetic. We opt for the latter.' The Uruguayan artist Francisco Matto went on to add: 'But we do not start out from antagonisms between two things that evidently complement one another. The artistic arrangement of the pieces would not be at odds with the archaeological principles. For the rest, I don't believe in a purely scientific archaeology.'[43]

It should be clear from this exchange that it would be wrong to try to draw a clear distinction between the two approaches. Nevertheless, there is an obvious preponderance of archaeological considerations when we find moai displayed alongside other artefacts from Easter Island, or more generally from Oceania. All the same, the effect of inserting an Easter Island moai into the context of a museum display thousands of miles from the island clearly has a major impact on how

it is viewed. If it is placed in an ethnographic display along with other artefacts from the island like the (heavily damaged) moai *Pou Haka-nononga* now in Brussels, it simply becomes one exponent of a native culture, on a par with the other objects that partake of and stand for that culture. Far more dramatic, because in isolation, is the presentation of the second moai in the same museum, even though it is a modern replica.

On the other hand, if displayed in a monumental setting along with other large objects from other places, the moai's geographical or ethnographic specificity is lost to the overriding monumentality of its new spatial setting. In particular, the moai that were erected on platforms stood on holy ground; that sacrality obviously disappears in a context like that of the Great Court of the British Museum.[44]

Besides these differences in modes of display, and therefore in their effects on the viewing public, in museum institutions, the discussion has to be widened to include the display of moai in any public place. It is perhaps the installations of various contemporary artists over the past couple of decades, such as Mona Hatoum and Christian Boltanski, that through their site-specificity have rendered us more aware of the suggestive power a site can exert on the perception of any object that is viewed in or on that specific site. The moai installed on traffic islands in the centre of Santiago, for instance, are completely out of place surrounded by the architecture of a modern Latin American metropolis and their Polynesian past is completely alien to that Latin environment. Yet at times that very incongruity may be the point: the presence of a moai in the Italian village of Vitorchiano is clearly out of place, although its general form as a vertical monument blends surprisingly well with its position at the centre of a village square. But, carved as it was to draw attention to the threat of erosion to the original moai on Easter Island itself, its inappropriateness may constitute its very strength.

Some of the photographs included here, which deliberately depart from the convention of showing archaeological objects detached from their immediate physical and human surroundings, show some of the different ways in which people 'consume' moai: they may view them with awe inside museum showcases or installations, they may find the base a useful place to sit on and socialize, they may occupy a park bench

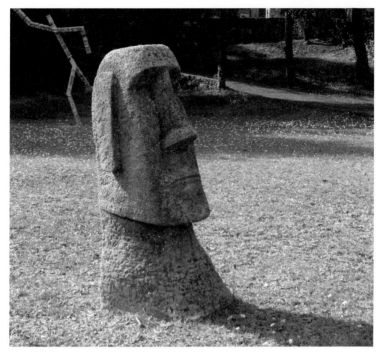

79 Moai head in a private garden, Saint-Paul de Vence, France, 2010.

nearby, they may carve a moai head and put it in their own private garden of sculptures. As we saw in the case of the obelisks in chapter Two, there is a whole range of degrees of formality and informality in which moai are presented and treated – 'recontextualized', some might prefer.

But one thing that is important to remember is that the removal of a moai from its original site is nothing new in the history of Easter Island. The moai now in the British Museum may have stood elsewhere first before being moved to the interior of a stone house at Orongo. Moai were transported in some way or other from the quarry at Rano Raraku to sites at various points on the island, and many of the moai that were found standing on the slopes of the quarry have been frozen in what was originally only a temporary resting place. Sometimes moai were incorporated in the fill or wings of the sacred platforms. Moreover, carvings were sometimes added to moai at a later date, especially in connection with the birdman cult of Orongo. For example, the back of *Hoa Hakananai'a* is carved with a raised ring and girdle, birdmen, paddles and vulvas. It is therefore difficult to talk about the 'original' appearance

or the 'original' location of a moai. And if it is difficult to determine the 'original' context, the 're-' of recontextualization loses all meaning.

In short, behind the unease that some may feel at the sight of moai in unusual or unsuitable places, there lies a belief in a pristine state or condition that turns out to be unfounded. We simply have to take the moai, whether original or replica, as they are, where they are, and be as receptive as we can to a sense of place.

6

TECHNOLOGY AND
SURREALISM

The Monolithic and the Minute

During a journey down the west coast of South America and back through the highlands of the Andes from 1599 to 1605 to raise funds for the cult of the Virgin of Guadalupe, Fray Diego de Ocaña had occasion to pass through Tiahuanaco, the ancient pre-Inca Tiwanaku, a few kilometres from Lake Titicaca. He was puzzled by the presence of buildings made of blocks of stone of such magnitude that it was difficult to know how they arrived there, since there were no stones of that kind within a radius of 280 km. A single block was 21 m long and 4.5 m wide. When he asked his native informants how the stones had got there, they told him that a supernatural being, Zupay, had transported them across the lake or through the air.[1] The presence of a stone figure 7 m tall led Fray Diego to suppose that giants might have been responsible, a view that he saw confirmed when the Spaniards excavated the gold head of a giant on the site.[2]

The idea that the platforms and statues of Easter Island display enough affinity with those of Tiahuanaco to suggest a direct link between the two cultures was first put forward in the nineteenth century, though it was later in the twentieth that the adoption of the theory by Thor Heyerdahl gave it larger publicity. Disregarding the enormous chronological and geographical difficulties that beset such a theory, Heyerdahl tried to establish parallels between some fitted blocks on the site of Vinapu on Easter Island and Inca walls at Cuzco, as well as between some of the Easter Island statues and those of Tiahuanaco, even though Cuzco is an Inca site and Tiahuanaco is a pre-Inca one.[3]

But unconvincing though the suggestion of an affinity between a culture from the Bolivian highlands and that of a low-lying island in

Polynesia may be, both Easter Island and Tiahuanaco raise a question of a different kind, the one addressed by Fray Diego, namely: how were such gigantic monoliths transported? The question, as we shall see, has obsessed many of those who have tackled the problems raised by the technology of the colossal, from carving and transport to erection, even though the technology and material culture of the Pacific Islanders played only a minor role in European attempts to classify the peoples of the region.[4]

Although iron smelting was known in Egypt from the sixth century BC, it was not until the incorporation of Egypt within the Roman Empire in 30 BC that the use of iron tools became common. Therefore the earliest carvers of the obelisks had to work with stone. After carefully marking out the ground, they detached the obelisk from its surroundings with the use of stone pounders and undercut the bottom once sufficient depth had been reached.[5] Katherine Routledge described a similar technique for carving the stone moai in the Rano Raraku quarry, Easter Island, and the same method was adopted during Thor Heyerdahl's expedition to the island in the 1950s, when six men outlined a 5-m statue using rock pounders in three days.[6] Routledge hypothesized that the carved statues were then slid down the slopes of the volcanic quarry on a causeway of earth.

The next problem was that of transport. One of those fascinated by the problem was the U.S. engineer Bern Dibner, who wrote a study of the subject, *Moving the Obelisks*, in 1970.[7] The obelisks of Egypt were probably rolled out of their bed onto a large sledge and then pulled along a lubricated track by a vast force of slaves and labourers to the river for transport on the Nile between the double hulls of specially constructed vessels.[8] The transportation of the moai from the quarry to other locations on Easter Island has likewise exercised the minds of engineers and others. Routledge records a legend about an old woman on the island who moved the statues by supernatural power, ordering them about at her will, as Zupay had moved the stones of Tiahuanaco; she also quotes from another account according to which 'they walked, and some fell by the way'.[9] But it is unlikely to have been as easy as that. She herself wrote:

> No statues were, therefore, found of which it could be said
> that they were in process of being removed, and the mode of

transport remains a mystery. An image could be moved down from the quarry by means of banks of earth, and though requiring labour and skill, the process is not inconceivable. Similarly, the figures may have been, and probably were, erected on the terraces in the same way, being hauled up on an embankment of earth made higher than the pedestals and then dropped on them . . . But the problem remains, how was the transport carried out along the level? The weight of some amounted to as much as 40 or 50 tons.[10]

Our earliest visual source for their method of transportation, it has been suggested, but one that has generally been overlooked, is an anonymous Dutch print from an anonymous account of Roggeveen's voyage published in Dordrecht in 1728.[11] On the far left it shows a group of nine natives in various postures around a large block of rock with a face carved on its surface. If they are involved in moving it, and if the block is resting on a stone slab with rollers beneath it, as Flenley and Bahn suggest, this might be an early indication, based on information from Roggeveen's companions, as to how the stone statues were moved.[12] H.-M. Esen-Baur also draws attention to this print, which has been rather neglected in the discussion of the transportation question. However, as she rightly points out, 'the large stone figure is not reproduced with complete fidelity.'[13] This is an understatement: the figure in the print bears not the slightest resemblance to anything known from Easter Island. The same can be said of the rendering of the rock formations. And if the actions of the natives are taken to match anything in Roggeveen's account at all, then it is his account of the form of worship of the Easter Islanders:

> We noticed only that they kindle fire in front of certain remarkably tall stone figures they set up; and, thereafter squatting on their heels with heads bowed down, they bring the palms of their hands together and alternately raise and lower them.[14]

The neglect of the print in the discussion of how the transportation of the moai was carried out is therefore fully justified. All the same, transportation by means of a sledge is a distinct possibility and is the

80 Battle between Easter Islanders and Dutch in 1722, anonymous engraving from *Tweejaarige Reyze Rondom de Wereld* (1728).

explanation adopted by the Czech engineer Pavel Pavel and others. It is also the method that was used when English sailors dragged the moai *Hoa Hakananai'a* to the shore of Easter Island before floating it out on a specially built raft to be hoisted aboard HMS *Topaze*.[15] Rollers, preferably on a lubricated track, are preferred by others, among them the French architect and archaeologist Jean-Pierre Adam. Van Tilburg has conducted an experiment with a sledge on slides, while the engineer Vince Lee prefers levers. As to the position in which the statues were transported, this may not necessarily have been horizontal. Heyerdahl was told by natives that the statues had wriggled along, suggesting movement in a vertical position on their bases. Experiments carried out with replicas in clay (Pavel Pavel) and concrete (Charles Love) have demonstrated the advantages of this method for long-distance transportation. On the whole, it seems most likely that a variety of methods was used, including transportation by sea where earth causeways permitted access to the water.[16]

By the time the Romans began to transport obelisks, they could take advantage of the use of pulleys, blocks and tackles, capstans and other wooden and iron instruments. After what may be regarded as a test run in which Emperor Augustus had two obelisks transported

from Heliopolis to Alexandria, he went on to successfully transport two obelisks from Heliopolis by sea to Rome and have them erected there. Roman obelisk ships appear to have been three-hulled versions of the Egyptian ones.[17]

Finally there came the problem of the erection of the monumental stone. As we have seen, Routledge favoured the idea of hauling them up a sloping embankment of earth and then dropping them in place. A similar technique involving the use of sand ramps was envisaged by Reginald Engelbach in the 1920s for the erection of the obelisks in Egypt, though alternative techniques involving the use of facing brick ramps and levers have also been put forward.[18] Most of those who have reflected on or experimented with erecting moai or their replicas have agreed on the use of a combination of levers and a ramp of earth and stones along the lines of that suggested by Routledge. Pavel's successful attempts to raise and position the cylindrical head-dress of the moai by means of a sloping beam of wood draw on a similar technique.[19]

When Pope Paul III planned to move an Egyptian obelisk 25.5 m high from its former position south of St Peter's Basilica in Rome to its present location in the middle of the piazza, he realized that any engineer who accepted the commission would have to face the daunting task of lowering, moving and then erecting the obelisk without damage. Michelangelo expressed precisely this doubt when approached. Later popes harboured the same wish, and over the years a number of proposals were put forward. One of these came from Camillo Agrippa, who had been successful with hydraulic engineering. His proposal involved moving the obelisk vertically instead of lowering and raising it, but it failed to convince.[20] However, it was during the papacy of Sixtus V that the architect Domenico Fontana was contracted for the project, which he documented in full after the event in his *Della trasportatione dell' Obelisco Vaticano* of 1590. The dramatic events between the lowering of the obelisk at the end of April 1586, its transportation on a sledge and its successful raising on the new location on 26 September of the same year have often been recounted.[21] The complicated system of capstans and counterweights went far beyond anything that had previously been attempted.

The subsequent transportation and erection of obelisks was progressively facilitated by developments in technology. Advances in

physics, mathematics and engineering on which Jean-Baptiste Apollinaire Lebas based his scheme for the lowering of an obelisk in Luxor and its erection in the Place de la Concorde in Paris in 1836 went beyond the abilities of the sixteenth century. Later in the century, the use of steam engines, steel cable and hydraulic jacks revolutionized the transportation and erection of Cleopatra's Needle in London in 1878. It was towed by sea in a customized cylindrical vessel, surviving a storm that cost the lives of six members of the crew.[22]

Besides the erection of monumental statues, their permanence in an erect position had to be guaranteed as securely as possible. As early as the 1660s, one of the problems discussed at a meeting of the short-lived Florentine Accademia della Vacchia was that of how the weight of the Colossus of Rhodes could have been supported.[23] The sculptor Herbert Maryon, author of an authoritative work on metalwork and enamelling and restorer of the Sutton Hoo treasure in the British Museum, approached the technical problems involved in the construction of the Colossus by Chares of Lindos in a lecture given to the Society of Antiquaries in London in 1953.[24] The process of constructing the Rhodian Colossus is described in detail in a text that probably draws on a Hellenistic source and is attributed to Philo of Byzantium, *De septem orbis miraculis*. Philo describes a process by which the huge statue was modelled and cast in parts *in situ*, rising in stages like the building of a house. Since the need to be able to reach the successively higher stages depended on the construction of a conical earth mound around the statue, it can only have stood on a location large enough to permit the creation of such an earth base, which, Maryon argued, ruled out the possibility of the statue's having been located astride the mouth of the harbour or on a small islet projecting from the harbour. He opted for a location in a district of the city further inland and facing the rising sun (the figure shields its eyes from the sun with its right hand). As the body buckled at the knees during an earthquake, leaving the head and shoulders in touch with the ground, the lower part must have been more strongly reinforced than the rest, as one would expect, with an interior core of stone and iron beams. If a similar technique was employed for the colossal statue of Zeus (about 18 m high) by Lysippus at Tarentum, this might explain why in 209 BC Q. Fabius Maximus left this work where it was because it was too difficult to move, although he did bring

a smaller statue of Heracles from Tarentum to Rome on that occasion, next to which an equestrian statue of himself was erected.[25]

Following the analogy of other Greek bronzes, Maryon further assumed a technique in which thin bronze plates were beaten into shape rather than cast. This view, however, has been contested on philological grounds as the words of Philo – '[the artist] heaped up a huge mound of earth round each section as soon as it was completed, thus burying the finished work under the [accumulated] earth and carrying out the casting of the next part on the level' – seem to indicate that the casting was done *in situ*, a time-consuming process which would have entailed the need to move the furnaces progressively higher with each stage.[26] It has been suggested that the same technique of fused casting *in situ* was also employed by Zenodorus for the Colossus of Nero in Rome and would explain why, 'when it became necessary to move the Colossus during the reign of Hadrian, the statue was not disassembled and transported in parts to its new site but moved in its entirety'.[27]

The Father of Surrealism was Dada, its Mother was an Arcade

The Colossus of Rhodes and nineteenth-century engineering meet in a description of the Thames in the poem 'London' by the French satirical poet Auguste Barbier:

> Arched over by gigantic bridges on colossal piers,
> Like the man of Rhodes,
> Allows thousands of ships to pass.[28]

The application of the epithet 'colossal' to a city can be found in the draft plan of an anthropomorphic form for the city of Paris by the Saint-Simonian Charles Duveyrier during the same period, but there the plan to 'extend the left arm of the colossus along the bank of the Seine' clearly applies to the horizontal dimension while the colossal proper, as we have seen, requires not only monumentality but also verticality – like the massive piers supporting the bridges of London.

Both passages are cited by Walter Benjamin in his *Arcades Project*.[29] Benjamin also notes that the palace for the Paris World's Fair of 1867

on the Champ de Mars was compared by some to Rome's Colosseum.[30] What had changed, however, was the new possibility of constructing a vast edifice from a combination of an almost infinite number of minute and identical parts:

> Never before was the criterion of the 'minimal' so important. And that includes the minimal element of quantity: the 'little', the 'few'. These are dimensions that were well established in technological and architectural constructions long before literature made bold to adapt them. Fundamentally, it is a question of the earliest manifestation of the principle of montage.[31]

He went on to illustrate this with the example of the Eiffel Tower, erected for the World's Fair of 1889. The citation is from Adolf Meyer's book on iron construction:

> The number of figures that were written to calculate the Eiffel Tower amounts to hundreds of thousands; around 700 constructional and 3,000 working drawings were prepared for it. Thus the plastic shaping power abdicates here in favour of a tremendous span of spiritual energy, which channels the inorganic material energy into the smallest, most efficient forms and conjoins these forms in the most effective manner . . . Each of the twelve thousand metal fittings, each of the two and a half million rivets, is machined to the millimetre . . . On this work site, one hears no chisel-blow liberating form from stone; here thought reigns over muscle power, which it transmits via cranes and secure scaffolding.[32]

In the passages from Meyer omitted by Benjamin, Meyer makes explicit reference to the pyramids of Egypt, and concludes the section with the words: 'Many hundreds of years separate the Tower from the climax of the Gothic, many thousands from the pyramid of Cheops.' This comparison with Egypt brings out more closely exactly what the new technology has revolutionized: the montage of minimal elements is fundamentally different from the carving of a monolithic block, or even of the block-by-block assembly of a colossus.

The new products enabled by the new technology nevertheless fell back on familiar forms. Already in the mid-1830s the first iron furniture began to appear 'in the form of bedsteads, chairs, small tables, *jardinières*; and it is highly characteristic of the epoch that this furniture was preferred because it could be made to imitate perfectly any type of wood'.[33] The process was not confined to iron:

> Every tradesman imitates the materials and methods of others, and thinks he has accomplished a miracle of taste when he brings out porcelain cups resembling the work of a cooper, glasses resembling porcelains, gold jewelry like leather thongs, iron tables with the look of rattan, and so on. Into this arena rushes the confectioner as well – quite forgetting his proper domain, and the touchstone of his taste – aspiring to be a sculptor and architect.[34]

Thus Jacob Falke on the history of modern taste as cited by Benjamin. The latter, however, goes on to draw far-reaching conclusions:

> This perplexity derived in part from the superabundance of technical processes and new materials that had suddenly become available. The effort to assimilate them more thoroughly led to mistakes and failures. On the other hand, these vain attempts are the most authentic proof that *technological production, at the beginning, was in the grip of dreams*. (Not architecture alone but all technology is, at certain stages, evidence of a *collective dream*.)[35]

This correlation of production based on the technological progress of the nineteenth century with the dream is summed up in Benjamin's famous aphorism: 'The father of Surrealism was Dada; its mother was an arcade.'[36] Indeed, he considered that the critique of the nineteenth century should begin not with its mechanism and cult of machinery but with its 'narcotic historicism, its passion for masks, in which nevertheless lurks a signal of true historical existence, one which the Surrealists were the first to pick up'.[37]

The allegiance of the Surrealists to the arcades, established as these *passages couverts* were on the twin revolution brought about by glass

and iron architecture, is neatly condensed in the fact that 'at the end of 1919 Aragon and Breton, out of antipathy to Montparnasse and Montmartre, transferred the site of their meetings with friends to a café in the Passage de l'Opéra.'[38] At the same time, perhaps as a pendant to this fascination with technological progress, the Surrealists took a lively interest in what was becoming known as 'primitive art' at the time, especially masks, caught up as they were in the effervescence that was a part of the changes sweeping through anthropology and ethnography in the French capital in the 1920s. Among them in these years, before his break with the movement in April 1930, was Alberto Giacometti.

The Cube: A Colossal Undertaking

Some of Giacometti's works hark back to the concerns of the previous chapters. For instance, there is a striking resemblance in technique between his extremely unusual *Head of the Artist's Father II* of 1927, a life-size bronze head in which the features of Giovanni Giacometti have been incised directly onto a flat surface,[39] and an Olmec head in Carlos Pellicer's Parque-Museo La Venta in Villahermosa. As mentioned in chapter Four, knowledge of Olmec culture reached the Surrealists with the publication of the results of the early excavations in the 1920s, but I have been unable to trace any evidence indicating that Alberto Giacometti saw, or could have seen, a photograph of that particular Olmec head. In an interview (though dating many years later) with Jean-Marie Drôt, Giacometti mentioned 'great flat heads', but in relation to African or Oceanian sculpture, not to anything from the Americas.[40] And in an interview with David Sylvester recorded in 1964, when he associated flatness in sculpture with direct perception, it was with a reference to Cycladic sculpture:

> If I didn't know that your skull had a certain depth, I wouldn't be able to guess it. So, if I made a sculpture of you according to my absolute perception of you, I would make a rather flat, scarcely modulated sculpture that would be much closer to a Cycladic sculpture, which has a stylised look, than to a sculpture by Rodin or Houdon, which has a realistic look.[41]

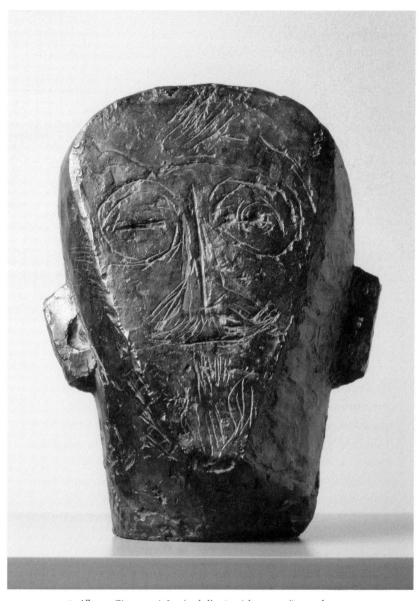

81 Alberto Giacometti, *Le père de l'artiste (plat et gravé)*, 1927, bronze.

82 Olmec incised stone, Parque-Museo La Venta, Villahermosa, Mexico.

On the other hand, there is evidence of his having been influenced by objects from the ancient cultures of the Americas. His *Cubist Head* from 1934, for instance, has been described as 'a sibling of those Mexican skulls cruelly carved out of crystal, a specimen of which was exhibited in the Trocadéro museum'.[42] It should not be forgotten that Georges-Henri Rivière, a former jazz pianist who approached Bataille to set up the review *Documents*, collaborated with the anthropologist Alfred Métraux to stage the first major exhibition of more than 1,000 objects of pre-Columbian art in the Musée des Arts Décoratifs, housed in the Louvre, in 1928, and many of those objects were lent by collectors who were themselves Surrealists.[43] Giacometti belonged to the same avant-garde circle; we know that he kept the complete publication of Bataille's *Documents* throughout his life.[44]

The (fortuitous?) parallel with an Olmec head illustrates the difficulties of trying to relate Giacometti's works from his Surrealist period to specific non-European objects. There is hard evidence for such borrowing in the case of the sketches of Easter Island objects mentioned in the

previous chapter, which were copied from a special issue of *Cahiers d'Art* from 1929, and for some of his copies from archaic Egyptian and Etruscan art.[45] In the case of his *Disagreeable Object* (1931), however, which has been brought into connection with a wooden sculpture from Easter Island representing a fish, such evidence is lacking.[46] Moreover, unlike the *Disagreeable Object*, the fish sculpture is neither phallic nor spiked, so the parallel is hardly compelling anyway, and its whereabouts are unknown. For Sylvester its shape 'was almost certainly derived from an Easter Island bird figure', but he is closer to the mark when he continues, 'but what it really looks like is a piece of equipment bought at a sex shop'.[47]

These and other varied and contradictory suggestions in the literature on the ethnographically exact source for this and other works by Giacometti and his contemporaries show that a number of criteria have to be satisfied if the argument is to be convincing. Solid documentation is required demonstrating that such sources were on show to the public at the time, either in exhibitions or in the pages of publications. But it is also necessary to be able to demonstrate that the artists in question actually did take cognisance of them. All the same, this should not be allowed to become a 'philology' of Giacometti.[48] He was fully capable of transforming material from one or more non-European sources into something quite different, a process that William Rubin has called 'creative misreading'.[49] Indeed, his sculptures from this period may have many interconnected references and cannot be pinned down to a single source of inspiration.[50] In other words, they are overdetermined. Moreover, in his later texts he often returned to earlier works and experiences and recast them in the light of his later development, resulting in a chronology that proves to be fickle and highly elusive.[51]

This is the context in which to situate an enigmatic work by Giacometti that is most pertinent to the concerns of this book because it has been characterized as colossal by several commentators: *The Cube*. Georges Didi-Huberman, who has written the most detailed study of the work to date, evokes a number of interconnected references:

> Larger than a face, smaller than a body, *The Cube* presents itself to us in the very dimension of the place to gather both the lack of faces and the 'here lies' of bodies: it is precisely

83 Alberto Giacometti, *Le Cube*, 1934, bronze.

the dimension of tombstones, and sometimes of megaliths or funerary *colossoi*.[52]

He even goes so far as to compare it with the stelae of old Jewish cemeteries, certain worn megaliths and '*the large heads of Easter Island*'.[53] In an earlier study,[54] the same author made much of the numerological implications of the thirteen facets of the object, but it is doubtful whether Giacometti adhered to any such system. Moreover, it is by no means easy to establish exactly how many facets *The Cube* has.[55] In his monograph, Didi-Huberman describes the object more accurately as lacking in geometric exactitude, for although the black-and-white photograph of *The Cube* in plaster on a small pedestal that appeared in the Surrealist review *Minotaure* in 1934 emphasizes the apparently smooth surfaces and clean-cut edges of the polyhedron, other photographs from the same year show this to be far from the case: the surfaces are rough and incised, the edges have no clear-cut dividing line.[56] Unlike *Cubist Head*, there is nothing Cubist about *The Cube*; there is no parallel to the convex monolith of *The Cube* in the essentially frontal treatment of different elements by the Cubists.[57] Nor can *The Cube* be regarded as a Surrealist sculpture; unlike many of the works that characterize Giacometti's Surrealist period, which are striking for their horizontality, *The Cube* is unambiguously – and anthropomorphically – vertical.[58]

It is an odd man out in other ways too. The date is uncertain – from towards the end of 1933 or from the following year. Of the two plasters that Giacometti made of *The Cube*, one is in a private collection and the other is in the Centre Pompidou in Paris.[59] The work also exists in two bronzes, cast between 1954 and 1962 by the Susse foundry in Paris. One of these is in the Fondation Maeght in Saint-Paul de Vence, one of the 37 plaster sculptures in Giacometti's studio that Aimé Maeght commissioned to be cast in bronze in 1948.[60] The other is in the Kunsthaus in Zurich.[61] The number two is unusual, for Giacometti usually had his bronzes cast in editions of six.[62] And since the two plaster versions differ from one another, we are actually dealing with unique versions in bronze of each of them. The status of the work is further obscured by the fact that when first exhibited on a small pedestal at the exhibition 'Thèse – Antithèse – Synthèse' in Lucerne in 1935, it was entitled *Part of a Sculpture*.[63] We do not know whether this was the name that the

sculptor himself gave to the work or not. It suggests some inadequacy in the work, but if he had not felt that he had finished with it and that it would have been pointless to go on any further, he would not have allowed it to go to the foundry for casting:

> When he stops working on a sculpture and lets it go to the foundry, this is not because he believes that at long last he has brought the work to completion, but because he feels that at this stage it would be pointless to go on: he knows that if he were to go on in search of finality, he would never finish anything.[64]

Yet the title *Part of a Sculpture* suggests an incompleteness, a yearning for a wholeness that remains elusive. Giacometti's friend Samuel Beckett also reduced prose texts to small fragments, abandoned them and then went on to publish these 'unabandoned' pieces as finished works, such as *Imagination Dead Imagine*, which was conceived as a novel and published as such in spite of its mere 1,500 words.[65] The two artists and friends had much in common.

Clearly, the unusual features of this work within the artist's oeuvre indicate that it meant something special to Giacometti. What that something special is can be discovered from a reading of one of Giacometti's first published texts, 'Yesterday, Quicksand', written for *Le Surréalisme au Service de la Révolution* and which exudes the same yearning for wholeness.[66] It opens as follows:

> As a child (between the ages of four and seven), the only things I saw in the outside world were those that might give me pleasure. They were above all stones and trees, and seldom more than one object at a time. I remember that for at least two summers I saw nothing of my surroundings but a large stone about 800 metres from the village, this stone and the objects directly related to it. It was a monolith of a golden colour, opening at the base onto a cavern: the whole of the bottom part was hollow, the water had effected this. The entrance was low and long, just about the height we were at the time. In places the interior was hollowed out even more so that there seemed

to be a second small cavern at the back. It was my father who, one day, showed us this monolith. A tremendous discovery: from the outset I considered this stone as a friend, a being filled with the best intentions towards us; calling us, smiling at us, like someone previously known and loved, and met again with infinite surprise and joy.

Bonnefoy opens his magisterial biography of Giacometti with a chapter entitled 'The Black Stone', in which he analyses the text in terms of a fixation on Annetta, the artist's mother: 'fulfilment, as this child understood it, meant living in a space defined and circumscribed by his mother.'[67] However, a detail in the text is symptomatic: the casual syntax of the words 'one day' in the phrase 'It was my father who, one day, showed us this monolith' implies a casualness that deflects from the significance of the bond between the stone and his father, the painter Giovanni Giacometti. Giovanni died in June 1933. Alberto was too stricken to attend the funeral.[68] And in the very year in which *The Cube* was conceived, 1934, Alberto carved a memorial for his father's tomb from local granite.[69]

Before examining the implications of this bond between the work and the death of Alberto's father in more detail, there is yet another determinant factor to take into account: the tension between figuration and abstraction. In an interview with James Lord from the 1960s, Giacometti replied to the question 'Have you ever made a really abstract sculpture?' with the words:

Never, with the exception of the large *Cube* that I made in 1934, and I would still consider it to be really a head. So I have never made anything really abstract.[70]

Often Giacometti's replies to his interlocutors were attempts to side-step the question or to lead it in a different direction rather than direct responses. The same is true when he claims to have been inspired by the showing of Dürer's engraving *Melencolia I* – one of the German artist's so-called 'Master Engravings' – in an exhibition of works by Dürer and Rembrandt in Paris in 1933.[71] Yet the recurrence of the same polyhedron, sometimes in transparent form (which is literally blocked out

84 Albrecht Dürer, *Melencolia I*, 1514, copperplate engraving.

in *The Cube*), in some of Giacometti's drawings from the immediately preceding years – *The Palace at 4 a.m.* (1932) and *My Studio* (1932) – must be a sign that he was already familiar with the Dürer engraving at an earlier date. Already as a young teenager he was making copies of Albrecht Dürer's *Knight, Death and the Devil* and *Self-Portrait* (perhaps their shared first name prompted the choice of the latter) and would have had no difficulty in gaining access to publications of the famous German artist's engravings before 1933, either in his father's library or elsewhere.[72] It is possible, nevertheless, that a viewing of it in the exhibition reinforced

his notion of a formidably solid object rather than a transparent one – in short, a monolithic block of stone.

Bonnefoy writes: 'There is no skull in Dürer's *Melancholia*, although one might have been expected . . . but this great thing, blind as a stone, closed as a tomb . . . is surely the nearest thing to a death's head, to a skull.'[73] However, as Didi-Huberman was the first to point out, one facet of the stone in Dürer's engraving is in fact marked by the faint features of a face, like a phantom,[74] recalling the features of Giovanni incised on the flat surface of *Head of the Artist's Father II*. Although the Dürer and Rembrandt exhibition was held from the spring to the late summer of 1933 – that is, before Giovanni Giacometti's death on 25 June – the 65-year-old artist had been complaining of fatigue for some time and was sent to a sanatorium to rest. The despondent mood of the seated winged figure in the Dürer engraving – Benjamin connected the block of stone with *acedia* or dullness of heart[75] – will have been in tune with Giacometti's own feelings at this date, and he may have felt that in looking at the phantom face he was seeing the ghost of his father. In fact, it has been suggested that the mood of Dürer's engraving reflects the death of his mother in 1514;[76] whether this is the case or not, it points to a path that Alberto would have had no difficulty in following. At a more general level, Dürer's strategy of deploying the engraving as a way to self-reflection would have been dear to Giacometti's heart.[77]

Neither entirely figurative nor abstract, *The Cube* might be said to serve as a double of Giovanni Giacometti. As we have seen, it was unusual for a single bronze to be cast from each of the *two* plasters. It seems as though the theme of duplication, of functioning as a double, marked the genesis of the work right from its inception.[78]

It should be clear by now that we are entering the domain of the Greek *kolossos*. Didi-Huberman makes the comparison explicit: 'It stands at present before us, between shade and light, like the double or colossos of some absent person' and refers to Vernant's seminal work on the Greek conception of the *kolossos*.[79] It is as aniconic as a *kolossos*; it is vertical; it is rigorously asexual;[80] and it is anthropomorphic while standing for an absent body.

The play of presence and absence, and the play of nearness and farness, of here and elsewhere, form a set of related and contrasting pairs in Giacometti's practice. In an earlier drawing of a transparent rhomboid,

he had included a small figure within the geometrical shape, but the presence of such figurative content is obliterated by the absence that characterizes the convex block. The renunciation of the former idea, Bonnefoy notes, 'clearly brings out Giacometti's interest, in 1932 and 1933, in anything that might signify presence or absence'.[81] The title *Part of a Sculpture*, if it was the artist's own, could also be taken to refer to the presence of the monolithic block that nevertheless connotes the absence of something else of which it is a part. And his frequent recourse to the statement that 'the more I take away, the bigger it gets' can also be taken to mean that the greater the reduction and compression, the greater the presence.[82]

For Giacometti, measurable proportions were not the same thing as right proportions. On a visit to Padua at the age of twenty, after having emerged from seeing Giotto's frescoes in the Scrovegni Chapel, he records his sensations of observing (and doubtless following) two or three girls who were walking a few steps ahead of him:

> They seemed immense to me, beyond all notion of measure, and their whole being and their movements were charged with a terrifying violence. I gazed at them in a state of hallucination, overcome by a sensation of terror. It was like a rip in reality. The whole meaning and relation of things had changed. At the same time the Tintorettos and the Giottos became small and weak, limp and lacking in substance, like a naïve, timid and awkward stammer.[83]

'Beyond all notion of measure' recalls the difficulty of establishing the dimensions of *The Cube*, or even of describing it, as well as the difficulties encountered by Kant and Goethe in trying to grasp the colossal that were discussed in chapter One. Giacometti returned to the theme in some notes that he made around 1960:

> Heads, persons are nothing but the continual movement of the inside, the outside, they are incessantly remaking themselves, they do not have a true substantiality, their transparent side. They are neither cube, nor cylinder, nor sphere, nor triangle. They are a mass in motion, a changing form that can never

be completely grasped. And then it is as though they are held together by an inner point that observes us through the eyes and which seems to be their reality, *a reality without measure*, in a space without limits and which seems to be other than that in which the cup stands before me or which is created by this cup.[84]

Closer in time to *The Cube*, however, is a text published in *Minotaure* at the end of 1933 in which it is once again proximity and distance that are the main articulating elements:

> I can only speak indirectly of my sculptures and hope to say only in part what motivated them. For years I have only made sculptures that came to my mind completely formed, I limited myself to reproducing them in space without changing anything, without asking myself what they might signify . . . Once the object has been made, I tend to discover displaced and transformed images, impressions, facts in it that have profoundly moved me (often without my knowing), forms that I feel to be very close to me, although I am often incapable of identifying them, which makes them all the more disturbing to me.[85]

In interpreting this work of condensation and displacement, the artist finds himself confronted by the constant return of an inadequately repressed experience, by a disturbing proximity, and with it the presence of the aura, 'at once too far and too near, too small and too big'.[86] This takes us back to Walter Benjamin's linking of distance with unapproachability and his definition of the aura as a 'unique phenomenon of a distance however close it may be' that were discussed at the end of chapter Four.[87] Giacometti's dead father had been literally unapproachable for him, though close enough to be in the next room. When Alberto's younger brother Bruno wanted to consult him about the funeral arrangements, he found Alberto lying rigidly outstretched under the bedclothes.[88] If his dead father's body had a double at that moment, it was his prostrate elder son. It is no wonder that Alberto found *The Cube* disturbing.

As we have seen, the many layers of overdetermination that surround *The Cube* do not make it an easy work to place or to interpret.

The subject of the following passage is Dürer's *Melencolia I*, but it could have been written about *The Cube*:

> Instead of mediating *a* meaning, *Melencolia* seems designed to generate multiple and contradictory readings, to clue its viewers to an endless exegetical labor until, exhausted in the end, they discover their own portrait in Dürer's sleepless, inactive personification of melancholy.[89]

Giacometti must also have seen his own portrait in that sleepless, inactive personification. He never made things easy, either for himself or for us. In the end, the endless exegetical labour to which *The Cube* obliges us is no more strenuous than the endless labour that Giacometti put into its continual remaking – in words, in plaster, in bronze. It was a colossal undertaking.

Epilogue

Between 1975 and 1978, the courses given by Jean-Pierre Vernant at the Collège de France focused on the figure of the dead among the Greeks, and in particular on the category of the double.[1] This naturally led him back to reconsider the nature and function of the *kolossos* among the Greeks, to which he had devoted a seminal article a few years earlier.[2] Within the perspective of these lectures, the broader ambition was to consider the transition from the double that stands in for the dead person to the likeness that seeks to represent that person: the portrait. Always true to his structuralist method, Vernant operates within a number of oppositions, such as that between the *kolossos* and the *psychē*: exiled in the world of the dead, the *psychē* appears in dreams as a perfect likeness of the dead person, but it lacks corporeality; the *kolossos*, on the other hand, is aniconic, which is to say it does not bear a likeness to the dead person, but in its coldness, fixity, immobility, opacity and solidity it is profoundly substantial. In fact, the very reality of the *kolossos* seems to exclude any form of similarity; it has to demonstrate its distance from the form of the living person.

However, in the course of the sixth century BC, Vernant argued, this aniconic, present memorial of the absence of the dead person gradually gave way to the use of the *kouros*, a statue of a youth, as a funerary monument. Though considerably more 'lifelike' than the archaic *kolossos*, the *kouros* was still too idealized to be considered the portrait of an individual, nor was that the intention; without resembling the external aspect of the dead person, it represented him by sharing the same aristocratic values and status.

It would be wrong to see this process as a smooth passage from aniconic to iconic, for cults continued to be addressed to planks, pillars

and stones side by side with the worship of more 'lifelike' representations of the gods. As Deborah Steiner points out, 'the Greeks continued to develop new aniconic forms through the classical period and beyond'; the animated stones (aeroliths) credited with supernatural powers of prophecy that were known as *baituloi* are first documented in sources from the Hellenistic period.[3]

The *kolossos* was aniconic; the only distinctive marking was, for ritual purposes, an indication of its gender. It was a substitute for or equivalent to a person, but not a portrait of that person. Still, it would be natural to suppose that there were cases that were situated somewhere between these two categories. Herodotus, for instance, records that, if a Spartan king died in battle, a statue (*eidolon*) of him was made, placed upon a litter and carried to the grave at Sparta.[4] This was not, Vernant stresses, a portrait or an effigy. It was a double, an equivalent made in order to comply with the religious necessity to bury the corpse of the king in Sparta. All the same, it can hardly have been completely aniconic. So here we seem to be confronted with a transitional case in terms of the spectrum extending from double to likeness.

These considerations evidently bear on all the instances of the colossal discussed in the present book: to what extent are they iconic or not, do they present us with likenesses, what can we say about their presence? It is this that makes them highly relevant, in spite of appearances given their remoteness in time or place, to a debate that lies at the heart of art history as such. To take an example, in his *Bild und Kult*, translated as *Likeness and Presence*, Hans Belting offers what he calls 'a history of the image before the era of art'.[5] Despite the richness of his text, the dichotomy in which he operates is an over-simplistic one: to relegate the period before the Renaissance to 'the era of the image' and that from the Reformation and Renaissance on to 'the era of art' implies a very narrow, post-Vasarian conception of art and art history, as well as failing to draw the finer distinctions within the history of the image that Vernant and others have discussed.[6] In a discussion of Greek victory statues from the sixth and fifth centuries BC, Steiner notes that the act of 'presentification' that many of those images seem to perform does not exclude, as the inscriptions make clear, their possession of a second dimension: 'their character as material and aesthetic objects, the products of the craftsman's shaping hand and a source of pleasurable viewing for

mortal and divine audiences'.[7] Nor does Belting's attempt to introduce
the devotional image to mark a transition between the era of the image
and the era of art resolve the problem for, as Felipe Pereda has acutely
pointed out, it is applicable neither to the Iberian peninsula nor to the
world of Latin America, where examples can be cited that combine the
cultic image with the devotional image.[8]

Sharing the same Vasarian framework as Belting, Carlo Ginzburg
writes triumphantly: 'Without this disenchantment of the world of
images we would have had neither Arnolfo di Cambio nor Nicola
Pisano nor Giotto.' He locates the birth of the idea of the image as
representation in the modern sense precisely here, after the proclam-
ation of the doctrine of transubstantiation in 1205.[9] We find a much
more nuanced view in an essay from 1905 by the philosopher Heinrich
Gomperz, who used the same term 'transubstantiation' to refer to
the process by which 'an image is translated from the conception of
an iconoclast into that of a worshipper, or generally when an object
is turned into a symbol'.[10] The reverse process, which 'changes that
which is represented into nothing more than a mere imaging', he called
'negative transubstantiation' or *Entbildung*. The latter, which Gomperz
regarded as a grand historical process but refused to particularize at any
specific time, negates the cult function of the image as it moves towards
increasing similitude, for, as Ernst Kris and Otto Kurz were later to
argue, there was an inverse relation between the magical or perform-
ative function of an image and its verisimilitude.[11] This development,
however, could never reach a final resolution, for a total similarity
between the subject and the object of the representation would be as
inconceivable as its opposite – an image identical to its model no longer
counts as an image at all.[12] Gomperz's approach is thus more dialec-
tical, for besides negating the cult function of the image, the process
of *Entbildung* also undercuts the performing arts as well as the visual
arts, it confounds the instinct for games, destroys the system of law,
annihilates the use of the sacraments as well as negating the forms
of social life. Hence what to some might be called a process of the
enlightenment of human nature could equally well be seen as its
impoverishment.

Gomperz was a friend of the art historian Julius von Schlosser, whose
history of the wax portrait was first published more than a century

ago.[13] Explicitly referring to Gomperz's thesis, Schlosser emphasized that the process in question should be understood as a psychological, not a historical one.[14] Both of these thinkers of the Vienna School thus invite us to (re)consider the relations between double, image and likeness without preconceptions about so-called historical eras or attempts to periodize different 'problematics'.

Another lesson that can be learned from Schlosser's intervention in the debate is the need to devote attention to areas and genres commonly ignored by art historians. It might seem at first sight that the colossal heads of the Olmecs, or the moai of Easter Island, offer a most un-promising point of entry to discussion of issues that are central to the concerns of the art historian. Still, the very fact that they influenced certain Western artists, as demonstrated earlier, might already be said to secure them a place within the bounds of even a conventional history of Western art. Moreover, the researches of Aby Warburg on such non-Renaissance themes as the snake rituals of the Pueblo people suffice to show that entry through the 'back door', as it were, can sometimes offer insights that would not be gained in other ways.[15] To put it differently, the so-called marginal is by no means always of marginal importance.[16]

Works in wax were passed over in the Vasarian account, concerned as he was to create an aetiology of Renaissance art that was specific, pictorial, artistic and secular. Unaccountably, therefore, he passed in silence over the phenomenon of the Florentine funeral masks to which Warburg was one of the first to draw serious attention.[17] This is remark-able given the fact that, as Schlosser was well aware, the painting of the death mask of Charles VII, who died and was buried in Saint-Denis in 1460, was entrusted to no less an artist than Jean Foucquet. This is an indication of the high level of artistic quality that was expected of such casts.

If this emphasis or focus on what traditional art history has repressed leads to a resurgence of that material that has been relegated to the margins as non-European, exotic or, in contemporary parlance, 'world' (a strange designation that excludes a significant part of the world as we know it), might not study of the moai, the Olmec heads, the obelisks of Egypt and Rome, the Rhodian colossus, the Colosseum and the rest represent a return of the repressed, of a notion of the colossal beyond measure, of the aniconic *kolossos*? If so, we are a long way from the

evolutionary character of the Vasarian project and closer to a syn-chronicity in which the 'archaic' can be just as contemporary as the 'contemporary' – in which the Aischylean *kolossos* can be just as con-temporary as the Giacomettian *Cube*. This puts us closer to Wittgenstein than to the evolutionists James Frazer or Edward Tylor, for, as Stanley Tambiah has argued:

> whereas Tylor and Frazer, fully conscious of being 'civilized', attempted to 'regress' to the primitive's condition, Wittgenstein is claiming that 'civilized' man has within him the same symbolizing and ritualizing tendencies as the 'primitive'. This is synchronic and not an evolutionary posture.[18]

Neither is it so far removed from the notion of origin as a contemporary of Wittgenstein, Walter Benjamin, understood it:

> The term origin is not intended to describe the process by which the existent came into being, but rather to describe that which emerges from the process of becoming and disap-pearance. Origin is an eddy in the stream of becoming, and in its current it swallows the material involved in the process of genesis. That which is original is never revealed in the naked and manifest existence of the factual; its rhythm is apparent only to a dual insight. On the one hand it needs to be recog-nized as a process of restoration and re-establishment, but, on the other hand, and precisely because of this, as something imperfect and incomplete.[19]

A process of restoration and re-establishment, yet imperfect and incomplete: proleptically, as it were, Benjamin's words fit the present contribution like a glove.

REFERENCES

Introduction: Inventions of the Colossal

1 M. B. Mena Marqués, 'El joven viajero', in *Goya en tiempos de guerra*, ed. M. B. Mena Marqués, exh. cat., Museo del Prado (Madrid, 2008), pp. 17–29. Her arguments immediately provoked fierce criticism from N. Glendinning and others, mainly in the pages of the Spanish review *Goya*.

2 Ibid., cat. no. 32; cf. J. Vega, 'La técnica artística como método de conocimiento, a propósito de *El Coloso* de Goya', *Goya*, 324 (2008), pp. 229–44.

3 The most extreme transposition of the Belvedere torso to a tortured and mutilated body impaled on a tree can be found in Goya's *The Disasters of War*, 37: *This Is Worse*, on which see V. I. Stoichita and A. M. Coderch, *Goya: The Last Carnival* (London, 1999), p. 95.

4 N. Glendinning, 'Goya and Arriaza's *Profecia del Pirineo*', *Journal of the Warburg and Courtauld Institutes*, XXVI / 3–4 (1963), pp. 363–6; J. Tomlinson, *Francisco Goya y Lucientes, 1746–1828* (London, 1994), p. 205.

5 Though it is labelled as 'The colossus' in A. E. Pérez Sánchez and J. Gállego, *Goya: The Complete Etchings and Lithographs* (Munich and New York, 1995), p. 210.

6 Glendinning, 'Goya and Arriaza', p. 363 n. 2.

7 Cited in W. Benjamin, *The Arcades Project*, trans. H. Eiland and K. McLaughlin (Cambridge, MA, and London, 1999), p. 398.

8 G. Dixon, 'The Origins of the Roman "Colossal Baroque"', *Proceedings of the Royal Musical Association*, 106 (1979–80), pp. 115–28.

9 This is not the first time that I lean on insights provided by Austin for their possible application beyond words to the field of the visual; see P. Mason, *Infelicities: Representations of the Exotic* (Baltimore and London, 1998).

10 J. L. Austin, *Philosophical Papers*, ed. J. O. Urmson and G. H. Warnock, 3rd edn (Oxford, 1979), pp. 186–7, and more generally his *How to Do Things with Words* (Oxford, 1962).

11 *Agamemnon*, ll. 416–19. Of the many different interpretations of these lines, the one offered here is closest to that of D. Steiner, 'Eyeless in Argos: A Reading of *Agamemnon* 416–19', *Journal of Hellenic Studies*, 115 (1995), pp. 175–82. In a later discussion of the lines in her *Images in Mind: Statues in Archaic and Classical Greek Literature and Thought*, 2nd edn (Princeton, NJ, 2003), p. 49, Steiner suggests that Menelaus sees the *kolossoi as* Helen, but that goes beyond the evidence of the text.

12 J.-P. Vernant, 'La Catégorie psychologique du double: Figuration de l'invisible et catégorie psychologique du double: Le Colossos', in his *Mythe et pensée chez les Grecs* (Paris, 1971), vol. II, pp. 65–78, here 76.

13 Alberto Giacometti in interview with Pierre Schneider in A. Giacometti, *Écrits* (Paris, 1990), p. 266.

14 The use of gigantic paintings of St Christopher in church interiors, extending in some cases from the floor to the ceiling, had a similar symbolic function: to support the edifice and prevent its collapse.

15 J. Rykwert, *The Dancing Column: On Order in Architecture* (Cambridge, MA, 1996), p. 19.

16 J. Ducat, 'Fonctions de la statue dans la Grèce archaïque: Kouros et kolossos', *Bulletin de Correspondance Hellénique*, C/I (1976), pp. 239–51.

17 Lutyens was aware of the Greek precedents for his technique in the entasis of the columns of the Parthenon; see C. Moriarty, 'The Cenotaph', in *Modern British Sculpture*, ed. P. Curtis and K. Wilson, exh. cat., Royal Academy of Arts (London, 2011), pp. 46–51, and Rykwert, *The Dancing Column*, p. 229.

18 B. Braun, *Pre-Columbian Art and the Post-Columbian World: Ancient American Sources of Modern Art* (New York, 1993), pp. 93–136.

19 A. Hartog, 'The Centre of Modern Sculpture: Some Thoughts on Hepworth and Moore', in *Modern British Sculpture*, ed. Curtis and Wilson, pp. 152–9.

20 W. Benjamin, *Illuminations: Essays and Reflections*, trans. H. Zohn, ed. H. Arendt (New York, 1968), p. 261.

21 Benjamin, *The Arcades Project*, p. 391.

22 J. Clifford and G. E. Marcus, eds, *Writing Culture: The Poetics and Politics of Ethnography* (Berkeley and Los Angeles, 1986); I. Karp and S. D. Lavine, eds, *Exhibiting Cultures: The Poetics and Politics of Museum Display* (Washington, DC, 1991). See also I. Karp, C. M. Kreamer and S. D. Lavine, eds, *Museums and Communities: The Politics of Public Culture* (Washington, DC, 1992), Mason, *Infelicities*, pp. 131–46, and C. Braae, M. Harbsmeier and I. Sjørslev, eds, 'Exhibiting Objects: Museum Collections in Policy and Practice', special issue of *Folk: Journal of the Danish Ethnographic Society*, 43 (2001).

23 J. Clifford, 'Four Northwest Coast Museums: Travel Reflections', in *Exhibiting Cultures*, ed. Karp and Lavine, reprinted in his *Routes: Travel and Translation in the Late Twentieth Century* (Cambridge, MA, 1997); M. Bal, 'Telling, Showing, Showing Off', in her *Double Exposures: The Subject of Cultural Analysis* (London and New York, 1996). P. Mason, 'Un paseo por el patio de recuerdos del Museo Azul de las Islas de Chiloé', in *Un Almuerzo Desnudo: Ensayos en cultura material, representación y experiencia poética*, ed. F. Gallardo and D. Quiroz (Santiago, 2008), pp. 81–91, offers a modest antidote from the South to these approaches.

24 Vernant, 'La Catégorie psychologique du double', p. 70.

1 Locating the Colossal

1 G. de Callatÿ, 'The Colossus of Rhodes: Ancient Texts and Modern Representations', in *History of Scholarship: A Selection of Papers from the Seminar on the History of Scholarship held Annually at the Warburg Institute*, ed.

C. R. Ligota and J.-L. Quantin (Oxford, 2006), pp. 39–74.

2 D. Steiner, *Images in Mind: Statues in Archaic and Classical Greek Literature and Thought*, 2nd edn (Princeton, NJ, 2003), pp. 98–100.

3 *André Thevet: Cosmographie de Levant*, ed. F. Lestringant (Geneva, 1985), pp. 104ff.

4 A similar figure, which Thevet claims was given him by the Greeks together with the image of the island, appears in a bird's-eye view of Rhodes by Jean Cousin in Thevet's *Cosmographie Universelle* (Paris, 1575) vol. I, f. 205 recto. On Thevet's habit of creating unverifiable false provenances for his images, see E. Dwyer, 'André Thevet and Fulvio Orsini: The Beginnings of the Modern Tradition of Classical Portrait Iconography in France', *Art Bulletin*, LXXV/3 (1993), pp. 467–80.

5 H. Maryon, 'The Colossus of Rhodes', *Journal of Hellenic Studies*, 76 (1956), pp. 68–86, here 79.

6 Pliny the Elder, *Historia naturalis*, XXXIV, 18.

7 I. M. Veldman, *Leerrijke reeksen van Maarten van Heemskerck*, exh. cat., Frans Hals Museum, Haarlem (The Hague, 1986), pp. 94ff. Designed in 1570, they were engraved by Philips Galle two years later.

8 V. Cartari, *Imagini delli dei de gl'antichi* (Venice, 1647), p. 39. The first edition was published in Venice in 1556; the Rhodian colossus appears with the same attributes in Gottfried Eichler's personification of Asia, presumably because the port of Rhodes formed a gateway to Asia; see C. da Ripa, *Baroque and Rococo Pictorial Imagery: The 1758–60 Hertel Edition of Ripa's 'Iconologia' with 200 Engraved Illustrations*, introduction, translation and 200 commentaries by E. A. Maser (New York, 1971), no. 103.

9 *Fiamminghi a Roma, 1508–1608: Artistes des Pays-Bas et de la principauté de Liège à Rome à la Renaissance*, exh. cat., Palais des Beaux-Arts, Brussels, and Palazzo delle Esposizioni, Rome (Ghent, 1995), cat. no. 111.

10 Thevet, *Cosmographie de Levant*, p. 109 gives the figure of 900 camels. Sebastian Münster hesitates between 900 and 90 in his *Cosmographei* (Basel, 1550), p. 1093. Münster's further description of the colossus is an aside in his account of the Turkish attack on the island, ibid., p. 1070.

11 L. I. Conrad, 'The Arabs and the Colossus', *Journal of the Royal Asiatic Society*, 3rd ser., V/2 (1996), pp. 165–87. Conrad relates the creation of the Arab legend to 'patterns of cultural perception that were characteristic of the scholarly Monophysite circles of Edessa and the Syro-Mesopotamian north in the seventh and eight centuries', ibid., p. 181.

12 Francesco Colonna, *Hypnerotomachia Poliphili: The Strife of Love in a Dream*, trans. J. Godwin (New York, 1999), pp. 35–6.

13 *Phlegon of Tralles' Book of Marvels*, trans. with introduction and commentary by W. Hansen (Exeter, 1996), pp. 43–4.

14 L. Ungaro, ed., *Il Museo dei Fori Imperiali nei Mercati di Traiano* (Milan, 2007), p. 147.

15 Pliny the Elder, *Historia naturalis*, XXXIV, 18.

16 Vaudoyer was a *pensionnaire* of architecture at the French Academy in Rome from 1784 to 1788. There is no documentary evidence to support the entry of such an item into the Museo Pio-Clementino in the Vatican, which was

founded in 1770 and to which a constant flow of such discoveries was diverted. See the catalogue entry by F. Giacomini in *Roma e l'antico: Realtà e visione nel'700*, ed. C. Brooke and V. Curzi, exh. cat., Fondazione Roma (Milan, 2010), p. 403. For the vast satirical literature on the antiquarian passion of the Museo Pio-Clementino, see P. Liverani, 'The Museo Pio-Clementino at the Time of the Grand Tour', *Journal of the History of Collections*, XII/2 (2000), pp. 151–9, here 157.

17 F. C. Albertson, 'Zenodorus's "Colossus of Nero"', *Memoirs of the American Academy in Rome*, 46 (2001), pp. 95–118. Under the heading 'De Colosso', the eighth-century author of the *Liber monstrorum* connects it with a garbled account of the death of the giant Thybris, mentioned in Vergil's *Aeneid*, VIII, 330, after whom the river Tiber was named; see C. Bologna, *Liber monstrorum de diversis generibus* (Milan, 1977), pp. 75–6, and F. Porsia, *Liber monstrorum* (Naples, 2012), pp. 130–31.

18 F. Coarelli, *Guide Archeologiche: Roma*, 4th edn (Milan, 2004), pp. 193–4.

19 E. Marlowe, 'Framing the Sun: The Arch of Constantine and the Roman Cityscape', *Art Bulletin*, LXXXVIII/2 (2006), pp. 223–42.

20 S. Freud, *Civilization and its Discontents* (London, 1930). This new order was literally inscribed on top of a Neronian site in the case of the large complex of baths erected on what is now the Oppian Hill during the rule of the emperor Trajan (AD 98–117). This complex was built on top of the northeastern wing of the Domus Aurea and recycled precious materials from the Neronian palace.

21 Coarelli, *Guide Archeologiche: Roma*, p. 185. The building already appears on a marble bas-relief from the tomb of the Haterii dating from AD 100–120, see E. La Rocca, C. Parisi Presicce and A. Lo Monaco, eds, *L'età dell'equilibrio, 98–180 d.C.*, exh. cat., Musei Capitolini, Rome (2012), cat. no. VI.13.

22 The first mention of the term is in the life of Pope Stephen II (752–7) in the *Liber Pontificalis*. However, persistence of the term *amphitheatrum* in the ninth-century *Itinerarium Einsiedlense* indicates that its old name was still in use.

23 This prophecy is sometimes incorrectly attributed to the Venerable Bede. The confusion is due to the fact that it was included in Bede's collected works in the sixteenth century.

24 Arguments for and against are summed up in H. V. Carter, 'The Venerable Bede and the Colosseum', *Transactions of the American Philological Association*, 61 (1930), pp. 150–64. Carter takes the prophecy to refer to the building, brushing aside the important objection that the noun *colossus* and related adjectives bear primarily on statues representing divine or human personages, not buildings.

25 As Ampitheatrum Coliseum: C. Denker Nesselrath, 'Il Colosseo', in *La Roma di Leon Battista Alberti: Umanisti, architetti e artisti alla scoperta dell'antico nella città del Quattrocento*, ed. F. P. Fiore, exh. cat., Musei Capitolini, Rome (Milan, 2005), pp. 202–9. As palace: Isa ben Ahmand al-Razi in the *Crónica del moro Rasis*, cited in M. Morán Turina, *La memoria de las piedras: Anticuarios, arqueólogos y coleccionistas en la España de los Austrias* (Madrid, 2010), p. 27.

26 P. Fortini Brown, *Venice and Antiquity: The Venetian Sense of the Past* (New Haven, CT, and London, 1996), p. 57; E. La Rocca, 'The Rhetoric of Rome

and the Reappropriation of the Ancient Monuments', *Fragmenta*, 1 (2007), pp. 141–71, here 145. The colossal statue of Constantine is now in the courtyard of the Palazzo dei Conservatori, Musei Capitolini, Rome.

27 P. A. Clayton and M. J. Price, eds, *The Seven Wonders of the Ancient World* (London, 1988), p. 12.

28 On this and other examples of the use of the Colosseum in the works of Heemskerck see S. Gropp, *Das Kolosseum der Druckgraphik des 15. bis 19. Jahrhunderts* (Bonn, 2012), pp. 140–59.

29 The Colosseum appears among the ruins in the drawing *An Imaginary City with Ancient Ruins* attributed variously to Jan van Scorel or to Maarten van Heemskerck; see K. G. Boon, *Netherlandish Drawings of the Fifteenth and Sixteenth Centuries* (The Hague, 1978), cat. no. 412.

30 K. van Mander, *Het schilder-boeck* (Haarlem, 1604), p. 245v.

31 On Heemskerck's Roman years see N. Dacos, *Roma quanta fuit: Tre pittori fiamminghi nella Domus Aurea*, 2nd revd edn (Rome, 2001), pp. 35–44.

32 *Fiamminghi a Roma, 1508–1608*, cat. no. 113.

33 Bartolomeo's *Peace between the Romans and the Sabines* in the Galleria Colonna, Rome, is dated to around 1488. See M. G. Bernardini and M. Bussagli, eds, *Il '400 a Roma: La rinascita delle arti da Donatello a Perugino*, exh. cat., Fondazione Roma (Milan, 2008), vol. II, cat. no. 20 (where the titles for nos 20 and 21 are reversed). Hartmann Schedel's *Weltchronik* of 1493, p. lvii, shows an intact, four-storey Colosseum on the margins of the city.

34 S. Münster, *Cosmographei* (Basel, 1550), p. clxxxii.

35 *Prospect of a Roman Amphitheatre* by Domenico Gargiulo (figures) and Viviano Codazzi (architecture). The painting was commissioned by the representatives of Philip IV of Spain around 1640 as part of the 'History of Rome' cycle in the Buen Retiro Palace, Madrid. See A. Ubeda de los Cobos, ed., *Paintings for the Planet King: Philip IV and the Buen Retiro Palace*, exh. cat., Museo del Prado, Madrid (London, 2005), cat. no. 37, apparently drawing on engravings by Giacomo Lauro.

36 For the cross-fertilization of the imagery of architectural ruins and anatomy, see P. Mason, 'La lección anatómica: Violencia colonial y complicidad textual', in *Discurso Colonial Hispanoamericano, Foro Hispánico*, 4, ed. S. Rose de Fuggle (1992), pp. 131–55.

37 For Salamanca, Lafréry and the engraver Beatrizet, see D. Landau and P. Parshall, *The Renaissance Print, 1470–1550* (New Haven, CT, and London, 1994), pp. 302–8, corrected on some points by J. L. Gonzalo Sánchez-Molero, 'Antonio de Salamanca y los libros españoles en la Roma del siglo XVI', in *Roma y España: Un crisol de la cultura europea en la eda moderna*, coord. C. J. Hernando Sánchez (Madrid, 2007), vol. I, pp. 335–65. For their influence on Spanish painters see Morán Turina, *La memoria de las piedras*, p. 79. On Valverde, note in particular the curious engraving of *Cuirasses with Viscera* by Nicolas Beatrizet in Book 3 of Juan de Valverde's work and the comments by M. Kornell, 'The Study of the Human Machine: Books of Anatomy for Artists', in M. Cazort, M. Kornell and K. B. Roberts, *The Ingenious Machine of Nature: Four Centuries of Art and Anatomy*, exh. cat., National Gallery of Canada (Ottawa, 1996), pp. 43–70, here 64–7.

38 C. da Ripa, *Baroque and Rococo Pictorial Imagery*, no. 151.

39 Palmer's *Ancient Rome* and its companion piece *Modern Rome* were shown together at the Rome Academy in 1838. See M. Liversidge and C. Edwards, eds, *Imagining Rome: British Artists and Rome in the Nineteenth Century*, exh. cat., Bristol City Museum and Art Gallery (London, 1996), cat. nos 29, 30; J.M.W. Turner, *The Colosseum by Moonlight*, 1819, ibid., p. 21, illus. 6; I. Caffi, *Nocturnal View of the Colosseum, c. 1843, Caffi: Luci del Mediterraneo*, ed. A. Scarpa, exh. cat., Museo di Roma, Rome (Milan, 2006), cat. no. 75.

40 J. Hamilton, *Turner and Italy*, exh. cat., National Galleries of Scotland (Edinburgh, 2009), pp. 39–53.

41 N. Moorsby, 'An Italian Treasury: Turner's Sketchbooks', ibid., pp. 111–17, here 115.

42 L. des Cars, D. de Font-Réaulx and E. Papet, eds, *Jean-Léon Gérôme (1824–1904): L'Histoire en spectacle*, exh. cat., Musée d'Orsay (Paris, 2010), cat. nos 70, 80, 81; L. Alma-Tadema, *The Architect of the Colosseum*, a watercolour from 1875, is illustrated in E. Querci and S. de Caro, eds, *Alma Tadema e la nostalgia dell'antico*, exh. cat., Museo Archeologico Nazionale Napoli (Milan, 2007), cat. no. 59.

43 É. Benveniste, 'Le Sens du mot *kolossos* et les noms grecs de la statue', *Revue de philologie* (1932), pp. 118–35.

44 Ibid., pp. 118ff.; J. Servais, 'Les Suppliants dans la "Loi sacrée" de Cyrène', *Bulletin de Correspondance Hellénique*, LXXXIV/1 (1960), pp. 112–47, esp. 126–7. Cf. R. Parker, *Miasma: Pollution and Purification in Early Greek Religion* (Oxford, 1983), pp. 332–51.

45 É. Benveniste, 'À propos de "ΚΟΛΟSSΟS"', *Revue de Philologie* (1932), p. 381; L. Gernet, *Anthropologie de la Grèce antique* (Paris, 1968), p. 213; R. Meiggs and D. Lewis, eds, *A Selection of Greek Historical Inscriptions to the End of the Fifth Century BC*, revd edn (Oxford, 1989), no. 5. The inscription itself dates from the fourth century BC, but the part containing the reference to *kolossoi* is taken by some scholars to go back to the foundation of the colony in the seventh century BC.

46 Steiner, *Images in Mind*, p. 9.

47 Benveniste, 'Le Sens du mot *kolossos*', p. 121.

48 For the application of the term *kolossos* to the rigid forms of archaic statues, see too J. Ducat, 'Fonctions de la statue dans la Grèce archaïque: Kouros et kolossos', *Bulletin de Correspondance Hellénique*, C/1 (1976), pp. 239–51, here 249.

49 A view that goes back to U. von Wilamowitz-Moellendorff, 'Heilige Gesetze: Eine Urkunde aus Kyrene', *Sitzungsberichte der Berliner Akademie* (1927), pp. 155–76. See E. Kosmetatou and N. Papalexandrou, 'Size Matters: Poseidippos and the Colossi', *Zeitschrift für Papyrologie und Epigraphik*, 143 (2003), pp. 53–8, an article that clarifies some of the doubts raised by P. Bernardini and L. Bravi, 'Note di lettura al nuovo Posidippo', *Quaderni Urbinati di Cultura Classica*, LXX/1 (2002), pp. 147–63. Kosmetatou and Papalexandrou also point out that Myron's modest-sized statues, none of them larger than life, were called *kolossoi*.

50 D. Steiner, 'Eyeless in Argos: A reading of *Agamemnon* 416–19', *Journal of Hellenic Studies*, 115 (1995), pp. 175–82, here 177. Cf. Steiner, *Images in Mind*,

p. 6 n. 9, where she refers to the work of Ducat; and Ducat, 'Fonctions de la statue dans la Grèce archaïque', p. 247: 'The word had several meanings, branches detached in the course of a long semantic evolution.'

51 Benveniste, 'Le Sens du mot *kolossos*', p. 119.

52 Ch. Picard, 'Le Cénotaphe de Midéa et les "colosses" de Ménélas', *Revue de philologie* (1933), pp. 341–54, here 348.

53 J.-P. Vernant, 'La Catégorie psychologique du double: Figuration de l'invisible et catégorie psychologique du double: Le Colossos', in his *Mythe et pensée chez les Grecs* (Paris, 1971), vol. ii, pp. 65–78.

54 Ibid., p. 70.

55 G. Roux, 'Qu'est-ce qu'un *kolossos?*', *Revue des Etudes Anciennes*, LXII (1960), pp. 5–40, and Steiner, 'Eyeless in Argos', p. 177, though see the criticisms of this view in Ducat, 'Fonctions de la statue dans la Grèce archaïque', p. 246. Also see Ducat for the relation between *kouros* and *kolossos*.

56 Benveniste, 'Le Sens du mot *kolossos*', p. 119.

57 Vernant, 'La Categorie psychologique du double', p. 76, following Roux.

58 Ibid.

59 Steiner, 'Eyeless in Argos', p. 181 n. 35.

60 P. Mason, *The City of Men: Ideology, Sexual Politics and the Social Formation* (Göttingen, 1984), pp. 40–43.

61 For the equivalence of sightless and out of sight see Steiner, *Images in Mind*, p. 150.

62 Sophocles, *Oedipus at Colonus*, ll. 1590–98.

63 Gernet, *Anthropologie de la Grèce antique*, pp. 295–8.

64 M. G. Shields, 'Sight and Blindness Imagery in the Oedipus Coloneus,' *Phoenix*, 15 (1961), pp. 63–74.

65 *Kant's Critique of Judgement*, trans. J. H. Bernard, 2nd revd edn (London, 1914), p. 112.

66 Ibid., p. 113.

67 See the extended discussion in J. Derrida, *La Vérité en peinture* (Paris, 1978), pp. 136–68.

68 V. Denon, *Travels in Upper and Lower Egypt During the Campaigns of General Bonaparte in That Country*, trans. A. Aikin (New York, 1803), vol. ii, pp. 251–2. For further discussion of the colossus of Memnon see chapter Four.

69 P. P. Bober and R. O. Rubinstein, *Renaissance Artists and Antique Sculpture*, 2nd edn (London and Turnhout, 2010), p. 172; see too F. Haskell and N. Penny, *Taste and the Antique: The Lure of Classical Sculpture, 1500–1900* (New Haven, CT, and London, 1981), pp. 136–41; Johan Wolfgang von Goethe, *Italian Journey*, trans. W. H. Auden and Elizabeth Mayer (London, 1970), p. 130.

70 For a variety of suggestions regarding the cause of the artist's despair, see C. Edwards, *Writing Rome: Textual Approaches to the City* (Cambridge, 1996), p. 15.

71 Goethe, *Italian Journey*, pp. 137–8.

72 Ibid., p. 148.

73 M. G. Barberini, '"Avere Roma": L'antico e la scultura a Roma negli ultimi decenni del Settecento nel *Viaggio in Italia* di Johan Wolfgang von Goethe (1786–1788)', in *Roma e l'antico: Realtà e visione nel'700*, ed. C. Brooke and

V. Curzi, exh. cat., Fondazione Roma (Milan, 2010), pp. 227–32.

74 Goethe, *Italian Journey*, p. 168.

75 *Kant's Critique*, p. 113.

76 Goethe, *Italian Journey*, p. 497.

77 K. Routledge, *The Mystery of Easter Island: The Story of an Expedition* (London, 1919, reissued Kempton, IL, 1998), pp. 184–5.

2 Obelisks on the Move

1 P. Belon, *Les Observations de plusieurs singularitez et choses memorables* (Paris, 1553), p. 168. In the same year Belon published a work in Paris in Latin on the Egyptian pyramids, sphinx (which he refers to in that work as a colossus) and other antiquities: *De admirabili operum antiquorum et rerum suspiciendarum praestantia*. A few years later (1567–8), another traveller to the Middle East, Marc'Antonio Pigafetta, noted the presence of an obelisk in the Hippodrome in Constantinople 'like the needle (*aguglia*) of Rome, made from a single stone like a pyramid'; see Marc'Antonio Pigafetta, *Itinerario da Vienna a Costantinopoli*, ed. D. Perocco (Padua, 2008), p. 136.

2 Francesco Colonna, *Hypnerotomachia Poliphili: The Strife of Love in a Dream*, trans. J. Godwin (New York, 1999), p. 38

3 *André Thevet: Cosmographie de Levant*, ed. F. Lestringant (Geneva, 1985), p. 130, woodcut on 129.

4 A. Thevet, *Cosmographie Universelle* (Paris, 1575), pp. 33v, 213.

5 A similar legend recounted that an ancient statue of a horse in the environs of the city of Elvira in Spain broke in the same year in which the Berbers seized the city; see M. Morán Turina, *La memoria de las piedras: Anticuarios, arqueólogos y coleccionistas en la España de los Austrias* (Madrid, 2010), p. 24.

6 The poem is taken from a collection by various authors published in Rome in 1586 to celebrate the transfer of the obelisk to its present position in front of the basilica of St Peter and cited in G. Cipriani, *Gli obelischi egizi: Politica e cultura nella Roma barocca* (Florence, 1993), p. 42.

7 I. M. Veldman, *Leerrijke reeksen van Maarten van Heemskerck*, exh. cat., Frans Hals Museum, Haarlem (The Hague, 1986), illus. 7.4. A fallen obelisk can be seen in the ruinous background of *The Triumph of Time* from the same series of prints, ibid., illus. 7.5. Obelisks also appear alongside a Roman triumphal arch and other ancient monuments in *Pride Produces Envy*, ibid., illus. 6.3. Among Heemskerck's sketches done in Rome is one of the Celian obelisk in its former position in a corner of the Campidoglio; see N. Dacos, *Roma quanta fuit: Tre pittori fiamminghi nella Domus Aurea*, 2nd revd edn (Rome, 2001), p. 38 and illus. 37. A sketch of an otherwise unidentified obelisk in a landscape may also be by Heemsckerck; see K. G. Boon, *Netherlandish Drawings of the Fifteenth and Sixteenth Centuries* (The Hague, 1978), cat. no. 315, and cf. cat. no. 615 10r.

8 See for example J. P. Filedt Kok, W. Halsema-Kubes and W. Th. Kloek, eds, *Kunst voor de beeldenstorm: Noordnederlandse kunst, 1515–1580*, exh. cat., Rijksmuseum Amsterdam (The Hague, 1986), cat. nos 116 (Master of the Good Samaritan) and 117 (Workshop of Jan van Scorel). The drawing *An Imaginary City with Ancient Ruins*, attributed variously to Scorel or

Heemskerck, includes both the Colosseum and obelisks; see Boon, *Netherlandish Drawings*, cat. no. 412.

9 A. Avila, 'La imagen de Roma en la pintura hispánica del Renacimiento', *Boletín del Museo e Instituto Camón Aznar*, 34 (1988), pp. 19–71; Morán Turina, *La memoria de las piedras*, p. 79.

10 B. Curran et al., *Obelisk: A History* (Cambridg, MA, 2009), p. 69. The obelisk dates from the 19th Egyptian Dynasty and was originally inscribed for Rameses II (1279–1213 BC).

11 See J. S. Ackerman, 'The Capitoline Hill', in his *Distance Points: Essays in Theory and Renaissance Art and Architecture* (Cambridge, MA, and London, 1991), pp. 385–416.

12 E. Blair MacDougall, 'A Circus, a Wild Man and a Dragon: Family History and the Villa Mattei', *Journal of the Society of Architectural Historians*, XLII/2 (1983), pp. 121–30. Since Ciriaco's first known position with the municipal government was two years later than the donation, in 1584, it is likely that the obelisk was given to him in honour of his father's services.

13 D.A.F. de Sade, *Viaggio in Italia*, ed. M. Lever (Turin, 1996), p. 124.

14 On the history of the Isaeum in the Campus Martius see C. Mazza, 'Le antichità imperiali e i culti orientali: L'Iseo Campense', in *Athanasius Kircher: Il Museo del Mondo*, ed. E. Lo Sardo, exh. cat., Palazzo di Venezia (Rome, 2001), pp. 133–41.

15 T. Webb, '"City of the soul": English Romantic Travellers in Rome', in *Imagining Rome: British Artists and Rome in the Nineteenth Century*, ed. M. Liversidge and C. Edwards, exh. cat., Bristol City Museum and Art Gallery (London, 1996), pp. 20–37, here 28.

16 For the long history of the obelisk see G. Alföldy, *Der Obelisk auf dem Petersplatz in Rom: Ein historisches Monument der Antike* (Heidelberg, 1990).

17 M. Verzár-Bass, 'A proposito dei mausolei negli *horti* e nelle *villae*', in *Horti romani: Atti del convegno internazionale*, ed. M. Cima and E. La Rocca (Rome, 1998), pp. 401–24, here 423–4.

18 For the transfer of the obelisk to the centre of the Piazza di San Pietro in 1586 see Curran et al., *Obelisk*, pp. 103–40. For the political and religious symbolism see Cipriani, *Gli obelischi egizi*, pp. 25–43.

19 Made for the principal Jesuit church in Rome, the Santissimo Nome di Gesù, between 1575 and 1580, the reliquary is the work of an anonymous silversmith in the entourage of Cardinal Alessandro Farnese, who financed the building of the Gesù between 1568 and 1575; see M. G. Bernardini and M. Bussagli, eds, *Il Rinascimento a Roma: Nel segno di Michelangelo e Raffaello*, exh. cat., Fondazione Roma Museo, Palazzo Sciarra (Milan, 2011), cat. no. 189.

20 Morán Turina, *La memoria de las piedras*, p. 12, provides some examples from Spain.

21 J. von Schlosser, *Die Kunst- und Wunderkammern der Spätrenaissance: Ein Beitrag zur Geschichte des Sammelwesens*, 2nd edn (Braunschweig, 1978).

22 S. Settis, 'Des ruines au musée: La Destinée de la sculpture classique', *Annales ESC*, XLVIII/6 (1993), pp. 1347–80. See also the interesting discussion of the medieval Islamic treatment of Indian idols in F. B. Flood, *Objects of Translation: Material Culture and Medieval 'Hindu-Muslim' Encounter* (Princeton,

NJ, and Oxford, 2009), pp. 26–37.

23 Cipriani, *Gli obelischi egizi*, p. 33.

24 E. Iversen, *Obelisks in Exile*, I: *The Obelisks of Rome* (Copenhagen, 1968).

25 Curran et al., *Obelisk*, p. 93.

26 C. Fox, 'Kleopatras Nadel in London', in *Europa und der Orient, 800–1900*, ed. G. Sievernich and H. Budde, exh. cat., Berliner Festspiele (Berlin, 1989), pp. 72–83.

27 M. J. Versluys, *Aegyptiaca Romana: Nilotic Scenes and the Roman Views of Egypt* (Leiden, 2002), p. 329.

28 Curran et al., *Obelisk*, p. 46.

29 Ibid., pp. 21–2. The tomb of the chief steward resonsible for the transport and erection of these obelisks at Deir el-Bahri, Senenmut, was also defaced; see I. Shaw and P. Nicholson, *British Museum Dictionary of Ancient Egypt* (London, 1995), *s.v.* Senenmut.

30 Versluys, *Aegyptiaca Romana*, p. 363; C. Bariviera, 'Regione XI: *Circus Maximus*', in *Atlante di Roma antica: Biografia e ritratti della città*, ed. A. Carandini (Milan, 2012), vol. I, pp. 421–45, here 433.

31 Cipriani, *Gli obelischi egizi*, p. 17.

32 Bernardini and Bussagli, eds, *Il Rinascimento a Roma*, cat. no. 100.

33 See Alföldy, *Der Obelisk auf dem Petersplatz in Rom*, and the classic study by P. Zanker, *Augustus und die Macht der Bilder* (Munich, 1987).

34 M. Fagiolo and M. L. Madonna, 'Instauratio Urbis Romae: La città e il sistema delle ville', in *Il Rinascimento a Roma*, ed. Bernardini and Bussagli, pp. 17–29.

35 Seventy years earlier Antonio da Sangallo the Younger had already envisaged the erection of an obelisk on the latter spot; see ibid., p. 21. In the first edition of his *Observations*, published in 1553, Pierre Belon also refers to an obelisk 'au Populo', p. 168; does this mean that there was an obelisk of some kind there before the erection of the one from the Circus Maximus in 1587?

36 C. Hendriks, *Northern Landscapes on Roman Walls: The Frescoes of Matthijs and Paul Bril* (Florence, 2003), pp. 48–51.

37 In spite of an inscription applied to the monument in 1650 mentioning the name of Caracalla, Domitian was the emperor responsible; see Cipriani, *Gli obelischi egizi*, p. 120 n. 116. Sade, *Viaggio in Italia*, p. 137, perpetuates the same mistake.

38 Cipriani, *Gli obelischi egizi*, pp. 116–18.

39 F. Checa Cremades, ed., *Cortes del Barroco, de Bernini y Velázquez a Luca Giordano*, exh. cat., Palacio Real de Madrid (2003), p. 175. The same catalogue includes some of Bernini's bronze and terracotta models and sketches for the fountain.

40 They are kept in the Liceo Visconti in Rome and illustrated in E. Lo Sardo, ed., *Athanasius Kircher: Il Museo del Mondo*, exh. cat., Palazzo di Venezia (Rome, 2001), pp. 102–8, and in Lo Sardo, ed., *La lupa e la sfinge: Roma e l'Egitto dalla storia al mito*, exh. cat., Museo Nazionale di Castel Sant'Angelo, Rome (Milan, 2008), p. 184. One of them, a present for Christina of Sweden, was inscribed in 33 languages with the words 'Great Christina, his Reborn, erects, deivers, and consecrates this Obelisk on which the secret marks of Ancient Egypt are inscribed'.

41 S. A. Bedini, *The Pope's Elephant* (Manchester, 1997), p. 177.

42 Cipriani, *Gli obelischi egizi*, p. 154.

43 I. Rowland, 'Athanasius Kircher o la scoperta dell'Egitto', in *La lupa e la sfinge*, ed. Lo Sardo, pp. 180–89.

44 Colonna, *Hypnerotomachia Poliphili*, pp. 24–5.

45 Ibid., p. 131.

46 See the catalogue entry by L. Konečny in S. Ferino-Pagden, ed., *I cinque sensi nell'arte: Immagini del Sentire*, exh. cat., Cremona (Milan, 1996), p. 104.

47 C. da Ripa, *Baroque and Rococo Pictorial Imagery: The 1758–60 Hertel Edition of Ripa's 'Iconologia' with 200 Engraved Illustrations*, introduction, translation and 200 commentaries by E. A. Maser (New York, 1971), nos 82, 110 and 191.

48 Ibid., no. 97.

49 Ibid., nos 114 and 198.

50 L. Pascoli, *Il testamento politico* [*c*. 1733], cited in E. Battisti, *L'Antirinascimento*, 2nd edn (Turin, 2005), p. 436.

51 A. Wilton and I. Bignami, *Grand Tour: The Lure of Italy in the Eighteenth Century*, exh. cat., Tate Gallery, London (1996).

52 J. W. von Goethe, *Italian Journey*, trans. W. H. Auden and Elizabeth Mayer (London, 1970), p. 154. The painting is now in the Städelsches Kunstinstitut und Städtische Galerie Frankfurt. The obelisk on which he is seated, which is more clearly visible with its hieroglyphs in a drawing of an earlier version (now in the Goethe Museum in Weimar), cannot be identified with certainty; see Versluys, *Aegyptiaca Romana*, p. 326 n. 429.

53 Goethe, *Italian Journey*, p. 155.

54 S. Pasquali, 'Per una storia delle colonne trasportate altrove: Il gusto dell'antico negli spazi privati, 1750–1800', in *Roma e l'antico: Realtà e visione nel'700*, ed. C. Brooke and V. Curzi, exh. cat., Fondazione Roma (Milan, 2010), pp. 213–20.

55 P. Liverani, 'The Museo Pio-Clementino at the Time of the Grand Tour', *Journal of the History of Collections*, XII/2 (2000), pp. 151–9.

56 P. P. Bober and R. O. Rubinstein, *Renaissance Artists and Antique Sculpture*, 2nd edn (London and Turnhout, 2010), pp. 172–4; F. Haskell and N. Penny, *Taste and the Antique: The Lure of Classical Sculpture, 1500–1900* (New Haven, CT, and London, 1981), pp. 136–41. For the difficulties involved see Curran et al., *Obelisk*, pp. 193–4.

57 A. Ottani Cavina, ed., *Viaggio d'artista dell'Italia del Settecento: Il diario di Thomas Jones* (Milan, 2003), p. 140. For Jones's interest in excavations, see too his painting *An Excavation of an Antique Building Discovered in a Cava in the Villa Negroni at Rome*, in *Thomas Jones (1742–1803): An Artist Rediscovered*, ed. A. Sumner and G. Smith, exh. cat., National Museum and Gallery, Cardiff, Whitworth Art Gallery, Manchester, and National Gallery, London (New Haven, CT, and London, 2003), cat. no. 65. For excavations of the Villa Negroni in the eighteenth century, see I. Bignamini and C. Hornsby, *Digging and Dealing in Eighteenth-century Rome* (New Haven, CT, and London, 2010), vol. I, p. 151. The Marquis de Sade described it as being in a terrible state in his *Viaggio in Italia*, p. 94.

58 Sade, *Viaggio in Italia*, p. 59.

59 Versluys, *Aegyptiaca Romana*, p. 357.

60 M. Cima and E. Talamo, *Gli horti di Roma antica* (Milan, 2008), pp. 108–33; M. C. Capanna, 'Regione VI: *Alta Semita*', in *Atlante di Roma antica: Biografia e ritratti della città*, ed. A. Carandini (Milan, 2012), vol. I, pp. 446–73, here 465.

61 Goethe, *Italian Journey*, p. 455.

62 For example, in the last line of the third of Pietro Aretino's 'I Sonnetti Lussuriosi', quoted with translation in B. Talvacchia, *Taking Positions: On the Erotic in Renaissance Culture* (Princeton, NJ, 1999), p. 203.

63 On the history and design of the Spanish Steps (Scalinata), see E. Kieven, 'Cascades and Steps: The Porto di Ripetta and Other Changes in the Urban Fabric of Rome in the Eighteenth Century', *Fragmenta: Journal of the Royal Netherlands Institute in Rome*, I (2007), pp. 123–39.

64 Liverani, 'The Museo-Pio-Clementino at the Time of the Grand Tour'.

65 Versluys, *Aegyptiaca Romana*, p. 362, is sceptical about claims regarding the possible placing of the Antinous obelisk in Rome prior to its relocation on the Pincian Hill. The 1630 excavation explains its presence at the centre of Jean Lemaire's *Landscape with Hermit and Classical Ruins* (Prado, Madrid), painted for the Buen Retiro palace in the Spanish capital in the 1630s, though since the obelisk was broken in three pieces at the time, Lemaire presumably followed a reconstruction drawing from the Paper Museum of Cassiano dal Pozzo; see *Roma: Naturaleza e Ideal, Paisajes, 1600–1650*, exh. cat., Grand Palais, Paris, and Museo del Prado, Madrid (Paris and Madrid, 2011), cat. no. 76; and A. Ubeda de los Cobos, ed., *Paintings for the Planet King: Philip IV and the Buen Retiro Palace*, exh. cat., Museo del Prado, Madrid (London, 2005), cat. no. 61. On the removal to the Pincian Hill: Curran et al., *Obelisk*, pp. 49 and 203.

66 J-Cl. Grenier, 'L'obelisco Barberini', in *La lupa e la sfinge*, ed. Lo Sardo, pp. 118–21.

67 F. Coarelli, *Guide Archeologiche: Roma*, 4th edn (Milan, 2004), p. 286.

68 Curran et al., *Obelisk*, p. 242.

69 Coarelli, *Guide Archeologiche: Roma*, p. 286.

70 There is a vast literature on the subject. For a concise summary of some Egyptian-style artefacts, from furniture and lamps to wallpaper, see F. Beaucour, Y. Laissus and C. Orgogozo, *The Discovery of Egypt* (Paris, 1990), pp. 203–23. On ancient Egypt and the Crystal Palace, see S. Moser, *Designing Antiquity: Owen Jones, Ancient Egypt and the Crystal Palace* (New Haven, CT, 2012).

71 We may surmise that the blue stone 'pyramid' that Maarten van Heemskerck had erected on his father's grave in the sixteenth century was in fact an obelisk; see K. van Mander, *Het schilder-boeck* (Haarlem, 1604), p. 247r.

72 C. Bargellini, 'Athanasius Kircher e la Nuova Spagna', in *Athanasius Kircher*, ed. Lo Sardo, pp. 86–91.

73 E. I. Estrada de Gerlero, 'El obelisco de Carlos III en la Plaza Mayor de Puebla', in *Esplendor y ocaso de la cultura simbólica*, ed. H. Pérez Martínez and B. Skinfill (Michoacán, 2002), pp. 97–110.

74 L. F. Voionmaa Tanner, 'Construcción simbólica de la nación chilena vista desde la iconografía: Una propuesta comparativa', in *Iconografía, identidad nacional y cambio de siglo (XIX–XX)*, ed. F. Guzmán, G. Cortés and J. M. Martínez (Santiago, 2003), pp. 121–38, here 127.

75 For the history of the first Santiago obelisk see L. F. Voionmaa Tanner,

Escultura Pública: Del monumento conmemorativo a la escultura urbana. Santiago, 1792–2004 (Santiago, 2005), vol. i, pp. 23–44.

76 Ibid., p. 34; Voionmaa Tanner, 'Construcción simbólica de la nación', p. 127.

77 Curran et al., *Obelisk*, p. 252.

78 Cited in W. Benjamin, *The Arcades Project*, trans. H. Eiland and K. McLaughlin (Cambridge, MA, and London, 1999), p. 399.

79 The obelisk opposite the Quirinale was erected in 1786, the obelisk above the Spanish Steps was erected in 1789, and the Montecitorio obelisk was erected six years later – all after Toesca's arrival in Chile.

80 Cipriani, *Gli obelischi egizi*, p. 25.

81 Voionmaa Tanner, *Escultura Pública*, vol. ii, p. 23.

82 P. Belon, *Les Observations*, p. 168.

83 Ibid.

3 The Colossal Statues of Easter Island

1 J. W. von Goethe, *Italian Journey*, trans. W. H. Auden and Elizabeth Mayer (London, 1970), p. 401.

2 R. J. King, 'The Mulovsky Expedition and Catherine ii's North Pacific Empire', *Australian Slavonic and East European Studies*, xxi/1–2 (2007), pp. 97–122. The expedition was eventually carried out under the command of Adam von Krusenstern in 1803–6.

3 A. Salmond, *The Trial of the Cannibal Dog: The Remarkable Story of Captain Cook's Encounters in the South Seas* (New Haven, CT, and London, 2003), p. 236.

4 G. Forster, *A Voyage Round the World*, ed. N. Thomas and O. Berghof (Honolulu, 2000), vol. i, p. 306.

5 M. E. Hoare, ed., *The Resolution Journal of Johann Reinhold Forster, 1772–1775* (London, 1982), vol. iii, p. 469.

6 J. R. Forster, *Observations Made during a Voyage Round the World*, ed. N. Thomas, H. Guest and M. Dettelbach (Honolulu, 1996), p. 158.

7 J. A. Van Tilburg, *Remote Possibilities: Hoa Hakananai'a and HMS 'Topaze' on Rapa Nui*, British Museum Research Publications 158 (London, 2006), p. 70; A. Métraux, *Easter Island* (London, 1957), p. 152.

8 R. Joppien and B. Smith, *The Art of Captain Cook's Voyages*, 3 vols (Sydney, New Haven, CT, and London, 1985–7), cat. no. 2.93.

9 For a recent biography of Jacob Roggeveen see R. van Gelder, *Naar het aards paradijs: Het rusteloze leven van Jacob Roggeveen, ontdekker van Paaseiland (1659–1729)* (Amsterdam, 2012).

10 *Easter Island: The First Three Expeditions* (Rapa Nui, 2004), p. 31. For an engraving of this scene, see illus. 80.

11 M. Duchet, *Anthropologie et histoire au siècle des lumières* (Paris, 1971), p. 64.

12 B. Smith, *European Vision and the South Pacific*, 2nd edn (New Haven, CT, and London, 1988), p. 71.

13 B. Smith, *Imagining the Pacific: In the Wake of the Cook Voyages* (New Haven, CT, and London, 1992), pp. 130–31; C. Greig, 'Hodges and Attribution', in *William Hodges, 1744–1797: The Art of Exploration*, ed. G. Quilley and J. Bonehill, exh. cat., National Maritime Museum, London (New Haven, CT, and London,

2004), pp. 15–20; H. Guest, *Empire, Barbarism and Civilisation: Captain Cook, William Hodges and the Return to the Pacific* (Cambridge, 2007), p. 1.

14 Smith, *European Vision and the South Pacific*, pp. 71–2. Hodges's paintings of the Cape of Good Hope and of the Antarctic show the same interest in painting light and atmospheric effect. In fact, it is already in evidence in Hodges's earliest recorded painting (signed and dated 1766), *A View of London Bridge from Botolph Wharf*. See Greig, 'Hodges and Attribution', p. 16.

15 Salmond, *The Trial of the Cannibal Dog*, p. 237.

16 Forster, *Observations Made during a Voyage Round the World*, p. 338.

17 G. B. Piranesi, *Prima parte d'architetture e prospettive* (Rome, 1743).

18 W. Benjamin, *The Arcades Project*, trans. H. Eiland and K. McLaughlin (Cambridge, MA, 1999), p. 355.

19 Smith, *European Vision and the South Pacific*, p. 140.

20 K. Routledge, *The Mystery of Easter Island: The Story of an Expedition* (London, 1919, reissued Kempton, IL, 1998), p. 320.

21 J. A. Van Tilburg, *Among Stone Giants: The Life of Katherine Routledge and Her Remarkable Expedition to Easter Island* (New York, 2003).

22 Routledge, *The Mystery of Easter Island*, p. 3. The suggestion of Easter Island was made by Sir Hercules Read and Captain T. A. Joyce of the Ethnological Department of the British Museum; ibid., p. ix.

23 For example S.-C. Chauvet (who never visited the island), *L'Île de Pâques et ses mystères* (Paris, 1935); T. Heyerdahl, *Aku-Aku: The Secret of Easter Island* (London, 1958) and *Easter Island: The Mystery Solved* (London, 1989); F. Mazière, *Mysteries of Easter Island* (London, 1969); *L'Île de Pâques: Une Énigme?*, exh. cat., Musées Royaux d'Art et d'Histoire, Brussels (1990); C. and M. Orliac, *Silent Gods: The Mysteries of Easter Island* (London, 1995); and most recently J. Flenley and P. Bahn, *The Enigmas of Easter Island*, 2nd edn (Oxford, 2003). In spite of the title, B. Haun, *Inventing Easter Island* (Toronto, 2008) has little to add.

24 S. R. Fischer, *Island at the End of the World: The Turbulent History of Easter Island* (London, 2005), p. 199. Their display *outside* the island is the subject of chapter Five.

25 Van Tilburg, *Remote Possibilities*, p. 12, but this alleged correlation between statue size and chiefly status remains to be proven. *Quod erat demonstrandum.*

26 Flenley and Bahn, *The Enigmas of Easter Island*, p. 137.

27 Fischer, *Island at the End of the World*, p. 229.

28 *L'Île de Pâques: Une Énigme?*, p. 350; F. Forment, *Le Pacifique aux îles innombrables Île de Pâques* (Brussels, 1981), p. 135.

29 *Easter Island: The First Three Expeditions*, p. 58.

30 Fischer, *Island at the End of the World*, p. 188.

31 Van Tilburg, *Remote Possibilities*, p. 15. I cannot understand what she means when she adds on the same page 'Coral and red scoria eyeballs were ritually inserted and removed.'

32 *L'Île de Pâques: Une Énigme?*, cat. no. 201; Van Tilburg, *Remote Possibilities*, p. 56.

33 Salmond, *The Trial of the Cannibal Dog*, pp. 45, 248.

34 Forster, *Observations Made during a Voyage Round the World*, p. 158.

35 Ibid., p. 338.

36 *Easter Island: The First Three Expeditions*, p. 57. See too Flenley and Bahn,

The Enigmas of Easter Island, p. 143.

37 'The *moai* is an icon that merges Rapa Nui's mythical, ancestral founder with that of individual, deified chiefs', Van Tilburg, *Among Stone Giants*, p. 240.

38 The most penetrating discussion of the concept of company that I know is Samuel Beckett, 'Company', in *Nohow On: Three Novels by Samuel Beckett* (New York, 1996).

39 Forster, *Observations Made during a Voyage Round the World*, p. 111.

40 Fischer, *Island at the End of the World*, p. 66.

41 Routledge, *The Mystery of Easter Island*, p. 172.

42 Van Tilburg, *Remote Possibilities*, p. 12.

43 Fischer, *Island at the End of the World*, p. 64: 'Eyewitness informants told the French in the 1870s'; p. 65: 'as Islanders told German visitors a century later'.

44 Ibid., p. 91.

45 Ibid., p. 64. Rongorongo is a glyphic script that was probably invented in imitation of the letters of the alphabet contained in Spanish documents that the islanders saw in the eighteenth century; see Van Tilburg, *Among Stone Giants*, p. 141, and Flenley and Bahn, *The Enigmas of Easter Island*, pp. 183–90.

46 Fischer, *Island at the End of the World*, p. 91.

47 Ibid., p. 14.

48 Routledge, *The Mystery of Easter Island*, p. 212.

49 Van Tilburg, *Among Stone Giants*, p. 119.

50 Van Tilburg, *Remote Possibilities*, p. 1.

51 Fischer, *Island at the End of the World*, p. 124.

52 Ibid., p. 129.

53 Ibid., p. 148.

54 P. Mason, *Deconstructing America: Representations of the Other* (London and New York, 1990), pp. 53–4.

55 Van Tilburg, *Remote Possibilities*, p. 10.

56 Fischer, *Island at the End of the World*, p. 55.

57 Ibid., p. 89.

58 Ibid., p. 55; Flenley and Bahn, *The Enigmas of Easter Island*, p. 154.

59 Van Tilburg, *Remote Possibilities*, p. 51.

60 Forster, *Observations Made during a Voyage Round the World*, pp. 158, 30.

61 T. Webb, '"City of the Soul": English Romantic Travellers in Rome', in *Imagining Rome: British Artists and Rome in the Nineteenth Century*, ed. M. Liversidge and C. Edwards (London, 1996), p. 24.

62 J. L. Stephens, *Incidents of Travel in Yucatan* (New York, 1963), vol. II, p. 309.

63 B. Smith, *European Vision and the South Pacific*, p. 71. Hodges was a pupil of Richard Wilson, from whom he learned the principles of classical idealism in landscape painting: ibid., p. 57.

64 Routledge, *The Mystery of Easter Island*, p. 136.

65 K. E. Manthorne, *Tropical Renaissance: North American Artists Exploring Latin America, 1839–1879* (Washington, DC, and London, 1989), pp. 95–8; F. Bourbon, *The Lost Cities of the Mayas: The Life, Art, and Discoveries of Frederick Catherwood* (New York and London, 2000), pp. 54–5.

66 Routledge, *The Mystery of Easter Island*, p. 178.

67 In a discussion of a stone sarcophagus, G. Didi-Huberman refers to the

'connivence du psychique et du minéral': see his 'Dans la lueur du seuil',
in *Phasmes: Essais sur l'apparition* (Paris, 1998), pp. 204–16, esp. 211.

68 Manthorne, *Tropical Renaissance*, p. 98 and pl. iv; Bourbon, *The Lost Cities of
the Mayas*, pp. 192–3.

69 Stephens, *Incidents of Travel in Yucatan*, vol. ii, p. 298, emphasis added.

70 J.-P. Vernant, 'La Catégorie psychologique du double: Figuration de l'invisible
et catégorie psychologique du double: Le Colossos', in his *Mythe et pensée chez
les Grecs* (Paris, 1971), vol. ii, pp. 65–78, here 70.

4 Colossal Heads

1 A third colossus from the group, standing 18 m high, has been excavated
and was re-erected – not without considerable difficulty – in February 2012.

2 Tip of obelisk of Karnak (left) and detail from the Colossi of Memnon (right),
engraving after a drawing by Frederick Catherwood, in John L. Stephens,
Incidents of Travel in Central America, Chiapas and Yucatan (New York, 1841),
vol. ii, p. 440.

3 Ibid., p. 105.

4 M. Hirsch, 'Mayrhofer, Schubert, and the Myth of "Vocal Memnon"', in
The Unknown Schubert, ed. B. M. Reul and L. B. Bodley (Aldershot, 2008),
pp. 3–23, here 23.

5 A. Warburg, *Images from the Region of the Pueblo Indians of North America*,
trans. with interpretive essay by M. P. Steinberg (Ithaca, NY, 1995).

6 P. Mason, *The Lives of Images* (London, 2001), p. 23

7 G. Didi-Huberman, *Invention de l'hystérie: Charcot et l'iconographie photographique
de la Salpêtrière* (Paris, 1982), p. 177.

8 G. Didi-Huberman, *L'Image survivante: Histoire de l'art et temps des fantômes
selon Aby Warburg* (Paris, 2002).

9 For a survey of Olmec archaeology down to the last decade of the
twentieth century see B. de la Fuente, 'Historia de la arqueologìa olmeca',
in *Descubridores del pasado en Mesoamérica*, ed. L. Gutiérrez and G. Pardo
(Mexico City, 2001), pp. 55–79.

10 S. Ladrón de Guevara, 'Olmec Art: Essence, Presence, Influence and
Transcendence', in *Olmec: Colossal Masterworks of Ancient Mexico*, ed. K. Berrin
and V. M. Fields, exh. cat., Fine Arts Museum of San Francisco and Los
Angeles County Museum of Art (New Haven, CT, and London, 2010),
pp. 24–33, and R. A. Diehl, 'The Olmec Legacy in Stone: A Mesoamerican
Alpha and Omega', ibid., pp. 76–85.

11 'Estudio sobre la antigüedad y el origen de la Cabeza *Colosal* de tipo *etiópico*
que existe en Hueyapan del cantón de los Tuxtlos', *Boletín de la Sociedad
Mexicana de Geografía y Estadística*, iii / 2 (Mexico, 1871), pp. 104–9, emphasis
added.

12 A. Chavero, *México a través de los siglos* (Mexico, 1887).

13 These sources include the works of fray Bernardino de Sahagún, fray Juan
de Torquemada, Diego Muñoz Camargo, Fernando de Alva Ixtlixóchitl and
the sixteenth-century manuscript *Historia Tolteca-Chichimeca*.

14 C. McEwan, *Ancient Mexico in the British Museum* (London, 1994), p. 22.

15 T. Pérez Suárez, 'The Maya and Their Olmec Neighbors', in *Maya*,
 ed. P. Schmidt, M. de la Garza and E. Nalda, exh. cat., Palazzo Grassi,
 Venice (New York, 1998), pp. 73–83.

16 In several respects the ancient Etruscans offer a similar case to the Olmecs.
 For an excellent collection of contributions, published to accompany the
 exhibition *Gli Etruschi e l'Europa* (Grand Palais, Paris, 1992, and Altes Museum,
 Berlin, 1993), which combines a detailed analysis of the archaeological record
 with a study of the images of Etruscan culture that have been proposed in the
 course of time; see M. Pallottino, ed., *Gli Etruschi* (Milan, 1992).

17 K. A. Taube, *Olmec Art at Dumbarton Oaks* (Washington, DC, 2004), p. 88.

18 C. A. Pool, 'Tres Zapotes: Where Olmec Archaeology Began', in *Olmec:
 Colossal Masterworks of Ancient Mexico*, ed. Berrin and Fields, pp. 54–67, here 64.

19 B. de la Fuente, *Los Hombres de Piedra: Escultura Olmeca* (Mexico City, 1977),
 p. 352; on the existence of an Olmec canon, see too J. Alcina Franch, *Arte
 y antropología* (Madrid, 1982), pp. 78–84.

20 B. Braun, *Pre-Columbian Art and the Post-Columbian World* (New York, 1993),
 p. 104.

21 O. Baddeley, 'Ancient Mexican Sources of Art Deco', in *Art Deco, 1910–1939*,
 ed. C. Benton, T. Benton and G. Wood, exh. cat., Victoria and Albert
 Museum, London (2003), pp. 60–61.

22 M. Tenorio-Trillo, *Mexico at the World's Fairs: Crafting a Modern Nation*
 (Berkeley, CA, Los Angeles and London, 1996), pp. 227–30.

23 M. de la Garza, 'The Rediscovery of a Civilization', in *Maya*, ed. Schmidt,
 de la Garza and Nalda, pp. 19–27, here 24.

24 See the classic work by B. Keen, *The Aztec Image in Western Thought* (New
 Brunswick, 1971). Bataille's essay 'L'Amérique disparue', first published in
 J. Babelon et al., *L'Art Précolombien: L'Amérique avant Christophe Colomb* (*Cahiers
 de la République des lettres, des sciences, et des arts*, 11, Paris, 1928), is more readily
 accessible in his *Oeuvres complètes*, vol. 1: *Premiers écrits, 1922–1940* (Paris, 1970),
 pp. 152–8.

25 Cited in Keen, *The Aztec Image*, p. 513.

26 Cited ibid., p. 6.

27 For a summary and blbliography see P. Mason, 'Native South Americans', in
 M. Beller and J. Leersen, eds, IMAGOLOGY: *The Cultural Construction and Literary
 Representation of National Characters, A Critical Survey* (Amsterdam and New
 York, 2007), pp. 86–9.

28 M. D. Coe and R. Diehl, *In the Land of the Olmecs* (Austin, TX, and London,
 1980).

29 F.Ph.J. Gerards, *Olmeekse Hoofden: De Omgekeerde Pyramide*, PhD dissertation
 (University of Leiden, 2000).

30 Ibid., p. 73.

31 Ibid., p. 241.

32 K. V. Flannery et al., 'Implications of New Petrographic Analysis for the
 Olmec "Mother Culture" Model', *Proceedings of the National Academy of
 Sciences of the United States of America*, CII/32 (2005), pp. 11219–23. For a
 balanced assessment of the 'mother' and 'sister' models, see J. E. Clark, 'The
 Arts of Government in Early Mesoamerica', *Annual Review of Anthropology*,

26 (1997), pp. 211–34.

33 Gerards, *Olmeekse Hoofden*, p. 56.

34 Ibid., p. 159.

35 For example, M. E. Miller, *The Art of Mesoamerica from Olmec to Aztec* (London, 1986); H. Stierlin, *Maya: Palais et pyramides de la forêt vierge* (Cologne, 2001), p. 38.

36 Berrin and Fields, eds, *Olmec: Colossal Masterworks of Ancient Mexico*, illus. 86.

37 Gerards, *Olmeekse Hoofden*, pp. 130ff.

38 R. F. Heizer, 'New Observations on La Venta', in *Dumbarton Oaks Conference on the Olmec*, ed. E. P. Benson (Washington, DC, 1968), pp. 9–40. Incidentally, Heizer's son Michael was an exponent of Land Art; see Braun, *Pre-Columbian Art and the Post-Columbian World*, p. 317.

39 See the summary in J. Flenley and P. Bahn, *The Enigmas of Easter Island*, 2nd edn (Oxford, 2003), pp. 131–46.

40 R. Piña Chan, *The Olmec, Mother Culture of Mesoamerica*, ed. L. Laurencich Minelli (New York, 1989). As the editor notes on p. 170 n. 6, Piña Chan's suggestion that the practice of monumental sculpture could have been derived from the non-Olmec cultures of Guatemala has to be ruled out for chronological reasons, as the round figures of Guatemala are posterior to those of the coastal peoples.

41 L. Tythacott, *Surrealism and the Exotic* (London and New York, 2003), p. 176.

42 W. Benjamin, *The Arcades Project*, trans. H. Eiland and K. McLaughlin (Cambridge, MA, 1999), p. 467.

43 Ibid., p. 460.

44 In this respect the present analysis proceeds in the opposite – though complementary – way to Carolyn Dean's *A Culture of Stone* (Durham, NC, 2010). While she resolutely turns her back on contemporary aesthetic approaches to Inka stone, it is aesthetic concerns that are at issue here.

45 Stele 2 on the site is a replica.

46 Miller, *The Art of Mesoamerica from Olmec to Aztec*, p. 26.

47 F. K. Reilly III, 'La Venta', in *Olmec: Colossal Masterworks of Ancient Mexico*, ed. Berrin and Fields, pp. 44–53.

48 A photograph of the plasters *Three Figures in a Field* is reproduced in Y. Bonnefoy, *Giacometti: A Biography of his Work* (Paris, 1991), p. 539. The work may also reflect awareness of the moai of Easter Island. In spite of the resemblance of Giacometti's work to another Olmec creation, a group offering of fifteen standing figurines and six celts, the parallel is entirely fortuitous, however, as the latter only came to light in 1955; see *Olmec: Colossal Masterworks of Ancient Mexico*, ed. Berrin and Fields, illus. 72.

49 W. Benjamin, *Illuminations: Essays and Reflections*, trans. H. Zohn, ed. H. Arendt (New York, 1968), p. 188. See too the development of these ideas in G. Didi-Huberman, *Ce que nous voyons, ce qui nous regarde* (Paris, 1992).

50 Benjamin, *Illuminations*, p. 188.

51 Ibid., p. 222, emphasis added.

52 Ibid., p. 243. There is some confusion in Benjamin's account between this notion of the aura of the cult image and the notion of the aura as a property of the uniqueness of the work of art, on which see A. Hughes, 'Authority, Authenticity and Aura: Walter Benjamin and the Case of Michelangelo', in

Sculpture and its Reproductions, ed. A. Hughes and E. Ranfft (London, 1997), pp. 29–45. What concerns us here, however, is the dialectic of closeness and distance.

53 On the distancing of distance (*Ent-fernung* in Heidegger's terminology), see P. Mason, *Deconstructing America: Representations of the Other* (London and New York, 1990), p. 183.

54 The expression is from Benjamin, *The Arcades Project*, p. 314.

5 Collecting Moai

1 L. Tythacott, *Surrealism and the Exotic* (London and New York, 2003), p. 139.

2 Cited in Y. Bonnefoy, *Alberto Giacometti: A Biography of His Work*, trans. J. Stewart (Paris, 1991), p. 170.

3 K. Varnedoe, 'Gauguin', in *Primitivism in Modern Art: Affinity of the Tribal and the Modern*, ed. W. Rubin, exh. cat., Museum of Modern Art (New York, 1984), pp. 179–209, here 195–6; R. Goldwater, *Primitivism in Modern Art*, revd and enlarged edn (Cambridge, MA, 1986), p. 70.

4 Varnedoe, 'Gaugin', pp. 188–9; I. Heermann, 'Gauguin's Tahiti – ethnological considerations', in *Paul Gauguin: Tahiti*, ed. C. Becker, exh. cat., Staatsgalerie, Stuttgart (Ostfildern-Ruit, 1998), pp. 147–65, here 162.

5 See *Alberto Giacometti: Le Dessin à l'oeuvre*, exh. cat., Centre Pompidou (Paris, 2001), pp. 78, 246–7.

6 For a detailed account of the 'collection' and transportation of these two moai see J. A. Van Tilburg, *Remote Possibilities: Hoa Hakananai'a and HMS 'Topaze' on Rapa Nui*, British Museum Research Publications 158 (London, 2006).

7 E. Ruiz-Tagle Eyzaguirre, ed., *Easter Island: The First Three Expeditions* (Easter Island, 2007), p. 31; J. Flenley and P. Bahn, *The Enigmas of Easter Island* (Oxford, 2003), p. 107.

8 Illustrated in Van Tilburg, *Remote Possibilities*, p. 3.

9 P. Mason, 'From Presentation to Representation: *Americana* in Europe', *Journal of the History of Collections*, VI/I (1994), pp. 1–20; P. Mason, 'Faithful to the Context? The Presentation and Representation of American Objects in European Collections', *Anuário Antropológico*, 98 (2002), pp. 51–95.

10 Flenley and Bahn, *The Enigmas of Easter Island*, p. 179.

11 Van Tilburg, *Remote Possibilities*, p. 44.

12 Ibid., p. 3.

13 K. Routledge, *The Mystery of Easter Island* (London, 1919), p. 184.

14 Goldwater, *Primitivism in Modern Art*, p. 240; A. G. Wilkinson, 'Paris and London: Modigliani, Lipschitz, Epstein and Gaudier-Brzeska', in *'Primitivism' in 20th Century Art*, ed. W. Rubin, vol. II, pp. 416–51.

15 Van Tilburg, *Remote Possibilities*, pp. 4–5.

16 P. Curtis and K. Wilson, eds, *Modern British Sculpture*, exh. cat., Royal Academy of Arts, London (2011), p. 57.

17 The third head, 42 cm high and carved in red scoria, falls outside the scope of the present article in view of its dimensions.

18 S. R. Fischer, *Island at the End of the World: The Turbulent History of Easter Island* (London, 2005), p. 113.

19 Van Tilburg, *Remote Possibilities*, p. 51.
20 D. W. Druick et al., eds, *Odilon Redon: Prince of Dreams, 1840–1916*, exh. cat., The Art Institute of Chicago, Royal Academy of Arts, London, and Van Gogh Museum, Amsterdam (New York, 1994), pp. 167, 223–4.
21 A. Métraux, *Ethnology of Easter Island* (Honolulu, 1940).
22 F.A.M. Forment, *Le Pacifique au îles innombrables: Île de Pâques. Catalogue d'objets de la Polynésie et de la Micronésie, exposés dans la salle Mercator* (Brussels, 1982), pp. 132–7.
23 U. Hänig and D. Sauer, 'Technique de coffrage et de moulage pour l'obtention de copies fidèles de deux *moai* et d'une façade *ahu* de l'Île de Pâques', in *L'Île de Pâques: Une Énigme?*, exh. cat., Musées Royaux d'Art et d'Histoire, Brussels (1990), pp. 152–9.
24 Routledge, *The Mystery of Easter Island*, p. 184.
25 D. D. Tumarkin and I. K. Fedorova, 'Nikolai Miklouho-Maclay and Easter Island', *Pacific Studies*, XIII/2 (1990), pp. 103–17. The combination of the lack of a safe anchorage on the island (Cook's negative verdict was 'there can be few places which afford less convenience for shipping than it does'), and the fact that more than half of the island population had just left for Mangareva, deterred the ship's captain from trying to land. Miklouho-Maclay subsequently caught up with the emigrants on Mangareva and tried to gather information there.
26 Ibid., p. 104.
27 Van Tilburg, *Remote Possibilities*, p. 47; M. Gusinde, 'Catálogo de los objetos originarios de la Isla de Pascua conservados en este Museo', *Publicaciones del Museo de Etnología y Antropología de Chile*, III (1922), pp. 200–44 includes a photograph of the *moai* on the island prior to embarkation. I am endebted for a photocopy of Gusinde's article to the late Anne Chapman.
28 Hänig and Sauer, 'Technique de coffrage et de moulage', p. 156.
29 The volcanic rock coloured red with oxidized iron came from only one place on the island, Puna Pau, at a considerable distance from the Rano Raraku quarry where most of the moai were carved. See Flenley and Bahn, *The Enigmas of Easter Island*, p. 142.
30 Fischer, *Island at the End of the World*, p. 245.
31 Larry Rohter, 'An Artist Sets Sail, but South Pacific Pulls Him Home', *The New York Times* (22 April 2006).
32 Though the stone gives the date of 1978, the inauguration of its placement is dated 1988 in L. F. Voionmaa Tanner, *Santiago, 1792–2004: Escultura Pública del monumento commemorativo a la escultura urbana* (Santiago, 2005), vol. II, p. 62. Whichever of the two dates is preferred, they both fell within the seventeen years of the military dictatorship.
33 *El Mercurio* (27 November 2009).
34 *La Tercera* (21 April 2006).
35 Flenley and Bahn, *The Enigmas of Easter Island*, p. 106. However, it should be noted that some of the watercolours made of Rano Raraku statues in 1868 by J. Linton Palmer show carved eye sockets. If these statues were not destined for a platform, then either the artist was mistaken, as Van Tilburg, *Remote Possibilities*, p. 30 assumes, or the modern assumption is wrong.

36 For the use of a similar label referring to 'sedimentary rocks 10 million years old' in the grounds of a museum further south in Chile on the island of Chiloé, see P. Mason, 'Un paseo por el patio de recuerdos del Museo Azul de las Islas de Chiloé', in *Un Almuerzo Desnudo: Ensayos en cultura material, representación y experiencia poética*, ed. F. Gallardo and D. Quiroz (Santiago, 2008), pp. 81–91.

37 Flenley and Bahn, *The Enigmas of Easter Island*, p. 138.

38 *Chile antes de Chile*, exh. cat., Museo Chileno de Arte Precolombino / DIBAM (Santiago, 1997), pp. 7, 79.

39 Fischer, *Island at the End of the World*, pp. 135ff.

40 Dancers accompanied the work of the sculptors. The *Rapa Nui News*, 14 (1 May 1988), reports on a similar event in Australia, where a troop of dancers led by Pedro Atan Paoa performed at the first National Multi-Cultural Festival as well as for the Chilean Embassy in Canberra, while three sculptors from the island carved a 2-m wooden moai as a gift to the people of Canberra. It was placed in front of the Chilean Embassy.

41 It has subsequently been brought back to Vitorchiano, but now stands on a different site in the village to that shown in the 2006 photograph reproduced here.

42 Fischer, *Island at the End of the World*, p. 131; Van Tilburg, *Remote Possibilities*, pp. 60, 52–5, 58 respectively.

43 Cited in Olga Larnaudie, 'Apuntes para un guión curatorial acerca de imaginarios prehispánicos (y / o primitivos)', in *Imaginarios Prehispánicos en el Arte Uruguayo, 1870-1970*, exh. cat., Museo de Arte Precolombino e Indígena (MAPI), Montevideo (2006), pp. 77–106, here 92.

44 Compare the thoughtful discussion of how new frameworks of meaning have been constructed around the transfer of a Maori meeting house (Hinemihi) to a National Trust park in Surrey, England, by E. Hooper-Greenhill, 'Perspectives on Hinemihi: A Maori Meeting House', in *Colonialism and the Object: Empire, Material Culture, and the Museum*, ed. T. Barringer and T. Flynn (London, 1998), pp. 129–43.

6 Technology and Surrealism

1 Similarly, half a century after Diego de Ocaña, the Franciscan Diego de Córdoba y Salinas credited the construction of the Inca temple, warehouse and stronghold Saqsaywaman to the devil rather to Andean engineers and masons; see C. Dean, *A Culture of Stone: Inka Perspectives on Rock* (Durham, NC, and London, 2010), p. 151.

2 Fray Diego de Ocaña, *Viaje por el Nuevo Mundo: De Guadalupe a Potosí, 1599–1605*, ed. B. López de Mariscal and A. Madroñal (Madrid, 2010), pp. 447–9.

3 On the chronological and geographical problems, see J. Flenley and P. Bahn, *The Enigmas of Easter Island* (Oxford, 2003), pp. 31–4 and 47–50; moreover, in spite of early reports that Inca architecture was based on Tiwanaku models, the form, style and construction of buildings at Tiahuanaco are significantly different from the 'nibbled masonry' of the Inca; see Dean, *A Culture of Stone*, pp. 76, 218 n. 43.

4 N. Thomas, *Entangled Objects: Exchange, Material Culture, and Colonialism in the Pacific* (Cambridge, MA, and London 1991), p. 132.

5 B. Curran et al., *Obelisk: A History* (Cambridge, MA, 2009), pp. 26–9.

6 K. Routledge, *The Mystery of Easter Island: The Story of an Expedition* (London, 1919), p. 179; T. Heyerdahl, *Aku-Aku: The Secret of Easter Island* (London, 1958), ch. 5; Flenley and Bahn, *The Enigmas of Easter Island*, p. 115.

7 He drew on the works dedicated to the history of science and technology in the Burndy Library that he founded in Brooklyn, New York, in 1941, as did the four authors of Curran et al., *Obelisk*. The library is currently located in California.

8 Curran et al., *Obelisk*, p. 30.

9 Routledge, *The Mystery of Easter Island*, pp. 182, 193.

10 Ibid., p. 197.

11 *TWEEJAARIGE REYZE RONDOM DE WERELD, Ter nader Ontdekkinge der Onbekende Zuydlanden, Met drie Schepen, in het Jaar 1721. ondernomen, door last van de Nederlandsche Westindische Maatschappij . . .* (Dordrecht, 1728).

12 Flenley and Bahn, *The Enigmas of Easter Island*, p. 125, though they inaccurately refer to 'a little-known Dutch drawing'.

13 H.-M. Esen-Baur, 'Sculptures mégalithiques et architecture monumentale', in *L'Île de Pâques: Une Énigme?*, exh. cat., Musées Royaux d'Art et d'Histoire, Brussels (1990), pp. 87–108, here 93.

14 *Easter Island: The First Three Expeditions* (Rapa Nui, 2004), p. 31.

15 J. A. Van Tilburg, *Remote Possibilities: Hoa Hakananai'a and HMS 'Topaze' on Rapa Nui*, British Museum Research Publications 158 (London, 2006), p. 37.

16 See the survey in Flenley and Bahn, *The Enigmas of Easter Island*, pp. 121–33.

17 Curran et al., *Obelisk*, pp. 40–44.

18 Ibid., pp. 30–32.

19 Flenley and Bahn, *The Enigmas of Easter Island*, pp. 140–43.

20 G. Cipriani, *Gli obelischi egizi: Politica e cultura nella Roma barocca* (Florence, 1993), pp. 25–6.

21 For example, ibid., pp. 28–33; C. Hibbert, *Rome: The Biography of a City*, (Harmondsworth, 1987), pp. 175–8; Curran et al., *Obelisk*, pp. 109–35.

22 Curran et al., *Obelisk*, p. 262.

23 F. Camerota, 'Il contributo di Galileo alla matematizzazione delle arti', *Galilæana*, 4 (2007), pp. 79–103, esp. illus. 1.

24 Subsequently published as 'The Colossus of Rhodes', *Journal of Hellenic Studies*, 76 (1956), pp. 68–86. The author acknowledges the assistance of his son John Gilbert Maryon, a civil engineer.

25 Pliny the Elder, *Historia naturalis*, XXXIV, 40. The erection of equestrian statues in the centre of Rome was frowned upon by the Senate, but was permitted as a private dedication in a sanctuary.

26 D.E.L. Haynes, 'Philo of Byzantium and the Colossus of Rhodes', *Journal of Hellenic Studies*, 77 (1957), pp. 311–12.

27 F. C. Albertson, 'Zenodorus's "Colossus of Nero"', *Memoirs of the American Academy in Rome*, 46 (2001), pp. 95–118.

28 A. Barbier, 'Londres', *Iambes et poèmes* (Paris, 1841), ll. 14–16, author's translation.

29 W. Benjamin, *The Arcades Project*, trans. H. Eiland and K. McLaughlin

(Cambridge, MA, and London, 1999), pp. 452 and 398 respectively. The version of Barbier's poem cited there on p. 452 is less faithful to the French original than the translation provided above.

30 Ibid., p. 189.

31 Ibid., p. 160.

32 Ibid., pp. 160–61. The passage is from A. G. Meyer, *Eisenbauten* (Esslingen, 1907), p. 93. The first sentence does not appear in Benjamin's citation, and I have replaced the translators' 'colossal' by 'tremendous' span of energy as there is no trace of the word 'colossal' in the German *ungeheuren*.

33 Benjamin, *The Arcades Project*, pp. 150–51, citing M. von Boehm, *Die Mode im XIX: Jahrhundert* (Munich, 1907), vol. II, p. 131.

34 Benjamin, *The Arcades Project*, pp. 151–2, citing J. Falke, *Geschichte des modernen Geschmacks* (Leipzig, 1866), p. 380.

35 Benjamin, *The Arcades Project*, p. 152, emphasis added; cf. p. 389.

36 Ibid., p. 82.

37 Ibid., p. 391.

38 Ibid., p. 82.

39 Y. Bonnefoy, *Alberto Giacometti: A Biography of His Work*, trans. J. Stewart (Paris, 1991), pp. 153–6; G. Didi-Huberman, *Le Cube et le visage: Autour d'une sculpture d'Alberto Giacometti* (Paris, 1993), pp. 107ff. For the plaster version of the flat head, see V. Wiesinge, ed., *Alberto Giacometti: Colección de la Fundación Alberto y Annette Giacometti, París*, exh. cat., Fundación Proa, Buenos Aires (2012), pp. 34–5. Regrettably, a bewildering variety of titles are used by different authors and institutions to refer to this work.

40 Bonnefoy, *Giacometti*, p. 132.

41 D. Sylvester, *Looking at Giacometti* (London, 1994), p. 211; A. Giacometti, *Écrits* (Paris, 1990), p. 288.

42 Bonnefoy, *Giacometti*, p. 214.

43 B. Braun, *Pre-Columbian Art and the Post-Columbian World* (New York, 1993), p. 39, who singles out its influence on Joaquín Torres-García; L. Tythacott, *Surrealism and the Exotic* (London and New York, 2003), p. 99; S. Fee, 'Not for Art's Sake: An Early Exhibition of Pre-Columbian Objects at the Toledo Museum of Art, 1928–1929', *Museum Anthropology*, XXXIV/1 (2011), pp. 13–27.

44 R. Krauss, 'Giacometti', in *'Primitivism' in 20th Century Art: Affinity of the Tribal and the Modern*, ed. W. Rubin, exh. cat., Museum of Modern Art (New York, 1984), vol. II, pp. 502–33, here 529 n. 39.

45 *Alberto Giacometti: Le Dessin à l'oeuvre*, exh. cat., Centre Pompidou (Paris, 2001), pp. 78 and 246–7. For Egypt see C. Klemm and D. Wildung, *Giacometti: der Ägypter*, exh. cat., Ägyptisches Museum und Papyrussammlung, Berlin, and Kunsthaus, Zurich (Munich, 2008); for Etruria see *Giacometti et les Étrusques*, exh. cat., Pinacothèque de Paris (Milan, 2011).

46 Krauss, 'Giacometti', p. 520; p. 533 n. 82 adduces a more convincing parallel in various examples of spiked weapons that were on display in the Musée de l'Homme from the end of the nineteenth century.

47 Sylvester, *Looking at Giacometti*, p. 96.

48 The term is used by C. Gatti, 'Des Étrusques à Giacometti: Une même lignée iconographique ancestrale', in *Giacometti et les Étrusques*, pp. 14–23, here 17.

49 W. Rubin, 'Modernist Primitivism: An Introduction', in *'Primitivism' in 20th Century Art*, ed. Rubin, vol. I, pp. 1–81, here 32–4.

50 Krauss, 'Giacometti', p. 514.

51 For instance, the heavily Surrealist text 'The Dream, The Sphinx and the Death of T.' was written for *Labyrinthe* in 1946, more than a decade after his break with the Surrealists, as pointed out by Sylvester, *Looking at Giacometti*, p. 113; for another example see note 83 below.

52 Didi-Huberman, *Le Cube et le visage*, p. 91.

53 Ibid., p. 227, emphasis added.

54 G. Didi-Huberman, 'Sur les treize faces du *Cube*', reprinted in Didi-Huberman, *Phasmes: Essais sur l'apparition* (Paris, 1998), pp. 217–27.

55 T. Stooss, 'Das Surrealistische Abenteuer, 1928–1934', in *Alberto Giacometti, 1901–1966*, exh. cat., Kunsthalle, Vienna (Ostfildern-Ruit, 1996), pp. 29–41, here 39, calls it 'nicht überblickbar'.

56 Didi-Huberman, *Le Cube et le visage*, p. 7; the various photographs are reproduced on pp. 227 and 10–11.

57 Ibid., p. 17.

58 The uniqueness of these horizontal compositions is stressed in the essay by Krauss, 'Giacometti'.

59 Didi-Huberman, *Le Cube et le visage*, pp. 10–11 gives the dimensions of the former as 94 × 54 × 59 cm and of the latter as 94 × 56 × 69 cm. A more recent publication by the Centre Pompidou gives the dimensions of the latter as 94 × 60 × 60 cm; see *Alberto Giacometti: Le Dessin à l'oeuvre*, cat. no. 208. Besides indicating the poor state of our knowledge of these two plasters, the discrepancy also illustrates the difficulty of providing the dimensions of an undimensionable object.

60 *Giacometti & Maeght, 1946–1966*, exh. cat., Fondation Maeght (Saint-Paul de Vence, 2010), cat. no. 19, which gives the dimensions as 93.5 × 58.5 × 58 cm; ibid., p. 18; J. Lord, *Giacometti: A Biography* (London, 1996), p. 314.

61 Didi-Huberman, *Le Cube et le visage*, pp. 160 and 167 gives its dimensions as 94 × 54 × 59 cm.

62 Ibid., p. 226.

63 Ibid., p. 65.

64 Sylvester, *Looking at Giacometti*, p. 17.

65 See S. E. Gontarski, 'Introduction: From Unabandoned Works: Samuel Beckett's Short Prose', in Samuel Beckett, *The Complete Short Prose, 1929–1989*, ed. and with an introduction and notes by S. E. Gontarski (New York, 1995), pp. xi–xxxii.

66 English translation ibid., pp. 111–13, French original in A. Giacometti, *Écrits*, pp. 7–9. The following translation is the author's.

67 Bonnefoy, *Giacometti*, p. 21.

68 Lord, *Giacometti: A Biography*, pp. 147–9.

69 Didi-Huberman, *Le Cube et le visage*, p. 192.

70 Cited ibid., p. 38.

71 The other two are *Knight, Death and the Devil* and *St Jerome in His Study*.

72 Lord, *Giacometti: A Biography*, pp. 20–21 dates *Knight, Death and the Devil* to 1913, when Alberto was twelve years old; in *Alberto Giacometti: Le Dessin*

à l'oeuvre, cat. nos 174–6, these drawings are dated 1915 and (*c.*) 1915–17 respectively. In the preface to a publication of his copies written in 1965, he gave 1915: Giacometti, *Écrits*, p. 95.

73 Bonnefoy, *Giacometti*, pp. 213–14.

74 Didi-Huberman, *Le Cube et le visage*, p. 157.

75 W. Benjamin, *The Origin of German Tragic Drama*, trans. J. Osborne (London, 1977), pp. 154–5.

76 E. Panofsky, *The Life and Art of Albrecht Dürer* (Princeton, NJ, 1955), p. 170 cites the suggestion but finds it unconvincing.

77 For the role of narcissism in melancholia, the classic text is Freud's 'Mourning and Melancholia', first published in 1917 and now available in S. Freud, *On Murder, Mourning and Melancholia*, trans. S. Whiteside (London, 2005), pp. 203–18.

78 Cf. Didi-Huberman, *Le Cube et le visage*, pp. 223–4.

79 Ibid., pp. 70, 220.

80 Didi-Huberman seems to contradict himself on this point: *Le Cube et le visage*, pp. 98 n. 1, 224–5.

81 Bonnefoy, *Giacometti*, p. 212.

82 Sylvester, *Looking at Giacometti*, p. 36.

83 I have modified the English in Bonnefoy, *Giacometti*, p. 94 to make it reflect the French text in Giacometti, *Écrits*, p. 72 more closely. There was a gap of more than 30 years between the Paduan experience and the publication of Giacometti's *May 1920*.

84 Giacometti, *Écrits*, p. 218, emphasis added.

85 Ibid., p. 17.

86 Didi-Huberman, *Le Cube et le visage*.

87 W. Benjamin, *Illuminations: Essays and Reflections*, trans. H. Zohn, ed. H. Arendt (New York, 1968), p. 222.

88 Lord, *Giacometti: A Biography*, p. 148.

89 J. L. Koerner, *The Moment of Self-Portraiture in German Renaissance Art* (Chicago, 1993), p. 23.

Epilogue

1 J.-P. Vernant, *Figures, idoles, masques* (Paris, 1990).

2 J.-P. Vernant, 'La Catégorie psychologique du double: Figuration de l'invisible et catégorie psychologique du double: Le Colossos', in his *Mythe et pensée chez les Grecs* (Paris, 1971), vol. II, pp. 65–78.

3 D. Steiner, *Images in Mind: Statues in Archaic and Classical Greek Literature and Thought*, 2nd edn (Princeton, NJ, 2003), p. 82.

4 Herodotus, *Histories*, VI, 58.

5 H. Belting, *Likeness and Presence: A History of the Image before the Era of Art*, trans. Edmund Jephcott (Chicago and London, 1994).

6 For a critique of the post-Vasarian tradition see G. Didi-Huberman, *Devant l'image: Question posée aux fins d'une histoire de l'art* (Paris 1990).

7 Steiner, *Images in Mind*, p. 20.

8 F. Pereda, *Las imágenes de la discordia: Política y poética de la imagen sagrada*

en la España del 400 (Madrid, 2007), pp. 38–9.

9 C. Ginzburg, *Occhiacci di legno* (Milan, 1998), p. 94. The original French version of this essay appeared as 'Représentation: Le Mot, l'idée, la chose', in *Annales ESC* (1991), pp. 1219–34.

10 H. Gomperz, 'Ueber einige psychologische Voraussetzungen der naturalischen Kunst', in *Beilage der Allgemeinen Zeitung*, 160 (Munich, 14 July 1905), pp. 89–93, and 161 (15 July 1905), pp. 98–101. I have used the translation by Karl Johns, *Journal of Art Historiography*, 5 (December 2011).

11 E. Kris and O. Kurz, *Die Legende vom Künstler: Ein geschichtlicher Versuch* (Vienna, 1934).

12 As the Eleatic Stranger argues in the Platonic dialogue *Kratylos*, 432c; cf. Steiner, *Images in Mind*, p. 69.

13 J. von Schlosser, 'Geschichte der Porträtbilderei in Wachs: Ein Versuch', *Jahrbuch der kunsthistorischen Sammlungen der allerhöchsten Kaiserhauses*, XXIX/3 (1910–11), pp. 171–258.

14 Vernant's initial essay on the *kolossos* was entitled 'The Psychological Category of The Double' (see note 2). Attempts to force his account into a rigid chronological framework, or to draw conclusions regarding the assumption of such a framework, are therefore misguided.

15 P. Mason, *The Lives of Images* (London, 2001), pp. 13–16.

16 F. Egmond and P. Mason, *The Mammoth and the Mouse: Micro-history and Morphology* (Baltimore, 1998).

17 G. Didi-Huberman, *La Ressemblance par contact: Archéologie, anachronisme et modernité de l'empreinte* (Paris, 2008), p. 98. The reference is of course to Warburg's *Bildniskunst und florentinisches Bürgertum* (Leipzig, 1902), translated as 'The Art of Portraiture and the Florentine Bourgeoisie', in A. Warburg, *The Revival of Pagan Antiquity*, trans. David Britt (Los Angeles, 1999), pp. 185–221, with addenda on 435–50.

18 S. J. Tambiah, *Magic, Science, Religion, and the Scope of Rationality* (Cambridge, 1990), pp. 59–60. The reference to Wittgenstein is to the latter's 'Remarks on Frazer's *Golden Bough*', of which there is a parallel German and English text in J. Klagge and A. Nordmann, eds, *Ludwig Wittgenstein: Philosophical Occasions, 1912–1951* (Indianapolis and Cambridge, 1993), pp. 118–55.

19 W. Benjamin, *The Origin of German Tragic Drama*, trans J. Osborne (London, 1977), p. 45.

LIST OF ILLUSTRATIONS

1 Francisco Goya y Lucientes, *The Colossus*, *c*. 1808–12, oil on canvas, 116 × 105 cm. Museo del Prado, Madrid.

2 Francisco Goya y Lucientes, *The Giant*, *c*. 1818, aquatint and burin, 28.5 × 21 cm.

3 Edward Lutyens, The Cenotaph, 1920, Whitehall, London.

4 'Colossus of Rhodes', from André Thevet, *Cosmographie de Levant* (Lyon, 1556).

5 Philips Galle, after Maarten van Heemskerck, 'Colossus of Rhodes', from *The Wonders of the World*, a series of eight prints, 1572. Rijksprentenkabinet, Rijksmuseum Amsterdam.

6 'Apollo', from Vicenzo Cartari, *Imagini delli Dei de gl'Antichi* (Venice, 1647), woodcut.

7 Maarten van Heemskerck, *Landscape with the Rape of Helen*, 1535–6, oil on canvas, 147.4 × 383.3 cm. The Walters Art Gallery, Baltimore, Maryland.

8 Antoine-Laurent-Thomas Vaudoyer, *Colossal Marble Finger*, 1785, pen, ink, pencil and wash, 20.5 × 19.4 cm. Coll. W. Apolloni, Rome.

9 Philips Galle, after Maarten van Heemskerck, 'The Colosseum in Rome', from *The Wonders of the World*, a series of eight prints, 1572. © Trustees of the British Museum, London.

10 Maarten van Heemskerck, *Self-portrait*, 1553, oil on canvas, 42.2 × 54 cm. The Fitzwilliam Museum, Cambridge.

11 Bartolomeo di Giovanni, *Peace between Romans and Sabines*, *c*. 1488, tempera on panel, 70 × 155 cm. Galleria Colonna, Rome.

12 Domenico Gargiulo and Viviano Codazzi, *Prospect of a Roman Amphitheatre*, *c*. 1640, oil on canvas, 220 × 352 cm. Museo del Prado, Madrid.

13 Engraving after Lambert Zutman, from *RUINARUM VARIARUM FABRICARUM DELINEATIONES . . .*, a series of 28 engravings, 1560. Rijksprentenkabinet, Rijksmuseum Amsterdam.

14 Engraving after Gottfried Eichler, 'Gratitude', from Cesare Ripa, *Allegories and Conceits* (Augsburg, 1758–60).

15 André Dutertre, *Thebes, Memnonium, View of the Two Colossi*, 1798–1801, pen and wash. Bibliothèque Nationale, Paris.

16 'Obelisk in Alexandria', from André Thevet, *Cosmographie de Levant* (Lyon, 1556).

17 Philips Galle, after Maarten van Heemskerck, 'The Triumph of Fame', from *The Triumphs of Petrarch*, a series of six prints, *c*. 1565. © Trustees of the British Museum, London.

18 Philips Galle, after Maarten van Heemskerck, 'The Egyptian Pyramids', from *The Wonders of the World*, a series of eight prints, 1572. Rijksprentenkabinet, Rijksmuseum Amsterdam.

19 Obelisk, Celian Hill, Rome, 2007, before restoration.

20 Obelisk, Celian Hill, Rome, after restoration.

21 Giovanni Battisti Piranesi, 'View of the Piazza della Rotonda', from *Vedute di Roma*, c. 1745–78, copperplate engraving, 41 × 54.7 cm. © Trustees of the British Museum, London.

22 Obelisk, Piazza di San Pietro, Rome.

23 Reliquary of the Sacred Thorn, 1575–80, gilt silver, rock crystal, oil on copper, *h*. 46 cm. Chiesa del Gesù, Rome.

24 Nicola da Urbino (attrib.), *Caesar Leaving Rome*, c. 1533, majolica, *dia*. 26 cm. Museo Correr, Venice.

25 Obelisk, Basilica di Santa Maria Maggiore, Rome.

26 Obelisk, San Giovanni in Laterano, Rome.

27 Giovanni Battisti Piranesi, 'View of the Piazza del Popolo', from *Vedute di Roma*, c. 1745–78, copperplate engraving, 40 × 53.8 cm. © Trustees of the British Museum, London.

28 Andrea Locatelli, *View of Piazza Navona*, 1733, oil on copper, 73 × 93 cm. Gemäldegalerie der Akademie der Bildenden Künste, Vienna.

29 'Museum of Athanasius Kircher', from G. de Sepi, *Romani collegii Societatis Jesu musaeum celeberrimum* (Amsterdam, 1678).

30 Ercole Ferrata, after a design by Gian Lorenzo Bernini, elephant surmounted by obelisk, 1667, Santa Maria sopra Minerva, Rome.

31 Elephant surmounted by obelisk, woodcut from Francesco Colonna, *Hypnerotomachia Poliphili* (Venice, 1499).

32 Obelisk on top of immense pyramid, woodcut from Francesco Colonna, *Hypnerotomachia Poliphili* (Venice, 1499).

33 Giulio Bonasone, 'Happy is He Who Established the Good that Is One', engraved design for a monument to Ugo de Pepoli, from Achille Bocchi, *Symbolicarum quaestionum, de universo genere, quas serio ludebat, libri quinque* (Bologna, 1555).

34 Engraving after Gottfried Eichler, 'Depravity', from Cesare Ripa, *Allegories and Conceits* (Augsburg, 1758–60).

35 Obelisk, Piazza del Quirinale, Rome.

36 Obelisk, Piazza di Montecitorio, Rome.

37 Obelisk, Trinità dei Monti, Rome.

38 Obelisk, Pincian Hill, Rome.

39 Obelisk, Villa Torlonia, Rome.

40 Franceso Podesti, 'Africa', from the series *Three Continents*, c. 1835 (detail). Hall of Bacchus, Casino Nobile, Villa Torlonia, Rome.

41 Obelisk, Viale Einaudi, Rome.

42 Reconstruction of Gioacchino Toesca, *Obelisco de los antiguos Tajamares*, 1950, brick. Parque Providencia, Santiago de Chile.

43 Georg Forster, from Johann Reinhold Forster, *Journal of a Voyage on Board His Majesty's Ship the 'Resolution'*, 1774, pen and ink on paper, 20.3 × 14.1 cm. Inv. MS Germ. quart. 225 o.f. 136, Staatsbibliothek Berlin. Photograph Christine

69 Moai head, tuff, *h*. 1.85 m, Musée du Quai Branly, Paris, 2009.

70 Moai head, tuff, *h*. 1.85 m, Musée du Quai Branly, Paris, 2012.

71 Moai Pou hakanononga, basalt, *h*. 2.73 m, Musées Royaux d'Art et d'Histoire, Brussels, 2006.

72 Replica of a moai from the Ranu Raraku quarry, Easter Island, Musées Royaux d'Art et d'Histoire, Brussels, 2006.

73 Bene Tuki Paté, *The Brotherhood Moai*, travertine marble, Hotel Plaza San Francisco, Santiago de Chile, 2009.

74 Moai, Alameda–Lord Cochrane-Sur–Amunátegui Norte, Santiago de Chile, 2009.

75 Moai facing the National Stadium, Campo de Deporte–Avenida Grecia, Ñuñoa, Santiago de Chile, 2009.

76 Moai, tuff, *h*. 2.81 m, Corporación Museo Fonck, Viña del Mar, Chile, 2009.

77 Stone with man-made perforations, Corporación Museo Fonck, Viña del Mar, Chile, 2009.

78 Atan family, moai, peperino stone, Piazza Umberto I, Vitorchiano, Viterbo, Italy, 2006.

79 Moai head in the private garden of an Italian artist, Saint-Paul de Vence, France, 2010.

80 Battle between Easter Islanders and Dutch in 1722, anonymous engraving from *Tweejaarige Reyze Rondom de Wereld* (1728).

81 Alberto Giacometti, *Le père de l'artiste (plat et gravé)*, 1927, bronze, 27.5 × 21 × 14 cm. Kunsthaus Zürich, Alberto Giacometti Foundation, gift of the artist.

82 Olmec incised stone, Parque-Museo La Venta, Villahermosa, Tabasco, Mexico.

83 Alberto Giacometti, *Le Cube*, 1934, bronze, 95 × 54 × 59 cm. Kunsthaus Zürich, Alberto Giacometti Foundation.

84 Albrecht Dürer, *Melencolia I*, 1514, copperplate engraving, 23.9 × 18.5 cm. © Trustees of The British Museum, London.

ACKNOWLEDGEMENTS

Some of the material contained in this book has been presented in various locations: Buenos Aires, Lisbon, London, Madrid, Santiago de Chile, Trujillo (Spain, within the framework of the research project 'Cuerpo y Sentimiento. Expresiones Culturales Amerindias', HUM2007-63242) and Villahermosa (Tabasco, Mexico). I would like to thank the following for their kind invitations to vent the pent: Margarita Alvarado Pérez, Manuel Gutiérrez Estévez, Mario Humberto Ruz, Filipa Lowndes Vicente, Gonzalo Pedraza, Marta Penhos, Juan Pimentel Igea, Robert Storrie, Jaime Valenzuela Márquez.

The chapters on the moai, though extensively rewritten, are based on 'Siete maneras de ser moai', *Boletín del Museo Chileno de Arte Precolombino*, x/2 (Santiago de Chile, 2005) and 'Moai on the Move', *Journal of the History of Collections*, xxiv/1 (2012). For guidance on these matters I am grateful to Christian Báez Allende and Carolina Odone, especially for helping me to locate and document the moai on the Chilean mainland, as well as to Christine Barthe in Paris, the late Anne Chapman and to Ian Rolfe.

Felipe Pereda is the kind of critical reader that every author would love to have. For having taken the time and trouble to go through the entire manuscript and make extremely pertinent suggestions, Felipe, *muchísimas gracias. Estoy enormemente en deuda contigo.*

Florike Egmond accompanied me to Brussels, Easter Island, Lisbon, London, Madrid, Saint-Paul de Vence, Vitorchiano, Yucatán. Each journey was as adventurous and rewarding as our life together in Rome.

INDEX

italic numbers refer to illustrations